As an only child reeling from the demolition of her parents' toxic marriage, the New York City underground music scene offers a young Ali a different family of misfits and talented outsiders to belong to.

She becomes the bass player for edgy band Speedball Baby, a decision that will take her around the world—from onstage at the legendary CBGBs to the red-light district of Amsterdam. She's often the only girl in a broken-down tour van, being strip-searched at the Croatian border, chased by lunatics, and navigating the seedy underbelly of a male-dominated music scene full of addiction, violence, and misogyny—all while keeping her sharp wit and dark humor intact.

Rimmed with heavy black eyeliner and smelling faintly of cheap booze, *The Ballad of Speedball Baby* is a pulse-quickening, unpredictable ride through the '90s music scene—alternately terrifying, hilarious, and painfully evocative—as well as a love letter to the power of female solidarity.

T0383818

The BALLAD of SPEEDBALL BABY

books by ali smith

Laws of the Bandit Queens
Momma Love: How the Mother Half Lives
The Ballad of Speedball Baby

The BALLAD of SPEEDBALL BABY

A

MEMOIR

ALI SMITH

BLACK
STONE
PUBLISHING

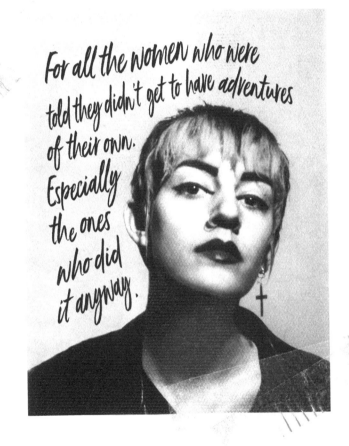

For all the women who were told they didn't get to have adventures of their own. Especially the ones who did it anyway.

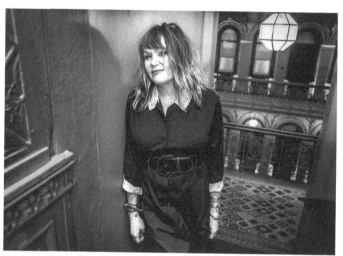

Exene at The Beekman Hotel, NY. Photo by Ali

foreword

Exene Cervenka

(founding member of the seminal punk band X)

I met Ali Smith twenty years ago, when she interviewed and photographed me for her book *Laws of the Bandit Queens*. I was immediately smitten by that smart, witty, beautiful, young woman. We became friends, and I have since witnessed her cool artistic vision, threading through photography, music, and writing. *The Ballad of Speedball Baby* is her own amazing story.

Ali goes from bohemian baby to punk girl 'neath the harsh NYC skyline.

The Los Angeles punk scene, which birthed me in the late '70s, was radically different from the NYC scene of the late '80s and '90s. We were 50 percent female and we never

even noticed. We played nice under the sun, where rent and cars and guitars were cheap and easy to play. Drugs and booze were everywhere, but there was an innocence and lightness around the edges; until things got dark.

By the time Ali entered the punk/post-punk scene, hard core had darkened those edges back up to black. It was CBGBs the way you expect it to be: wrecked bathrooms, graffiti, nihilism, violence; all that and sleet and ice and subways, too. And there weren't that many women in bands.

But here is Ali; a bass-playing bandit queen holding her ground in this universe of men, sure-footed in combat boots, loading film and shooting away at the troops staggering down the sidewalk into Alphabetland to score drugs. This book is about bands, art, teenagers falling in love, and falling downstairs. It's stories of improbable luck and broken-down vans (of course; 'cause it's about punk bands). It's about playing around the world and pissing off A&R people (record label reps with the power to sign bands and fulfill, or sometimes ruin, all their biggest dreams), about capsizing and standing up again. It's about a woman brave enough to say "Yes!" and smart enough to know when to walk away.

I loved reading this book about a world I didn't get to experience and a musical history of which I knew too little. I don't think I could have survived this dark, crazy, happy place of New York City punk. I've always thought of her as strong, but I never knew Ali was this tough!

introduction

Harper darts back and forth behind me, ducking to avoid the prying eye of the jumbotron cameras as they sweep the crowd, projecting a sea of graying heads onto four huge screens over the stage. There's a smattering of younger heads sprinkled in the mix; mainly those of kids who, like Harper, have come with their "we-were-once-punk" parents. He is phobic about being on camera, which confounds me as he's got a mom who's spent a lifetime trying to get in front of or behind one.

The jumbotrons worry me too. Not because I'm camera-phobic like him, but because they offer an ominous premonition for what kind of show this is going to be.

I keep waiting for the dreaded "spring break" beach balls to emerge, bouncing over the crowd. (When they finally do, hours later, I will gleefully reach out for one and launch it to Harper without a trace of irony.)

X is on stage and Exene Cervenka and John Doe are framed by New York City's skyline, which is sparkling chrome and glass in the bright summer evening. Sailboats and ferries glide past, completely indifferent to the fact that this is supposed to be one of the most important moments of my life.

I'm seeing two of my all-time favorite bands—X and the Psychedelic Furs—and all I can think about is that it's too bright, too hot, and I feel too old. Billy Zoom has assumed his trademark guitar playing stance—legs spread into a split—but he's propped up by a stool tonight. I want to chug my margarita to change my mood, but it cost me an unbelievable twenty-four dollars, so I sip it prudently. Plus, with the heat, I'm afraid I'll get tired if I knock it back. Harper hops from foot to foot, gnawing on a stale, $15 pretzel. He's not dancing to the music, but obsessively away from the cameras. His thin, twelve-year-old arms encircle my waist. Arms that are full of promise. That will someday pull a lover close. That he may use to defend himself or to play an instrument or hold a protest sign or to grow his own food in his postapocalyptic garden. He is my favorite thing in the whole world. But in this moment, I want to shake him off. I want to be young again.

Exene wails like a beautiful siren, but it's hard, at first, for the band to get the crowd going. I flash back to that feeling of being on a stage—maybe it was in Belgium? Croatia? Maybe Ohio!—trying to get a crowd excited at an outdoor show in the brightness that overwhelms any flattering stage lighting and makes your heavy makeup look like you're Nosferatu emerging from a tomb, unawares, only to be sizzled to ash by the sun.

I take a long, expensive sip off my drink, and very suddenly—maybe it's with the certain slash of a guitar or crash of a cymbal—the alchemy begins to work. The band is amazing as ever, the booze is effective, and I'm starting to teleport away, back to my bedroom in my mother's apartment where I'm singing along to X's "The Hungry Wolf." I've only just heard it on WLIR, New York's alternative radio station, and I've taped it off the radio to play over and over and to sing along to and to crawl inside of. My copy starts a full verse into the song, since once I realized I had to have it for my own, it required lunging for the "record" button on the tape deck.

My bedroom belongs to a girl who's living in between two lives. She's fourteen and the remnants of her childhood—a practice barre from her ballet days, stacks of Archie comics, Disney gatefold records with storybooks inside, a hamster, hairbrushes meant for long, shiny healthy hair—lie around the room like discarded animal carcasses: once full of life, now carrion. Around these

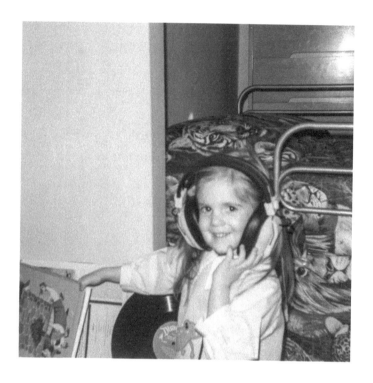

relics—on top of them, encroaching on their space—are the experimental acquisitions of a new life, one that seems to belong to a different person: black clothes, army boots, a 45 by Blondie, a dresser-top littered with black eyeliner and blood red lipstick. These changes happened at a disorienting speed, and life is now lived completely in the in between place—not childhood, definitely not adulthood, but a space in which time moves so fast, everything is unrecognizable one day to the next. A place that's on fire.

Mom is so confused. She just shakes her head.

I sing along to that tape of "The Hungry Wolf" into a microphone that plugs into my stereo and produces a tinny, metallic version of my amplified voice. It's 1983 and I have no idea that someday, I'll watch X on stage because Exene and I have now been friends for twenty years. And that she'll put me—and my husband and my son—on the list whenever they're in town. And that before this show, I'll wince and whine and hem and haw to her about coming because there's a pandemic on and "Is it safe?" and "I'm not used to being around people anymore!" And all of that fear that has crept into the mundane task of just living will be on full, embarrassing display. And she'll be as sweet as peach pie about it. Not like the caterwauling, silent film star-looking, intimidating icon that peers out, enigmatic but defiant, from every album cover she's on. I can't fathom any of this in 1983. I just know that this song excites me. And that the man and, particularly, the woman singing it are barreling down a highway, away from the mundane. And that I want to be on that road with them.

part 1

america

one

There's blood on my hands.

I use them to push Ron down the stairs, over and over, but he just keeps bouncing back up, like a blood-covered-yo-yo; lunging ferociously, trying to push past.

It's 3 a.m.

Five hours ago, I was on stage. It was the first show of the tour. The first tour since my band got signed to a major label. And it was horrible.

We're a chaotic, shambolic, confrontational, poetic band from the bowels of New York's Lower East Side, a neighborhood as edgy and insane in 1996 as it's ever been. But some major label genius booked us with three hardcore

bands in a move that says while they signed us, they really don't know who the hell we are.

The crowd had no use for us if we weren't going to grunt and flex or break into some racist chant they could rally around. So they just stood back, looking like they might murder us.

After the set, while rolling up my cord I spotted a T-shirt stretched over a bulbous stomach, the writing on it distorted almost beyond legibility:

"Back off, man. Dicks are for chicks!"

My brain hurts. Get me the fuck out of here.

Only I couldn't get the fuck out of there because the person who said he'd put us up for the night hadn't shown up. So instead, I slumped at the bar, waiting for Matt, my best friend and our guitarist, to sort it out like he always does. Meanwhile, a chorus of grunting and the meaty slapping of flesh-on-flesh exploded behind me as thick men slammed into each other during the next band's set.

I'm no stranger to hardcore shows. I spent every Sunday for years at them at CBGBs on the Bowery—hair dyed bright orange, black eyeliner "raccoon" strong, heavy military boots cinched tight—hurling myself into the pit to prove (to myself mostly) that I could handle anything. But in New York City, my hometown, I know who, in that scene, is a sweetheart and who has literally killed someone. I know who's a bonehead fascist and who's knocking heads with fascists at anti-racist rallies. Here, they all just

seemed like assholes, so I did my best to drown them out with shots and cheap pints until midnight. That's when a friend of a friend of someone we barely knew offered Matt a place for us to stay.

We followed that guy—his name was Blue—in his weaving, lurching, dented Dodge Charger to this dump. He didn't seem drunk when we left the club but watching him stab at the keyhole of his front door a few times with his car key, it became clear he was wasted. Good thing this part of Philly is desolate, crumbling, not another car around, no one crossing the street. If he'd killed anyone with his car, it would have only been his own damn self. With no other option and no budget for a hotel, we glumly dragged our gear up the narrow staircase to his apartment, since equipment left in a van overnight is equipment gone in the morning. Once the amps, the bags, the guitars, the drums and cymbal cases were all inside, it was clear that what we should have done was drive straight through the night to anywhere but here. Should have slept on the side of the road.

Matt paced the living room floor for an eternity, running his thick hand through his waxy black hair—what he does when he's the most anxious. Martin quickly crammed himself into one corner of a stained couch, cradling a can of beer, and pulled his leather jacket over his head. Our host, Blue, vibrated with a coarse, angry energy. He sloshed whiskey onto himself and the brown carpet and wiped

snot from his nose with his thick, tattooed forearm while carrying on about the innate superiority of the white race. And guns.

"Hey, man," Matt shook his head, looking around at our equipment strewn across the floor of this shitty place in the middle of the night in who knows where. "We're *really* not into that. Not at all."

Matt would walk the circumference of the earth backward in order to avoid conflict if it's standing in front of him. It's not that his thin but strong frame couldn't handle it. It's just that he's the peacemaker, the caretaker, the first and last line of common sense and defense. He's pragmatic above all else. And right now, it's his job to get our band across the country to meet our record label and secure our spot in music history while managing our singer's drug habit, our drummer's low-grade but constant British nay-saying, and my pissing and moaning about always being the only girl in the van, on the stage, in the dressing room, broken down on the side of the road, at the police station, etc.

We've been given a beeper by our record label—a clunky, cigarette-box-sized thing that vibrates and displays a phone number when somebody calls it. Sometimes people just send a code. Like 911 means "Call immediately." But no one was sending us any communication in the middle of the night. Especially not one that translated to "R-U-AL-R8?"

Blue ignored Matt completely as he'd long stopped listening to anybody. He just carried on about "the Blacks" (only he didn't use that word) and "the Jews" (only he didn't use that word) and, well, you get the idea. Blue was red and sweaty and incensed.

I leaned wearily against Gigi, my friend who we brought to drive the van and count the cash, but, mostly, to keep me company.

A Rosedale, Queens girl with vague mob connections and a heart of gold, Gigi is small, sexy, and heavily tattooed. Famous actors and musicians flock to date her. Which is how I've learned what a bunch of fucked-up, crooked assholes so many famous actors and musicians really are. Gigi is the kind of girl—funny, wise-cracking, ballsy, and nice—that will hopefully help me feel less alone on tour this time.

Beyond the babbling, sloppy Blue and the increasingly anxious Matt and the curled-up Martin, I could see Ron, our singer, at the end of the long room, sparking like a severed live-wire slapping the ground at gale force looking for someone to bury its lead in. He smiled inanely at me and held something up. It was a glossy 8x10 of Adolf Hitler he'd discovered in a dresser drawer he felt entitled to rifle through by that point. And before I could say *Wait. Is that thing signed??* Ron was standing over Blue's bed, setting the photo on fire with a lighter.

My eyes darted nervously from Blue's puffy, ranting

face to Mein Führer's as it smoldered just beyond him. Once it was a pile of ash settled onto the bedsheets, Ron put his finger to his lips in an exaggerated "Ssshhhhhh," and bent down to pull a blanket over them like he was lovingly tucking in a child.

I turned, wide-eyed, to Gigi.

"Let's get out of here."

We found an empty room on the second floor, spread our jackets out on the hard wood, and huddled together in the dark for warmth. Tired but amped up, we talked about the shitty show that night and the latest rock star she was dating.

"Aren't you thrilled you came with us?" I whispered close to her ear.

"Ha!" she barked. "I mean, ask me in a week."

Then silence again. I wondered if she was listening for chaos coming from beneath the floorboards too.

"At least *this* is nice." I let my head rest against hers. "Even though it's like daddy's drunk again and mommy's locked us up here so he doesn't toss us out the window."

This time she really laughed—a guttural, exhausted laugh—and one of her soft, blond curls brushed my face. That made me think about my friend Melanie, whose crown of golden curls and full, dimpled cheeks make her look like a cherub in a Renaissance painting.

"Melanie's sleeping under the Manhattan Bridge now," I shared, the amount of anger in my voice surprising me.

"She got out of rehab and hooked up with this mess of a girl and now they're stealing clothes from laundromats and selling them on the sidewalk."

Gigi started to respond with "Jesus Chri—" but cut herself off when a shadowy figure stepped out of the darkness. It loomed over us unsteadily, something silhouetted, hanging like a thick, black snake, from its waistline.

———

When I was 15, I was lured, by way of the promise of love, to the home of my high school crush. He was beautiful— light brown bangs hanging over one of his bright, blue eyes, with a wry smile. Not a friendly smile, but a sneering one, like a cartoon wolf. I must have looked like a tiny teenaged bullseye to this handsome boy. How did he even know so much about hunting a girl? Who taught him that? Or do some boys just know, the way geese know to fly south?

I went to his father's apartment. Where was his father? Had he said, "'Listen dad, I've got a tiny teenaged bullseye coming over tonight and I want you to make yourself scarce!' before reassuring him, 'Don't worry! I'll do it all like you taught me.'"

With his dad gone, we listened to records and drank shots of vodka. I'd drunk sweet mixed drinks before. There wasn't a bouncer in New York City in the '80s who wouldn't let a thirteen-year-old girl into a nightclub. But those were

drinks that soda had prepared me for. This was straight shots of vodka, which burned and worked fast. So fast I didn't realize, until pictures started to develop in my mind days later—slowly, like ghost images emerging in a dark-room—that he'd long stopped pouring them for himself as he emptied the better part of a quart into my infinity pool of a shot glass.

The song "Boys Don't Cry" was playing. I loved that song, and as I reached out for the album cover, the room turned sideways and the floor smacked me in the temple. Such a strange apartment, with its rotating walls.

Then it was just snapshots, showing up at unexpected times once I'd finally developed my memory's film and as-sembled the images, like a series of drying prints clipped to a taut cord.

Black. Then the view of the ceiling. Black. Then my crush above me. Black. Then my legs in the air with my pants being clumsily, aggressively tugged off. Then that final image—just like now—a body silhouetted above me, something hanging like a thick, black snake, from its waist-line. Then just black. A lot of black. Until the sharp sunlight cleaved my forehead in two at the center, like a machete, when it cut through the curtains at dawn. My mind learned to go somewhere else that sorry, high school night, leaving my poor little body far behind on its own.

———

By the time I registered it was Blue standing above me and Gigi, my mind had already jumped ship, watching from the ceiling, as my body froze below, a useless, terrified little thing, like a fainting goat. I felt Gigi's do the same, her small fingers still slightly entwined with mine.

The only sound in the darkness was the rattling of Blue's breath. Strips of light through the blinds fell on his heaving chest which seemed to have doubled in size. Minutes, hours, days passed in tense silence.

Until he pounced.

Gigi's hand clutched mine. Our breaths sucked in sharply. My eyes shut. We braced ourselves for impact. And then . . . nothing. Blue had hurtled himself over and past us and crashed, like a blind bull, through a door which he slammed behind him, not once, but twice.

Bang!

Bang!

And we were on our feet, gathering our shoes and jackets and stumbling down the stairs to the boys, who were already halfway through stealthily moving all of our stuff out to the van. We joined them. Every time Ron came back for another amp or guitar, he took the opportunity to knock something over: a small table, a pile of crap.

I was just rounding the landing on what I hoped would be my last trip up when I heard a voice that sounded genuinely hurt slur, "Whereyouguysgoing?"

Just as Blue stumbled into view, Ron barreled past me

and punched him square in the jaw before latching onto him. They clung to each other like drunks fighting will— swinging blindly, sometimes landing a punch but mostly not. Ron had the added velocity of the rabid animal which has lost all concern for its own well-being and is only fixated on spreading the virus.

Suddenly, remembering a mention of guns and strengthened by fear, I yanked Ron off Blue with one, enormous effort, yelled "GO!" and shoved him toward the stairs. Ron turned on his heels and snapped at me like a pit bull while trying to push back to Blue. I grabbed him by the shoulders and shook him as violently as I could. And in that moment, staring into his crazed, nihilistic face, at the thin, taught skin barely concealing the skull beneath, I realized: *I'm going to watch this guy die! Maybe not tonight. But when he goes, I'm going to be right there next to him.* The certainty and the ugliness of it was like being hit by a truck.

And now there's blood on my hands. And it's smeared across Ron's big nose. And he and I are doing the cha cha at the top of the stairs until Matt twirls up behind him and asks, without words, *May I have this dance?* And now they're working their way down the stairs together, bouncing off of the narrow, dirty walls.

I breathe. I didn't realize I'd been holding my breath. I look at my hands. Then the silence settles on me like a wet blanket, and I realize I'm the only one left in the apartment,

standing in my socks. Just me and Blue. Where is Blue, anyway? I remember his face when he talked about his guns: glazed over with an almost sexual euphoria. And suddenly I know that when I turn around, I will be staring down the dark, hollow end of a gun's barrel.

two

It may be the Pink Champale playing tricks on this eleven-year-old's eyes, but that naked woman looks like she's walked into a banana cream pie, boobs-first, and I'm PRETTY sure she's holding a shotgun.

An enormous, gangly man towered over her, long legs sticking out from the bottom of a Playboy Bunny unitard, paired with bunny-tail, ears, and a horrific thing I can only call a "human-flesh-mask."

I blinked my green, marble eyes at them and took another sip.

Then the woman pulled the trigger and everything exploded into chaos. Smoke, sparks, and fire were

everywhere. And just as a massive wall slammed to the ground, my mom's hand came down, violently, on the top of the boxy television set.

"STOP IT!" She ordered the image to stop rolling over on itself. Then she yanked the rabbit-ear antenna around. But a chaotic, colorful static continued to break up the image in a way that only confirmed for me that this show was, in fact, being broadcast to earth by aliens from outer space.

People on the screen leaped out of the way as lights and amplifiers smashed to the ground.

And although it made my stomach lurch, I couldn't look away. As the last notes of destruction and feedback trailed off into a commercial break, my mom sat back on the couch next to me and sipped her Pink Champale.

"Well, they seem nice," she quipped, with a bone-dry delivery.

She had poured the syrupy, malt liquor into two of the three delicate crystal glasses my dad bought us—the only thing I can think of that ever proved we'd once been a unit of three.

Pink wine. In crystal. At MY age. GODDAMMIT, we are sophisticated people!

For an anxious kid who performed every song-and-dance routine in her repertoire in order to keep two fairly unhappy parents as happy as possible, watching TV late into the night with my mom was a newfound freedom.

My dad spent most of his energy in life trying to erase the horror of his twisted, suburban childhood not only from his memory, but from his DNA: the military school at five; the well-respected German stepfather who beat him with a garden hose; the caustic boredom of life on a dead-end street; the terror that that was all there would ever be. He'd wrenched himself away from it all with intense force, and to his mind, TV—the great suburban pacifier—represented that dead life. TV ruined kids' posture, brains, imagination, patience. It caused cancer. It was responsible for nine out of ten crimes. It pushed old ladies down on the sidewalk. It would stick a needle in your arm if you let it. So I was, to say the least, not allowed to watch it. What muddled my dad's clean break with pop culture was that watching TV was my mom's #1 favorite pastime. It was a distraction from a stultifying nursing job, a failing marriage, and the amorphic Catholic guilt the church had given her as a parting gift when she left home. When they fought about me and TV, it was either in hushed tones, or in the musical, sing-songy ones I came to associate with tense conversations. Later, I'd perfect that same tone, causing a series of boyfriends to label me as "passive aggressive."

The only solution for this break between them seemed to be to lie. So, mom and I secretly watched a lot of TV. And when my dad's keys jingled in the front door lock, I'd scramble to turn off the set and spread a book across my lap.

That's how I grew up frustratingly watching a lot of fifteen-minute segments of thirty-minute shows.

This strategy was successful for a long time—me and mom bonding over lying, dad imposing his intolerant will while being duped—until one frightening night.

In my defense, I was *trying* to be funny. I think there should be special dispensation in court when a defendant was "trying to be funny," even if they end up running somebody over or burning something to the ground. Sometimes "funny" is all we've got.

Dad was out late and mom and I were watching *Saturday Night Live*. Mom was crocheting on one of the two single beds they slept in, I was lying on the other. Sometimes those two single beds were pushed together, but they'd been moved apart that night. When we heard my dad's keys, I knew the drill and I shut my eyes, tight. I heard his footsteps down the wood hall. I heard him whisper greetings and she whispered back. I felt the movement of the bed when he sat at the foot of it and a little jiggle of the mattress before hearing one of his shoes hit the floor. Then I heard Gilda Radner on the TV. She was my favorite, with that big, goofy smile, crazy hair, and sparkling eyes. In her scratchy, nasally voice, she said something funny. And, as though we were workshopping in an improv group together, I thought of the perfect response. I mean side-splittingly funny. So smart I figured my parents *had* to hear this line. They would undoubtedly bond in their

delight over how clever a child I was and share dreams of a future for me on the stage.

So I said the line (with, I might add, impeccable comic timing), and I waited for the laugh to come. But it never came. And when I cautiously opened one eye, my father sat frozen, his other shoe in his hand, and my mother was still, a length of red yarn twisted around her pointer finger.

Before I understood what was happening, the lights were on in the room, and unlike the usual hushed, hissing tones or the sing-songy ones that confused me, my dad was yelling, which I'd never heard him do. He was standing very close to my mother's face. His arms were flailing. I can still see clearly in my mind, the two of them lit by the stark overhead light. I can feel the panic rising in me, even now. That night, it felt like I was watching a silent film, as the dad character picked up the TV—my beautiful little lifeline—and threw it to the floor, smashing his foot through the screen in one swift kick. I curled into a tight ball, pulling the comforter around me.

Roll up the baby burrito, I imagined my mom cooing, comfortingly.

Dad disappeared quickly down the hall, and with the slam of the front door, sound bloomed back into life and I heard my own sobbing. My mom slid into bed beside me, jittery, and I buried my head in the soft cradle between her armpit and breast and cried and shook, neither of us knowing what to do or say.

This was my fault. I had caused it. I had ruined everything.

Not long after that night, I stared up at a cityscape of boxes piled in the front hall by the door. The light on them was soft and yellowy through the living room windows, and dust motes lazily floated around my head like a filthy crown. If anybody explained to me what was happening, I didn't hear it. But a few days later, my little nuclear family of three had detonated, leaving a toxic, ruined landscape behind.

The good part was that now we could watch TV around the clock.

I joined the massive ranks of "latchkey kids"—mostly kids of divorced parents who let themselves into empty apartments after school, snacking and half-heartedly doing homework in front of the TV until their exhausted working moms dragged themselves home. Dinner for the two of us happened in front of *The Carol Burnett Show*. For dessert, it was *The Love Boat* and *Fantasy Island*. In the morning, before school, while sucking down the dregs of sugar-milk from the bottom of a cereal bowl, *The Flintstones* and *Bugs Bunny* sent me on my way. Then there were hours of school—boring, boring, boring—then after school, *The Wheel of Fortune* and *Family Feud*. During this time is when I learned life lessons like "If you're a female detective, you'll have to know how to shoot a gun while running in heels and also wearing a bikini." *One Day at a*

Time is the reason I still get crushes on building supers, and why a tool belt turns me on.

This wasn't just happening in my house. As best I could tell, this was how plenty of other children were raised—by a TV set and bowls of sugar-milk.

But TV with mom now—along with shared Pink Champale—was my favorite kind of TV. *Saturday Night Live, Second City*, and *Fridays* made us laugh till we cried. Hooting and wheezing—usually at the naughtiest bits—my mom made sure to squeeze out "Oh, that's terrible!" just in case God was listening and judging. These shows also had incredible musical guests like Elvis Costello, Devo, Chuck Berry, Patti Smith, Ray Charles, the Jim Carroll Band, Jimmy Cliff, David Bowie, Tom Waits, Gil Scott-Heron, the B-52's. And of course, the Plasmatics.

Which is how, at eleven years old, a little bit tipsy, I watched singer Wendy O. Williams fire a pump-action shotgun into a stage, destroying the lighting rig and two walls of amps in an explosive display of destruction.

When the funky, saxophone-heavy *Fridays* theme song kicked in at the end of the show, a panic alarm sounded in me. I hated bedtime. Not just like all kids hate it because it's a hard wrap on fun and reminder that parents control everything. But because bedtime was when the gray fog began to settle on my mom. When the warmth started to drain out of her. When she disappeared down the long hall to her bedroom after cutting off my lifeline with the vulgar

chunk of the television knob. In her room, I'd hear the TV go on again, but only for her, not me. The dark night felt like a punishment in my room.

So, I spun the big dial on my dad's silver stereo, down into the low numbers where all the good stuff happens. When 92.7, WLIR, tuned in, DJ Donna Donna introduced me to bands from England—the Cure, Depeche Mode, the Specials—and bands from New York—Blondie, the Talking Heads, the Ramones. Bands I could have seen just a subway ride downtown if I'd only been a little bit older or a *whole* lot cooler than I was.

There's no way I could know that it would be me on the radio someday as I lay on my back in the dark and Debbie Harry's North Jersey accent led me to my dreams.

Oh, you sit all alone in your rocking chair
Transistor pressed against an ear
Were you waiting at the bus stop all your life?
Or just to die by the hand of love?
Love for youth, love for youth
So live fast 'cause it won't last.

three

I turn, cringing, to face my fate. But instead of the barrel of a gun, I'm looking at Blue, lying flat on the floor of his apartment. It's his blood on my hands. Smeared off of Ron, onto me.

I grasp the wood banister. *Run or stay? Run or stay? Is he ok? No, but he's a demented asshole, so do I care? But do we leave someone unconscious, bleeding on the floor? Is that who we are? Run or stay? Is he moving? Is this okay?*

The staircase tilts. My armpits smell sour.

I'm running. Down the stairs. Out the door. Onto the deserted street in my bare feet.

"COME ON!" Matt yells and I leap toward the sliding door as the van starts to move. Ron can barely be contained in the back seat. He wants out. He is not finished yet. Not even close. Now we're driving. No other cars. Nowhere to go.

Heart is beating. Heart is beating. At least my heart is beating.

Are you glad you came now, Gigi?

We ride in silence. Ron is indignant, glowing, prideful. Matt is running his hand through his hair, considering the mess we're in, rehearsing his call with MCA Records.

We are on our way to your shining, glass offices in LA and we are going to be your next glorious success! Ignore the wreckage in our wake. Never mind the band of heavily armed skinheads nipping at our heels.

We drive for ages until we see *M-O-T-L 6* glowing ahead. The *E* is dead. We're not picky. Matt reluctantly hands over his personal credit card and we check in as a weary couple, then sneak the rest in, plus all the equipment, out of sight of the office. It's cheaper that way.

In the room, which is just steps off the parking lot, a highly flammable, floral bedspread has never looked so inviting. "FUCKYOUINEEDABATH," is what Ron says as he slams the bathroom door behind him.

Good. Go away.

Exhausted but wired, I collapse onto the bed and turn

on the TV to see a ridiculously buoyant man wearing a green sweater-vest and plaid bow tie. He's interviewing a small boy for a very early morning talk show. The boy's face is more freckle than not and he holds what looks like a fur handbag in his lap, but which eventually reveals itself to be a colossal hamster. He's being praised for raising the large thing, which heaves and bucks in his grasp. A close-up on the animal shows its tiny, pointed claws ripping at the boys small, freckled fingers which are striped with cuts from restraining it. I turn off the sound and stare blankly at the pantomime as the child wrestles with the animal and the host pretends to enjoy his job.

Martin is outside smoking. Gigi's gone to call a friend. *I won't blame her if she heads back to New York.* I push myself up and catch site of the reflection, in a dusty old dresser mirror, of a girl who looks bone-tired and fed up.

You're twenty-five years old. You should be smarter than this by now . . . shouldn't you?

I plop down on the curb outside next to Matt as dawn slowly filters through the darkness, officially ending a monumentally shitty night.

"Ron might be right, Matty. I mean, I wanted to punch Blue too," I look down at the brown, flaky blood on my fingers. "But Ron's an asshole."

"I know. Don't worry, Smitty." Matt puts his arm

around my shoulder. "It's all gonna be smooth sailing from here."

Back in the room, we hear the water still running in the bathtub. It's been ages since Ron went in there.

Matt knocks on the bathroom door. "Ronnie? . . . Ron? . . . Ron, I'm coming in."

He cracks the door a bit and whatever he sees makes him burst through it urgently. "SHIT!" his voice echoes off the tiles. "RONNIE!"

I stumble in the opposite direction. The skin of my palms snags, unpleasantly, on the rough, garish bedspread as I scramble over it, backward, out the door.

"What's happening?" I hear Gigi return, but she's far away and under water. I hear my voice say "No no no no no no no . . ."

I watch Gigi move into the room in slow motion. I see Martin light another cigarette, his eyes on the floor. Shadows dance jerkily on the walls just beyond the partly opened bathroom door. I can't feel my feet on the ground. I seem too tall. I must be floating. A dog barks; it's an angry, sharp sound. There's a low, tinny buzz coming from the neon sign above me; the sound of its death throes. There's nowhere to run. I just want to go home. I just want somebody to come and take me home.

Then Matt is rushing toward me and I shoot forward to him through a tunnel.

"He's alive," he says with mixed emotions, running his hand through his greasy hair. His voice pierces the bubble I'm in and the TV is loud. Gigi and Martin are talking. The bathroom door is closed again.

My suitcase—my grandma's little brown, vintage suitcase with the oversized orange flowers on it—is on the bed where I threw it, fed up, when we first came in. I leave Matt outside and rush to it, sliding open its rusty, brass zipper. Shoved inside, with my underwear and T-shirts, is my Pentax K100 camera. I check the film count. Thirty-six frames left. A full roll. I loaded it to shoot at the club that night—last night?—but things sucked so badly, I'd just stuffed the camera back into my bag.

I walk toward the bathroom door and knock timidly.

"Ronnie. Can I come in?"

The response comes in the form of a weak grunt, and I push the door open slowly, unsure of what I'll find or why I want to find it. Ron is lying in the bath, naked and submerged almost entirely except for the very front of his face, which is the color of the white walls. His black hair, stiff with wax, stays plastered to his skull, exaggerating my sense of him as a vampire of sorts, only instead of sucking others' blood to survive, he sucks poison into his own.

I sit cross-legged on the linoleum floor just next to the bath and peer over the lip of it, hesitant, like a child finding their parent drowned in the tub.

"Ronnie, can I take your picture?" I don't know why I ask it. I don't know what else to say. I feel like I'm watching him die and I don't know how else to witness that except through the lens. To try to make some sense of it. To frame it and control the lighting and ponder the shape and form of it and anything but to sit with the fear of it.

He grunts again and so I do. I raise the camera and I take three frames of him lying in the now-cold water. Through my lens, everything is just shapes and light and shadows contained inside a manageable rectangle. He slides himself to a seated position. I can see the effort of it in the slight tremble of his arms. He makes three attempts at reaching the towel on the floor and once I realize what he's doing, I hand it to him and wait as he painstakingly wraps it around his head, tucking the end in at the back before looking at me mournfully, with the soft, heavy-lidded eyes of a cow. With his little shower turban, he's a sad, depleted, pill-ravaged housewife deciding whether to come out of the bath and face it all again, or to just lie back down where nobody needs anything more from her and submerge fully. I take four pictures of him like that before I put my camera down.

He mumbles through dry lips. He tells me he's left his bag at Blue's house. But I saw him come in with his bag. Not that bag, he says. A different bag.

In an uncharacteristically-responsible-for-a-drug-addict way, Ron always cleans up before we go on the road.

Ali Smith

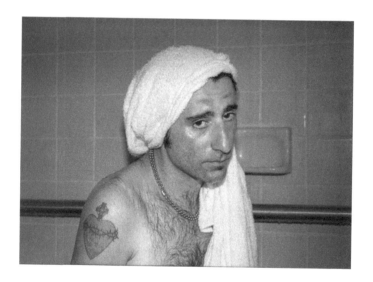

Checks into rehab. But he hasn't quite succeeded this time, so the clinic helping him quit heroin has given him exactly enough methadone to last the length of this month-long tour. He reverently dedicated a special bag to the medication. A small, black leather bag, well-oiled and stylish. His lifeline and our peace of mind. A small, black leather bag that has been left behind at Blue's house in the madness.

His jaw is tightly set now, grinding in tiny circles. He pushes himself to stand and holds onto the shower curtain rail unsteadily. It bows a bit under his weight. I feel myself recoil, and then I raise my camera to look up at him through the lens. It's just shapes. A black stubbly chin and hair sprouting from under his arms and coating his chest. It's thin legs bent slightly, his hip jutting to the side. His penis, just a shape, dangling.

I shoot three frames. He seems to be posing a little bit for me. *Ever the showman.*

"What is it like?" I ask, with a compassion I rarely show for him.

Through a stiff jaw, he slowly answers, "It feels like every cell in my body is on fire."

Ron stumbles into the van before dawn and drives the 8 hours back to New York City, shaky and aching, to find methadone on the streets around the clinics where people sell their own doses. He insists on going alone. Which is fine with me as I can't stand the whole ugly business of it, or the idea of being in a van with him driving in that

tattered state. The rest of us spend our time thrift shopping, eating chicken fried steak and biscuits at Bob's Big Boy, and burning through Matt's credit with the extra motel costs. It's almost dawn, the following morning, when Ron reappears, exhausted. Apparently, he couldn't get enough of what he needs to be ok, but it's enough to get by.

four

This rickety old van already hobbled like a broken-down nag when we bought it for three hundred dollars. It's so filthy and graffiti-covered on the outside that if we roll through a town too slowly, kids with thick Sharpie markers descend on it, adding their tags to its dented sides.

There are no seat belts and a constant jet of cold air streams in through the chasm-like seams at the edges of the doors in the winter.

Gigi's driving, chatting with Martin about her tattoos. "Sometimes I wake up and I just wanna scrape them all off." The thought of her taking a cheese grater to all fifty of them makes me sick.

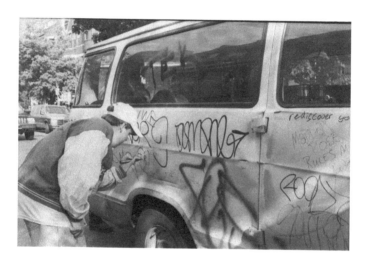

Matt and Ron are sleeping like the dead. Matt can sleep anywhere and is lying on his back on the floor, between my legs and the driver's seat, his head wedged tightly against the gear shift. Ron's head falls heavily, side-to-side, front-to-back, his eyelids fluttering as chaos explodes behind them.

Where is all that Kentucky bluegrass they talk about? I wrestle my journal out from between the seats where I've stuffed it. It's a beat up, artist's black sketch book smothered with stickers from places we've been. Martin cracks his window and lets smoke snake out from his mouth. Ron mumbles in his sleep. The image of his green-white body floating in the bathtub barges into my brain, uninvited, and I wince. I find a pen in a cupholder and write.

In the Before Time:
 It was easy when I was small, three of us rattling around in that big old apartment, looking out at the brown of New York City—brown buildings, brown corduroy pants, bushy brown mustaches, brown air. My family was already dead, but I was blissfully unaware. Just danced around in my Holly Hobbie bonnet, cuddling cats, making things out of clay, having birthday parties, carrying on as though I wasn't living with zombies. One dad. One mom. The poison had already seeped in, and they hated each other.
 Dad was full of fairy-magic but, emotionally, as solid and reliable as winning the lottery.
 When I was eleven, he jumped into the New York City

subway tracks. He danced as lightly as Fred Astaire over the third rail to rescue a stroller that had rolled in on the other side. My screams were so all consuming I thought my skin might shred. Train after train whipped by with me, wailing like a siren on high, desperately leaning toward the tracks, trying to jump in after him but stuck in the grip of a stranger he'd handed me to, instead. He was my world, my hero.

I catch a glimpse of a billboard as we rattle past: *Get high . . . Get stupid . . . GET AIDS!* Paid for by the church of so-and-so.

I wonder how much trouble my dad got in for sneaking me onto the stage at the Metropolitan Opera House at Lincoln Center so I could "feel what it feels like to be inside the music." He didn't ask anyone. Just opened a tiny, me-sized door at the side of the stage when the conductor tapped his baton and I scrambled through and sat on a folding chair between him and the timpani drum, heart fluttering wildly, dazed by the bright lights. I marveled as he pressed his trombone to his lips and the sound of the orchestra began to swallow me whole, vibrating the wood boards under our feet. I got what he meant. I really did. Every time I play now, I try to climb inside that cocoon.

Tell a magical unicorn-dad you want a soft-serve ice cream in a cone, and he'll fart sprinkles onto it for you and you'll think "GODDAMMIT I love unicorns!"

But come to a unicorn with a problem. Say to him "I feel so sad since my parents divorced and my mom hides in her room and cries." Or "I don't have enough money for rent." Tell a unicorn "I'm lonely and scared," and it will leap away, calling behind, "RAINBOWS ARE HIGHWAYS TO YOUR DREEEEAAAAMMMS!" before leaving you covered in a fart-trail of sprinkles.

And you know—you just know—unicorns meet up in dark basements where they swap stories of misery. And the male unicorns leer at the mares and they slobber "Will you look at that. It's enough to make you weep!" And they conspire in a way that would make a long-legged, young colt hurry past. And that in the hot center of a dark night, a unicorn is prone to filing his own horn down to the nub with an industrial file because he doesn't believe in his own magic anymore and he longs to be a stallion, bucking and wild and free. That he will writhe on wet sheets until dawn, angry and vengeful and deeply, deeply disappointed. Massively disappointed. They've made him fart sprinkles. He was meant for more than this.

When he shows up next, you might cock your head and say "Daddy, your horn looks crooked. In fact, it looks like a strap-on horn." And he'll smile and bounce you on his knee and say "Don't be silly. Let's build a castle!"

We hit a bump and Matt's head bashes violently against the floor.

The world inside my brain—after the nuclear-family explosion—was filled with a dull, oppressive, lonely flatness. I became convinced there was only one person that had come into this world broken, unfixable, unredeemable. One person who had won the lottery of shit, and that person was me. Perhaps the only person more unlucky was my mom.

Oh Momma, with your beautiful, white, Chiclet teeth, your glowing olive skin, thick, black hair, and that dark cloud you wear like a halo. I could not—I still can't—fix that for you. But Lord knows a child will try.

I know you felt lonely and flat too. I'm sorry I resented you so much for it. But I didn't want to drown with you. I needed to live. And that, my sweet, lovely momma, is why I divorced the both of you. I was done with your sadness and done with dad's high-flying unicorn act. Done trying to make anybody happy when nobody was happy.

So when punk and new wave music rode the radio waves into my bedroom at night—and I shaved my head and eyebrows, and painted on heavier, meaner eyebrows, and threw my ballet flats down the garbage chute and replaced them with army boots, and wore black clothes and lipstick, and embarrassed you with my presence and made you wonder why I'd killed off your little baby girl—what I was doing was saving my own life, momma. It was this music— made by other misfits and messy girls—that showed me the

beauty in my darkness. Suddenly there was a soundtrack
of angry guitars and longing, melancholic voices adding
meaning to the movie of my life.

My first savior was Debbie Harry. Emulating her,
I stood—back to the mirror, hands on hips, legs spread
apart—and spun my messy, crimped head around, ballpoint
pen dangling from my lip like a cigarette. And while I looked
more like a girl in anaphylactic shock trying desperately to
remove the cap from her EpiPen with her mouth, I did feel
like someone who was, if not "divine," then a little bit less
insecure and dull than she'd been before she started.

But Debbie was a gateway drug that led straight to
the dark queen herself—Nina Hagen. With a voice like an
opera singer stuck in a paper shredder, Nina showed me
that real beauty is confrontational, unsettling, dramatic and
it starts inside and throws up all over the place.

Debbie and Nina were the first of many to take me
by the hand and lead me toward a life I couldn't fuck
up because the whole point was to fuck things up. I see
now that all the biggest, boldest, bravest, dumbest, most
dangerous things I've ever done—like being in this van
with these beautiful jerks thinking, "Ron, PLEASE don't
turn blue tonight!"—I've done in the hopes of finding a new
family. Of finding love.

"Whoever's in charge," Ron slurs out of his slumber,
"has got to shut this God-awful shit off!" Martin ejects the

tape of Fart Stomper, a band that slipped him their demo after a show.

Ron crosses his arms and lets his chin fall on his chest. "No Fart Stomper on my watch," he mutters before he's snoring again.

Love means all sorts of things. It means escaping your shitty, abusive family or corrosive small town where they hunt you for being different. It means finding your tribe so you can beat femur bones together and dance around the fire instead dying alone on the vast, cold plains. It means laying claim to one cubic inch of this stinking universe that doesn't feel cold, hypocritical, disappointing. Slamming together, sweaty chests colliding in the pit at shows, through the chaos and the roaring. If you listen for it, it's there. I LOVE YOU!! *Slam!* I LOVE YOU! *Crack!*

The need to find "our people" is why some of us join the church. Others join prison gangs. I joined a band. Matt, Ron, Martin, and I invade seedy clubs together in black leather, bringing something like love to outcasts in small towns everywhere who suspect what the radio taught me years ago; that it's a big old world out there and it's worth every danger you'll ever face to grab it by the labia.

The van swerves and Matt rolls into my legs, then sloppily pulls himself upright.

"I think I fell asleep."

"Ya think, Matty?"

I offer a hand and pull him up next to me. Of all the family I've ever made for myself, Matt is my #1. This little flesh-bag of blood and bones, with thick, square Italian hands and honey-brown eyes he can wrinkle up to imitate a Shar Pei dog to make me laugh. Good old Matty—my brother, my champion, my soul.

In the dirt and ugliness of the Lower East Side, we record day and night, in the timeless vacuum of Matt's apartment with the sound room he built in it. We laugh till we cry and we paw at Matt's instruments—bass, guitar, drums, organ, theremin, Echoplex, violin, vibraphone— like animals until we sort of know how to play all of them.

When we get hungry, we crawl outside, past the drug dealers and the addicts and the families bar-b-queuing on their tenement stoops. Past "The Colonel," a slight, Hispanic, self-appointed traffic agent, drunkenly directing traffic at the base of the bridge on Clinton and Delancey. If cars follow his orders, they'll careen into lampposts and store fronts. Past Floyd, a kind, funny war veteran who wears all manner of foliage tied to his head, including—on December 25th— an entire, small-scale Christmas tree covered in tinsel. Past "Hot Dog," a tiny, stout woman with a shaved head who is as likely to be wearing only men's underpants and a hospital bracelet from a recent stay in the mental ward as she is a sky-blue, taffeta prom dress with the ass burned

off it from a fire she sat in by accident the night before. Hot Dog marches forward with the urgency of a medic running to the scene of an accident. And no matter what you say to her—"Hi, Hot Dog," or "Look out for that car, Hot Dog," or "YOUR PROM DRESS IS ON FIRE, HOT DOG!" she only ever says one thing back—"HOT DOG!!"

New York City will stretch and bend you in its never-ceasing, bubbling cauldron of diversity, trauma, drama, thrills, and desires, both crushed and fulfilled. You definitely can't come to a place like the Lower East Side demanding that it bend to suit you, especially as a white girl from uptown. It will run you through on a spike, as it should. You owe it something—art, revolution, even sincerity and a lack of arrogance will do.

When it's not busy gutting you or squashing your will to live because it's so damn dangerous and hard to survive in, New York fills you up with truth. That said, sometimes I can't wait to get the fuck out.

Seeing as I have no money, no degree in finance, I lack my father's unicorn-magic skills, and I can't *tolerate* the idea of marrying rich, playing music is my ticket to . . . well, everything.

five

"HELLO, YOU BASTARDS!" Ron commands attention like a carnival barker. "YOU BEAUTIFUL SONS OF BITCHES! WE'RE *speedball baby* AND WE'RE HERE TO MAKE SWEET, SWEET LOVE TO YOU!!"

The crowd is full of baseball caps and cowboy hats, the room is far too brightly lit for a show, and everyone is sitting at tables, which is the absolute worst unless you're playing a very quiet jazz show. Which we definitely are not.

We've been on tour for two weeks, playing a series of under-attended, poorly-booked shows. We've been listed in the paper as Speed Baby, Sideball Baby, or sometimes just Baby. Does our record label even know our band's name?

Smelling indifference on the crowd—the thing he tolerates the least—Ron starts the first song by leaping up and grabbing hold of a pipe the club foolishly mounted over the stage. It mercifully doesn't break as he swings by one arm, like an orangutang.

I plow through the set, my instrument slung low, like every self-respecting bass player before me. Matt has assumed his signature shape—that of a question mark, curled over his orange Gretsch 6119, perfecting a sound like a chainsaw caressing a baby lamb; everything wrong and everything right. I look back to Martin and he hits a change with me on the crash. Generally, we follow Matt for changes and Matt follows Ron and Ron does whatever the voices in his head tell him to do. The seated crowd looks particularly small and menaced under him as he leans over it now, finger wagging above his head.

"Rubber Connection" ends and instead of applause, a sports commentator shouts, "THAT'S GOTTA BE A FOUL!" from a TV mounted over the bar before a pile of plates crashes to the ground, followed by an exhausted "SHIT!" Then the murmuring of conversation takes over.

In New York and Boston, we sell out clubs. We play rooms so packed with bodies it's a fire marshal kind of situation. So it's humbling to drive out into the rest of the country— black jeans, Converse sneakers, kid's Pee-Wee baseball League T-shirt, bright orange hair, heavy makeup, nose ring, and, most of all, swagger—and be met with

baseball caps, band name misspellings, massively undersold rooms, and annoyed people who prattle on while we're sweating and heaving and trying to, oh, I don't know, *transform this evening into something amazing!!??* It's not just boring to play for a crowd like this. It's deeply humbling. And in my midtwenties, *humble* is not how I want to feel. I want to feel like I'm headed somewhere, and that "somewhere" is eagerly anticipating my arrival.

Still, standing behind big crazy daddy Ron, I'm more amused than upset. Ron is like one of those sea cucumbers that spits its guts out of its body—literally turns itself inside out—to scare away predators. Or Daffy Duck, so frustrated nobody likes his magic act he ends it by blowing himself up for the applause. You can only do it once, *but what an ending!*

With Ron vomiting his insides onto the crowd, I don't really mind so much that they're clearly disappointed to discover what the band "Ball Baby" sounds like.

"Everybody knows it's a fucked-up town!"

Ron wails from inside of his threadbare men's suit with the worn elbows and the too short hems.

"Everybody knows it's bringing you down!"

There couldn't be a more fucked-up, boring town than this one in . . . Kansas? I really have no idea where we are. I get in the van. I eat in the van. I sleep in the van. I beg for bathroom breaks. I get out of the van someplace, we set up, and we play. Sometimes Matt and I explore a town, but I don't always remember where I am at the time. I just know

that that's the place where they have the world's biggest
ball of twine, or the restaurant where Johnny Cash threw
up in the buffet, or where Patsy Cline's plane crashed, or
the best place to buy a taxidermy jackalope (it's Douglas,
Wyoming). I don't usually know where we've been until I
read about it later in my journal.

This is a fucked-up town. Testify, poppa Ron.

We never run away, not even when the crowd hates us.
Except for that one time. (Okay, two times we ran away, but
that was because they were *literally* chasing us.) What's
going to happen in this very moment? It may be good, or
bad. Just don't let it be boring-vanilla-porridge-bland.

Let this moment matter. Let it be *something.* Some-
thing that leaves us all a little bit shaken up. When I step
on stage, I do it to feel bigger than the smallness of me
in the world. For those forty-five minutes, I'm trying to
puncture through the milky, dull membrane of reality that
covers all of our lives to the point of suffocation.

The chorus hits and our sea cucumber leaps onto the
end of the bar.

"Here comes the man, he's bringing you down!"

He sweats and chants and saunters his way along,
kicking people's drinks to the floor with complete, per-
fect confidence as he goes.

I climb up to play from on top of my amp and survey
the scene. *Will it be fight or flight tonight?*

All is silent in the room now except for the racket we're

making that drowns out even the TV. I watch the mic cord drag over people's heads and tangle around their necks behind Ron.

Everything is frozen until, suddenly, the room explodes.

Baseball caps and cowboy hats jump up from their barstools, fear, anger, and recognition on their faces, and they start to stomp and clap and pound the bar and they love it. All but the bartender, who does not love it as they follow Ron's feet, wiping with a dirty rag.

Suddenly, it's a perfect night.

It is a fucked-up town because they're *all* fucked-up towns and "the man" is always bringing you down, so let's burn it all down to the ground.

We finish the song and the show with one ear ripping crash and I bound off stage. A music orgasm. Finally.

Backstage, Ron is quietly mopping his head with a towel. His suit is soaked through. He looks at me and laughs, "Well, we got there, honey."

Our dressing room is clearly usually the janitor's closet. There are buckets and mops pushed into its corners.

Hot and buzzing, I pluck a warm can of Budweiser from a bowl of melted ice and it sprays all over me when I pop the tab. Not in a "Super Bowl championship champagne" sort of way, but in a "let's just add that sticky mess to the pile, shall we?" sort of way.

I need to pee.

The bathroom is next to the janitor's closet / dressing

room, and it's gross and in it is another bucket and mop. Which begs the question, *What do they spill so often and so much of on these floors?*

The water in the sink won't turn off. The sole of my sneaker is stuck to the floor and when I wrench it free, it makes a loud sucking sound. I "lady hover" over the toilet which has no seat, an elbow braced against one wall while the other hand searches for toilet paper it will never find. I jiggle a few times to drip dry.

I ease my way back out—trying not to touch too many surfaces—close the door behind, and a girl leaps at me, pinning me with a hand on each shoulder. Her white T-shirt is tucked into blue jeans, but instead of a baseball cap or cowboy hat, she's got one little girl's brightly colored barrette clamped on either side of black, blunt-cut bangs and the world's tiniest little speck of a stud in her nostril. Her face is shiny and she looks slightly crazed as she leans in close.

"You know," she smiles conspiratorially, breathing sour breath on me. "There aren't *any* girls in bands in this fucked-up town. I'm *really* glad you're here!"

I've been pinned up against the wall, pulled into a bathroom stall, dragged to the ground into a pile of bodies, and literally swept off my feet several times on this tour, and all by other girls who want to tell me they're happy I'm here. And while I really appreciate that, I have to admit, it makes me equally sad to be reminded of what an event it seems to be to see a woman on stage.

six

Take one van. Fill it with five road-weary people plus their boots and sneakers, leather jackets that have been held over heads in sudden downpours, remnants of food bought at gas stations, and cups of forgotten, milky coffee stuffed into the sides of doors. Let these things fester in that closed van. Now step into that van and drive for three, for seven, for maybe ten hours at a clip, trying not to breathe too deeply for the duration.

If we tour with another band, add four more guys— they're always guys—to the mix, plus *their* shoes and rotting food.

Even Ron, whose alternating heroin and methadone

habits haunt us all, keeps himself clean and well groomed.

"Honey," he tells me often. "I don't know how you put up with all these men. They are disgusting!"

I crack the window, find my journal and, after a minute of letting the pen hover over the empty page, I write.

The List:

I leave out the word "SEX" in case anyone ever finds this and thinks I'm pathetic or perverted or a pathetic pervert for writing down a list of all the men I've had sex with. Just in case, I decide, no names.

First, the criteria. What makes the cut? Tongue-on-tongue action? Jeans-against-jeans? I decide to throw it all in the mix, using code names only I'll understand:

Gum-Snapping Psychopath
Chilean Sea Bass
Hot-Pants, Piano Legs
Banana curl clown head

Dating in New York City is like doing penance. There's always someone prettier, more famous, cooler, sexier than you. Sometimes you can practically feel the heel print of the motorcycle boot of the person you're dating stamped on your forehead as they clamber over you toward a better offer.

Mop-Headed Bag o' Denim
Curtain Bangs
Pompadoured Dull-billy

Gorgeous, with a skull as empty as a five-gallon jug. Sex with him was like a military drill, only less fun: "Drop and give me twenty good strokes, soldier!"

Closet Nazi (?)
Pizza Flipper
Secret Junkie

That one took me for a lovely bike ride on a warm, summer day. And just as I was thinking, *I could really see this working out,* he handed me a box of shit wrapped in a bow. "I've been shooting up for three weeks now," he beamed proudly. My right pedal snapped off under the weight of a sudden burst of pressure, and I pushed my bike the mile home, both me and it wobbling, broken.

And so on and so on until . . . sixteen. I stare at that number. Is that it? That's not enough. OH!

Another one pops to mind and I add, simply,

Hairless!

If anyone ever does find this list, I can say I've been thinking up band names.

I rack my brain and slog away as the road whips by. Once you're on a US highway, unless the sun is bouncing off the gold-green of cornfields, or mountains pierce the cloud cover on the horizon, most roadside views look like a puppet show's scrolling background, endlessly repeating. It's a gray day.

Chip, chip, chip away.

Gay Sweater Vest

The fact he turned out to be gay is definitely the thing I liked most about him. The thing I liked least (besides the sweater-vest) was that halfway through our date, when a fight broke out at the awful party he'd dragged me to, he showed me a loaded gun shoved into the bottom of his messenger bag and boasted "Don't worry. I'll take care of you!" I never called him back, and a week later, the phone rang at 4 a.m. It was Ike, the friend who'd introduced us. Ike has a flair for drama, and his greatest wish is that at his funeral, his pallbearers will be mimes who silently pretend to sob while struggling under the weight of an invisible coffin. "He just beat the SHIT out of me," Ike slurred from a hotel room where they'd been partying, "and I think he might be coming for you next!" It was an ill-conceived plan that found me peering over my windowsill into the milky dawn, a kitchen knife shaking in my clumsy hands.

Oh yeah. Hands!

Mechanic Hands
Brass Knuckles
Entitled ass-hat
The Lovely Tra-La-La

I smile. He was a welcome break.

Arrogant Actor

The shit luck of it is that all the stupid, broken skeleton keys in that one's personality fit perfectly into my heart's misshapen tumbler-locks. The longing to tame someone I don't even really want to be with played me like a familiar, janky old fiddle.

Gentle But Dull 1. (Curly hair)
Gentle But Dull 2. (Mohawk)

Surely that's enough. Why doesn't it feel like enough?

What I want to know is whether this is what the boys do. Is this a "normal" amount for the boys? Because I don't want to be doing less, living less, experiencing less than the boys in my band. I'm as entitled to sex and life and adventure as they are and, somehow, this list is meant to help me prove to myself that I'm living the dream.

But wait. Does bad sex count? I don't mean clumsy, disappointing, "Oops! Finger-in-the-wrong-hole" sex. I mean bad, sad, mean-spirited sex. Does that count?

A splatter of wet mud, kicked up by the front wheel, slashes across my window like a Jackson Pollack painting. Jackson Pollack was a bastard to women. Poor Lee Krasner. I get lost in the shit-colored streak being elongated, in a jittering line, by the wind.

I think back again, like I have one million times, to that sloppy, drunk night with my high school crush at his father's apartment. To that first time I was hunted by a predator. I had no guile to resist it or experience to understand what was happening. After that high school crush, cartoon wolf lured me in, knocked me out, and took me, I figure I had the stink of the kill on me. Other bastards came sniffing around and too often, I let them in. And here's maybe the worst part. The ultimate betrayal, because it was me who betrayed myself. I went back to that first jerk. A second time. And a third. I think that I felt if I could somehow turn that ship around—prove to myself that what had happened wasn't cold, cruel, unkind, and selfish, but just the rocky start to what would become a romance for the ages, something inevitable—then it wouldn't destroy me. I was only fifteen. Everything I'd learned about romance was from movies like *Meatballs* and *Revenge of the Nerds*. Movies that, if I'm honest, now seem awfully "rapey" in nature, full of panty raids, peeping Toms, and unwanted

couch wrestling. Movies in which a woman's "No!" meant "Probably yes, once you've worn me down or if you trick me into it."

I can see myself there now, naked, lying in his empty bathtub—face down, ashamed, wings clipped, flattened, and muddy at my sides. My young, unmarked legs are crumpled under the weight of me, like a baby in a crib. The world tells me I'm grown because my breasts have come out and I'm hairy and I can have sex. But I still feel like the same child I was one year ago, two years ago, ten years: small, wide-eyed, eager, scared. I lie there, a sad, sorry, lonely pile of bones. To the predator, I look like nothing much, but, actually, I'm a queen. The me now longs to cover that girl with her regal robe and lift her onto my shoulder and adjust her crown and carry her to the apartment door and torch the place behind us on the way out. But I'm powerless. And the fact that that boy laughed and mocked and marveled at me—the poor idiot who had the audacity to like him—will always sit like bitter poison on my tongue and make me want to vomit and rage.

It sucks that my life as a sexual being began without love, without care, without autonomy, joy, satisfaction, or hope. I'm old enough now to know that that was completely fucked and that I want those things back.

Does terrible, demeaning sex belong on my list? I decide that it does. I didn't want it, but it's mine now and it goes on my list.

(Saving the first, and worst, for last) Subatomic particle (evolutionarily speaking). Lesser than all women. Malevolent. Malignant. Destined for small things. It's clear you thought I was an expendable extra in the movie of your life, but actually, I'm the star of this film. Wear the burden of your embarrassing cruelty like a necklace of boulders. Let the awareness shake you awake from your nightmares. Let it sprinkle dread throughout your happiest moments, as your acts have done to me. If an unwitting fool loves you in the future, let there be a voice—a low-grade irritant, consistent and true—that will haunt you as a hiss close to your ear ("You don't deserve this love.") or a whisper floating by on the breeze ("You're not worthy.") And because you've never done a thing to atone for your destructive acts, you'll know, deep inside of your thin skin, that that voice is right. That you are "that guy." That terrible guy. The one the audience is rooting against.

The rapist.

I stare at that last word and a trembling starts rolling through my shoulders, my hands. I skew my head to one side and squint at the word from an angle. The shaking makes it hard to replace the pen in my journal, but once I do, I slam the book shut and stuff it into the crease between the seats.

I close my eyes and lean my head against the streaked window, waiting for the uncontrollable jittering to subside.

I glare at the backs and sides of the heads of the boys in my band. *What have any of them ever done to a girl that she didn't like? Would any of them have protected me on that cold, lonely, unbelievably unkind night in that tiny apartment when a mean, selfish boy tried to teach me that "nothing" was my worth and had largely succeeded? Will they protect me now, on tour?*

Only once I fuzzily conclude the answer is "probably yes" do my shoulders drop.

seven

We signed our major label deal with MCA just months before this tour, but after three years of living as a tight, co-dependent, somewhat demented little unit: playing CBGBs, Coney Island High, Maxwell's, the Middle East, T.T. the Bear's, the 9:30 Club; recording at Matt's around the clock; constructing sets on Matt's tenement roof which was painted entirely silver, the perfect backdrop for shooting experimental art films with my Super 8 camera. There wasn't one gig that changed everything. It just seemed like we'd reached a sort of critical mass where we'd either explode like a glitter bomb or something bigger would happen.

Ever since, Matt has been acting like we've pulled off a bank heist. He's been down the major label road before, playing bass with a band called Madder Rose. Where Speedball Baby is coarse, Madder Rose was like a morphine drip—oozing with calm. Hypnotic melodies wrapped themselves around Mary Lorson's voice—gorgeous, both the sickness and the cure. Matt was dubbed "the cheekbones of the band" by music press at a time when success centered around music videos and MTV. But he quit them at the height of their success, realizing his heart belonged elsewhere: with us. So he'd been courted and flattered and had smoke blown up his ass already, and what he felt in the end—strongly—was that if you're not making the art that moves you, you may as well be working as a fry cook. (And if working as a fry cook is the art that moves you, you should definitely be doing that.) The label is there, exclusively, to facilitate good art. Anything else they tell you about the arrangement is garbage.

In response to the deal, Ron dips and wobbles between self-aggrandizing mania, and wanting to blow it all up, while Martin has welcomed each congratulatory free pint with a smile. And I . . . I *think* I think it's cool. I've wanted to be Debbie Harry since I was twelve, shimmying my shoulders to "One Way or Another" in my bedroom mirror. Maybe this will get me closer to my Debbie Harry goals. I just wanna be somebody who matters. It's a small ask, really. I just want to be a legend.

Of course, there have been sideways compliments and snide remarks about the deal from some other bands who've been slogging away just as hard on the scene. But I've been dragging gear in and out of seedy clubs for years. I've sat through shit bands for hours to get paid very little—if any—money at the end of the night. Our hazardous vehicles have barreled precariously through countless nights to hit-or-miss out-of-town gigs. I've recorded and practiced midnight to 4 a.m. in the tiny sound room Matt built in his apartment on Ridge Street, returning, bleary-eyed, day after day, to jobs I can't wait to quit all in service of the muse. I chose this life because I can't stand the idea of living a lukewarm one. But maybe, just *maybe*, if this life can get a little bit easier—if a few more people can give a shit about what we're working so hard to create—maybe that's . . . I was going to say okay, but that's a lie. That would be much, *much* better.

On the other hand, what the hell is MCA—the LA-based home of Olivia Newton-John and New Edition—going to do with us? There's LA and there's New York and it's not just 3,000 miles that divides them. It's a whole belief system and a mindset. And I know they've only signed us because it's the order of the day for major labels to gobble up small, strange bands with underground success in a desperate bid to end up with the next Nirvana. All any major label wants right now is to sign another underground sensation no corporate head could have seen coming.

Matt keeps saying, "Let's just take them for every cent they've got before they realize what they've done." Instead of splurging on an expensive studio, we just do things the way we always have—small, contained, beating on empty paint cans, a colander full of coins, recording the sound of slamming doors and power drills, taking inspiration from the scratchy popping sounds of a needle touching vinyl in the empty space before the first song. Not because it's cheaper that way, but because it's better. Ron's ramblings—scrawled in journals, scribbled on the edges of worn dollar bills, on fragmented scraps of paper he pulls from his out-turned pockets—are deposited at Matt's feet to cull from.

MCA is actually more like an absentee birthfather in this arrangement; they're paying for shit, but they're not there for the ass-wiping or cooking the meals. That makes Paul Kolderie and Sean Slade, of Fort Apache Studios in Boston, our responsible and nurturing stepfathers.

Paul and Sean have been turning out seminal tracks for the Pixies, Hole, Radiohead, Dinosaur Jr., the Lemonheads, Blake Babies for years. I think it's Paul, with his ultra-chill personality and matching, smoky voice, that likes us more. When Ron breaks a mic stand at a show or falls backward off Matt's amp, it's Paul laughing the hardest. Paul likes strange, Paul likes Ron, Paul likes us.

Evan Dando of the Lemonheads is a darling of the Boston scene, and he *seems to love* Ron. They're a

mismatched pair to be sure, but maybe it gets a bit tire-
some being anybody's darling. Maybe Evan wants to fuck
all that up. I can't really say.

I can, however, say that the tour we did of Midwest
colleges with the Lemonheads was a pretty shit idea. They
had a string of catchy hits to their name—"Mrs. Robin-
son," "Into Your Arms," "It's a Shame about Ray"—all
delivered in Evan's rich, honey-dripping voice. Their
videos featured his surfer hair, dreamy eyes, and cheek-
bones so sharp you could slice paper with them. All of
which made the Lemonheads the ideal fit for angsty,
hormone-ravaged college crowds. When you've got a
thousand kids salivating over the prospect of swooning
over Evan, they have no time for Ron's disjointed poetry
about the remorseful dance of the addict, or the attack
of Matt's stabbing guitar on their nerves, which are al-
ready jangled by the prospect of life after college. They
just want you to Get. Out. Of. The. Way. Which made us
feel sadistic and vengeful, and we played longer sets out
of spite. Which Evan seemed to love, despite all his blue-
blooded good looks.

However, there was always a small cluster of kids
at these shows who'd been waiting for something like
Speedball Baby to come into their lives. Kids who were
hating most everything about their college experience.
Who took solace in their painting and philosophy classes.
Kids who may not really know why they'd gone to see the

Lemonheads, but who were excited they'd stumbled into seeing us. Those kids were easy to spot with their pale makeup, black lipstick, shredded T-shirts, thrift-store clothing, and forlorn expressions on which hung the weight of the world. A spark of recognition flared in their eyes when we played. Those small clusters made the shows worthwhile.

Watching how some girls responded to Evan on tour was a lesson in close-up magic about which side of the equation I want to be on: the one with the power, or the one grasping for it. I stood firmly on the side of wanting the power. That's not a dig at the grasping girls. But it's like they didn't know who they were once they orbited him. We drove him back to the hotel after one gig with a very googly-eyed girl practically stuffed under his shirt.

When she ultimately tumbled out of the van in front of her dorm but didn't invite him up, no one was more surprised than Evan, who turned to me, shrugging, and said, "I guess you have to respect her for not wanting to sleep with me right away."

I could think of many reasons to respect her, but I got what he meant. I didn't like it, but I got it. Those were the rules of this game. I just thought it was a fool's errand to think you could absorb power, attention, and admiration for yourself by latching onto someone else's neck like a well-intentioned barnacle. I don't want to be an appendage. I want the whole *corpus vitalis* for myself.

So, for better or worse, between Paul, and, maybe, Evan's influence, we're signed to Fort Apache Records. And MCA uses Fort Apache to lead them through the warrens of an underground scene they have no connection to.

The result of this major label grift is *Cinema!*, an album the most hardcore among our crowd may, possibly—behind our backs—tell you is proof that we've lost our edge. But we know it's a strong blend of spoken word, jarring emotional explosions, gentle cooing, and the perilous satisfaction of petting a porcupine in the wrong direction. It's also about as close to "commercially viable" as we're ever gonna get.

And guess what? There is more money now. And even

though they're doing a shit job of remembering what our band's name is, it's fantastic to have somebody pay to send me across the country to do what I love most: To feel life blow through my hair at a hundred and fifty miles an hour.

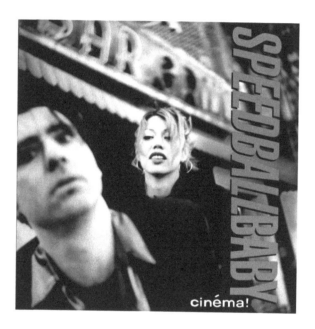

eight

When the album was done, Paul took us to the Odeon to celebrate. He brought a friend I'll call Dollar Sign (because I don't want to be sued). Dollar Sign is a hugely successful Geffen Records A&R guy, as famous for the bands he signs as for how liberally he spends on the company card. With its neon sign like a beacon in the abandoned Tribeca nights, the Odeon was a big deal for a fancier crowd than us. In its heyday in the '70s and '80s, Warhol, Basquiat, and Belushi all hung out at there in a flashy, cocaine-fueled scene. But by the time we got there, they were all long dead, leaving a night-life crowd of mostly the anonymous rich, those hoping to run into

a cultural icon, and those working hard to be mistaken for one.

Our band plays in dark, dank clubs and drinks in bars where the sour/sweet smell of years' worth of spilled beer

lives inside the wood. Newly minted Irish bartenders lord over us with iron (but fair) fists, and the scene is defined by an inverted snobbery; if anyone is discovered to be secretly rich, it knocks them down a couple of very serious pegs in everyone's eyes and makes them a target for ridicule and scams. So, we all ratchet up our street cred with tales of abuse, addiction, violence, and—surprisingly common— knowing somebody who's in jail for murder.

"I used to work with that guy."

"Oh yeah? Well, I used to DATE him!"

In fact, I've experienced five murders up close in my life. The first was a mafia dismemberment, which is a *hell* of an introduction to the world of murder for a child. The disembodied was the father of a boy I babysat. I can still muster a visceral, claustrophobic sense of the tension that surrounded the "mail watch" imposed by the FBI afterward, as it was a signature move, in such cases, for the killer to mail the victim's head to the widow. The three murders that followed in my immediate circles in my 20s can be summed up as "bludgeoning," "knifing," and "crack-induced-patricide." And while it is somewhat character defining to experience these things, it's not "cool." In fact, I'll go as far as to say it sucks. It turns out murder's a big, sad, animalistic business that makes a person feel less safe in this world. But as for street cred, it does buy you some.

No one is dining out on those kinds of stories at the Odeon though. This crowd pays an unthinkable twelve

dollars a drink compared to our usual four dollars, and the floors are disturbingly clean. In other words, we showed up to our celebratory dinner with an attitude.

But Dollar Sign had his wallet open, and free steak is good steak.

Paul and Dollar Sign met us at the door, each dressed in the A&R man's regulation uniform—open flannel shirt over a large tee, loose jeans, and a baseball cap covering thinning hair. This outfit is worn, without apology, by almost every A&R man (and they're always men) I've ever met. After all, they're the ones making and breaking careers. The last thing they have to prove to us is that they can slide into a pair of skinny black jeans.

"Speedball Baby!" Paul threw out his arms to pull me in for a warm hug. The hostess greeted us much more enthusiastically than she would have had we not been "friends of Dollar Sign," who's a high-spending regular. Her heavily made up, young face must have been the pride and joy of which ever small, Midwestern town she was now trying to hide the accent of. She wore a tight, black minidress like the girls from that nauseating Robert Palmer video, and the high heels she teetered on looked better suited to committing a quick, clean kill by way of impalement than anything a human should try to work her way across a slippery floor wearing.

I'd recently made a major investment of *twenty-five dollars* in a pair of gold leather, pointy-toed, Cuban-heeled boots. They made quite an entrance now, with the solid, crisp way

each footfall echoed on the tile, and they positively glowed set against the rest of the clothes we all wore which came in various shades of black. I wore an A-line, suede mini skirt topped with a vintage T-shirt with the words "Girl's Club" in flocked iron-on letters, and a small, shruggy leather jacket. The boys wore T-shirts, tight black jeans, and leather jackets.

As we followed in the hostess's wake, the promise of success began tugging me by the sternum and I swaggered with pride, as though the whole room might want to sit up and take this opportunity to have a look. *Any day now, people . . .* I thought. *Any day.*

Our hostess stopped at a large table and spread a handful of menus over the white tablecloth, like a Vegas dealer at a blackjack table. She offered a wine list and a wink to Dollar Sign before returning to her station where she would, with great gusto and vindictive delight, continue to tell people without reservations that there were no available tables.

Paul has lots of experience dining out on the company card. "Order whatever you want." An endless supply of wine arrived effortlessly, and, despite myself, I started to warm to the scene.

As the wine went down, the stories came up. Absurd, entertaining stories, usually about Ron, who finds trouble with the natural ease of smoke finding fire. I watched as though from behind a one-way mirror; Paul and Dollar Sign laughing at Ron's stories, Ron laughing at himself, the waiter moving in and out of our world silently, clearing

plates, setting down other plates, holding wine bottles in front of Dollar Sign for his inspection, constantly refilling the three water pitchers on the table.

The MCA deal came with the potential of a payoff, and I sat quietly with the buzzing anticipation of something great about to happen.

"The tours will get bigger," Paul leaned toward me to whisper. "I hope you're ready for that." The thought shot through me like a fork of lightning.

And then, as if far away in a dream, I heard Ron's nasally voice. "Let's give these people something to remember us by!"

Yeah! I thought. *Let's do that. Wait, what?*

And with that, he clambered up onto the dining table, all bent and angular limbs, like a spider. He wobbled there drunkenly until his pointy boots found their footing. Once stabilized, he bent down to grab two of the three recently-topped-up water pitchers, smiled, as though a perfect plan was forming in his mind, and filled his mouth with water. Then, turning like a rabid dog, he spit the stuff into a large ceiling fan that sprayed it to the outer reaches of the dining room. His first mouthful silenced the room. The next two drenched it. Matt, Martin, and I, Ron's three loyal bandmates who hadn't seen this coming, got the worst of it, sitting right under his looming frame.

Then, as suddenly as he'd begun, Ron jumped down from the table and marched to the restaurant's front door, arms swinging like a big, proud baby. A much older man

sitting with a much younger woman grabbed Ron by the arm. "You've ruined our meal!" he spluttered. Ron winked at him, like a cowboy in a western throws a knowing wink to a shoeshine boy before flipping him a coin and riding out of town, full of self-righteousness and justice. Then he walked out onto the street and disappeared into the Tribeca night.

I caught a glimpse of Matt who, gazing blankly ahead, reached for his cloth napkin, futilely patted his brow with it, folded it, and returned it neatly to its spot next to his upturned glass of wine. The red splattered across the tablecloth resembled a crime scene.

I couldn't look anyone in the eye. These people sipping their martinis and eating overpriced steaks should have seen me as a shooting star. Now they saw me as one of four scumbags who had somehow infiltrated their ranks.

All the meals in the room were returned to the kitchen. Many people grabbed their coats and angrily stomped out, leaving an eerie, unnatural silence. Dollar Sign opened his wallet, slowly laid down his card, and left a $600 tip on a $500 bill.

Martin lit a cigarette. It wasn't allowed, but what did it matter now?

"Well," he cocked his head, "that's Ron for you. He's got the uncanny ability to snatch defeat from the jaws of victory."

I imagined those trouble-solving gears in Matt's head grinding and our easy road ahead, dismantling itself, brick by brick.

nine

"Ooooo! Look, Matty." I point to a poster on the front of the club announcing our show. "Speed Bar Baby is playing tonight. I hope *they're* good." Matt lacklusterly rips the poster off the wall, sighs, and disappears to call MCA.

The venue is laid out strangely. There's a separate pool room as large as the room with the stage in it, which means a lot of temptation for the crowd to spread out too thin. We soundcheck, then play pool for a while with another band from New York called Firewater. Afternoon turns seamlessly into evening in the windowless space, and I dip into the main room to watch the opening band. They're young and enthusiastic and there's a girl on bass which makes

me happy. I love her confidence despite the fact she's playing like she's got Vienna sausages for fingers. It's all about the confidence.

I remember the first time I played bass. It was after I moved Colton into my poor, beleaguered mom's apartment. He was in the tenth grade; I was in eleventh.

"We *have* to let him stay, mom. His home life is *horrible!*" Which was true. His single mom had moved them from Oklahoma to escape his abusive, coke-dealing father. But she wasn't much better. He once told me a story that included the line: "And that was the Christmas my mother stabbed me in the chest with a kitchen knife." I just couldn't leave him out there like a wounded little puppy in the elements. Plus, some incredibly immature part of my snake brain still thought of Sid and Nancy as the height of romance, not the depths of addiction, idiocy, and sloppy murder.

By this time, mom had found us a small, affordable apartment in a housing complex on Fordham Road in the Bronx. It was bleak—long, empty hallways lit by fluorescent lights in humorless, brown brick buildings. But she made it nice inside: ferns hanging in baskets in the windows, a soft couch, little picture frames she glued decorative shells and trinkets to. She paid for it all by taking two buses and the rickety old 4 train to NYU Hospital where she, and all the (female) nurses, would spend long shifts being talked down to by the (male) doctors who were

half her age, made four times her pay, and who absolutely couldn't have done their jobs without her. Her hope—she shared it often—was that she'd be able to hang in there long enough to send me to college at New York University, since that was free for all the employees' kids. But she was clearly holding on by a very frayed thread.

When I announced that it was definitely a very good idea indeed to move my mohawked, whipped dog of a boy-friend in with us, part of her must have allowed it because she's a kind soul with a cavernous capacity for empathy and a soft spot for the underdog. But another part was surely too fed up to fight. After that, she had the displeasure of returning from twelve-hour shifts to punk rock music shaking my thin, bedroom walls, and two greedy, hungry mouths, parted like baby birds' beaks, wanting sustenance and treats, when she pushed her way wearily through the apartment door and kicked off her thick-soled, white shoes.

Colton's mom had a rich boyfriend by then and a pres-tigious job where they wouldn't have *dreamed* that she may or may not have tried to carve her son's chest open for Christmas one year, so she didn't seem all that both-ered when he stopped coming home.

The two of us immediately set up a play-pretend mar-riage inside the confines of my small room: We bought a gerbil, which escaped from its cage and died a hideous death; we painted a punk mural on the wall, an explosion

of angsty torment; we came in later than we should—always—and stayed up later than we should—loudly; we had a teenage couple's theatrical version of sex on the other side of my mom's bedroom wall, and, beaten down by life and by us, she just turned up the television volume to drown us out.

The next natural step seemed to be to start a band. I bought a twenty-five dollar bass guitar that the previous owner had stenciled the word "bass" on the headstock of, for clarity's sake. We pooled our allowances with Paul, Ezra, and Daria from school, booked a rehearsal room, and now, all we had to do was learn to play a song. *Any* song. "Sex and Violence" by the Exploited seemed like a good place to start for four people who could not play their instruments. It was literally three notes and three lyrics on repeat for four minutes and fifty-nine seconds. Now that was a song we should be able to master.

It was, in fact, *not* a song we could master. But we sure did try, for three solid hours in that rehearsal room. By the time we left what turned out to be my first ever band practice, I'd rubbed pink, raw holes into the flesh of my virgin fingertips, and Colton's voice croaked from shouting into the mic. But we left that studio—each of us—feeling like stars. This was the promise of punk. All you had to do was play till you bled. And that's an exciting promise for anyone who loves music. I didn't have to go to *Julliard*, like my dad, or practice incessant scales, or suffer the bland

torture of the piano practices I neglected to do as a child. I could just play music. And it was good enough.

As we draped ourselves over a scaffolding outside the studio, leaning on our instruments and sucking forty-ounce beers out of paper bags, delighted with ourselves, a couple stumbled by—him in a pink polo shirt and deck shoes, her in heels, pearls, and a Ralph Lauren sweater. They were drunk and they were *that* kind of rich. The kind of rich so used to buying what they want, they also think they can buy access to "cool." On seeing us, they must have thought they just *had* to have us.

"Oh my GOD, you guys are fabulous!" she slurred. "You have to play our party! Don't they have to play our party?" She poked the man. "YOU HAVE TO PLAY OUR PARTY!" She scribbled her number on a piece of paper and that was it. We were absolute fucking stars. After she stumbled away, Colton took the piece of paper and he ate it. He thought that was pretty punk rock. And I thought *You are a fucking idiot. That was our first gig. We could have played a three-hour set of "Sex and Violence" on repeat, and we, for sure, would have become stars.* But all I said was "Hahahahahhaha. Cool."

Colton and I carried on like this for over a year, until I graduated from high school. This was when, one night, my mom reached her limit. She pushed her dark, thick hair off her forehead with the back of her graceful hand. She looked down into her plate of chicken à la king and squeaked out,

almost breathless, "If you're going to do this, you're going to have to do it on your own." And that rubber band—the one a teenager pulls so taught the release of it could blind you—snapped with those words. She thought I had given up on her. I knew she had given up on me.

Colton's mom drove us around the Bed-Stuy/Clinton-Hill part of Brooklyn for exactly one day to see apartments we'd found in the back of *The Village Voice*.

Studio, 87 Clinton st, $550 / mo.
Prvt. Room in 2 bdrm 92 Ryerson,
NO STUDENTS, $400 / mo.
*1 Bdrm, railroad, *EIK, 172 Hall st, no pets $600 / mo*
(*Eat-in-Kitchen)

We took the last one. Colton's mom gave us a single mattress for our floor and co-signed the lease. My mom gave us $600 for the first month's rent, which I promised we'd pay back soon. After all, we were all grown up by my estimation. That was the first in a series of, not lies, exactly. Just well-intentioned bullshit.

Our new neighborhood had every amenity two teenagers could want. The Pratt Coffee Shop sold omelets and fries for $3.50. Kennedy Fried Chicken on Myrtle Avenue served up a hamburger that, despite being made of gray meat, was a culinary delight for a teenager with no discerning taste or the options that come with having money. For

our anniversary, we splurged on three bottles of Andre Pink Champale—something I still thought of fondly from nights with mom watching late night TV—for $9.99 at the local liquor store, plucking them from a barrel of melting ice on the sidewalk outside. Exactly nobody asked for ID in bars unless they thought you were a narc, and everybody could spot a narc because of their white sneakers and acid wash jeans. So we drank with new friends from nearby Pratt Institute, all of us underage, at the Alibi, a small basement bar. Most non-local young people living in the neighborhood were there to go to Pratt, a prestigious art school that exists like a gated community amid dilapidated brownstones, three-story, clapboard houses, and the projects.

Every Sunday afternoon, we took the hour-long train ride to the Lower East Side to go to hardcore matinees at CBGBs. When I was one of three punks in high school, it was easy to feel cool. All you had to do was be different. The "cool" was implied. But walking up to CBs that first Sunday—where everyone was different, even if we were all kind of alike—it wasn't clear how I was supposed to stand out and belong at the same time.

The crowd was intimidating. Out front, kids drank beer and malt liquor, stumbling drunk in the bright sunlight. They slumped on the sidewalk or leaned against the building. Pushing each other around, it was hard to tell which fights to take seriously. A few faces followed us aggressively that first time, then turned away. Old men from

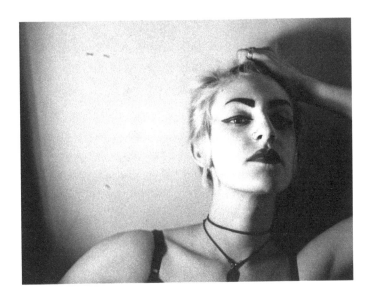

the flop house on the second floor over the club pushed through the crowd, too concerned with their own tenuous survival to care about anyone else.

Inside the swinging doors, a man with broad shoulders and tattoos, wearing a cutoff vest with biker patches on it, stuck out a meaty hand.

"Five." A demand, not a request.

Inside, the club was dark and hazy. A long corridor funneled the crowd past a bar. A singer shouted from the stage and a sea of bodies flew through the air, silhouetted against the stage light.

The crowd flowing in jostled me toward the stage where Colton and I hung back at the edge of the swirling pit: the funnel of madness at the lip of the stage that elbows and boots and hard skulls fly out from. The only girls I saw were lining the walls, arms crossed, heads bobbing furiously. In the thick of the crowd, boys charged each other like quarterbacks, head-butting each other's guts, repelling off each other. I took a breath and stepped forward just a little bit, before a flying body bent my knee into an unnatural shape, and a boot landed on the arch of my foot. I crumpled and retreated, feeling nervous and outmatched.

"WHERE'S THE BATHROOM?" I yelled into someone's ear.

"Ohhhh," he shook his head sincerely. "You don't wanna do that!"

There was no natural light, no space to move, nothing but sweat and bodies, fists flying everywhere, and music

pounding. But there was also the excitement of something real happening. Something urgent, meaningful. I decided to try again, stepping cautiously forward like an explorer. A large back hurled itself toward me and the owner's boot came down on mine. But this time, I shoved the back, pressed my lips together tightly, and didn't give up. I kept my stance wide, elbows out from my sides, and clumsily moved forward, closer to the energy, until, in the belly of the beast, something changed. The boys around me rolled their heads and screamed and punched the air and bounced against me, but I felt calm. I was inside the center of a tornado. Inside the funnel that carries cows and chickens and grandmothers who've been sucked up by the traveling thing. And I could look out and think, "Wow! This thing is really tearing shit up out there!" But inside of it was peace. A leg landed on my shoulder—I pushed it off. An elbow dug into the side of my neck—I shoved it away. And the longer I stood there, the more I felt like a girl who would always be able to survive a storm.

We went to hardcore matinees every Sunday for a year. We saw the Cro-Mags, Warzone, Murphy's Law, and hundreds of other bands whose only purpose was to make other people explode. It was our little angry utopia filled with fury and release. And there were more girls than I'd seen at first, who'd venture up front and dive off the stage. Tough girls. Violent girls. Crazy girls. Funny and sweet girls. Friendly girls.

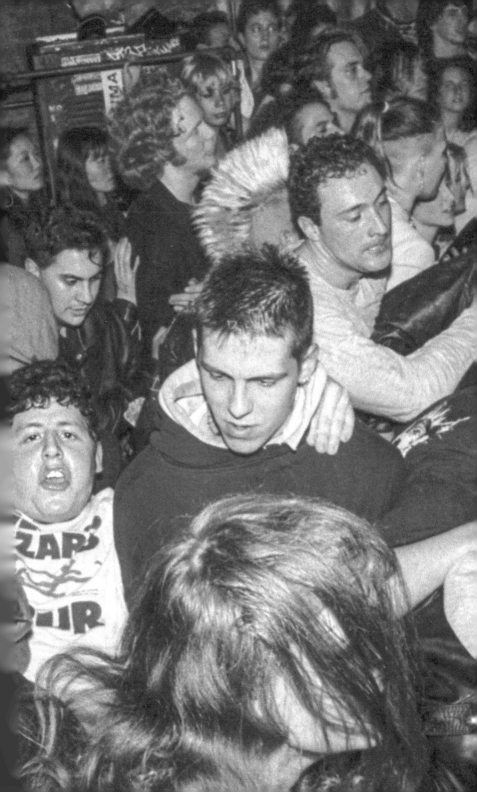

About a year in, things started changing. The crowd had been a blend of punks and skinheads and "norms" and straightedges and drunks and Black and white and Asian and Hispanic and, although it was generally an open secret, gay people. The violence was mostly cathartic and, if violence can be, generally good-natured. Like "Primal Scream Therapy," where white men go into the woods to yell and "reconnect with their animal nature" rather than dying a little every day in their corporate jobs. But there was a small group of skinheads who were more menacing than that.

Whether any of them were racist seemed incidental. In fact, many of them were Black and Hispanic. The thing that seemed to appeal to them most about being skinheads was the fear it brought out in other people. Skinheads were just starting to be all over the news, developing a sort of "stormtrooper" reputation, as in both Nazis and *Star Wars*. These guys reveled in that, and they started to take over the space near the stage.

"NO BREEDERS IN THE FRONT!" a guy as wide as he was tall shouted before shoving two small girls violently off to the side. "THE FRONT IS FOR MEN ONLY!" Then he pulled his shirt off and rubbed his chest against his friend's hairy girth.

I couldn't believe it. I thought we'd collectively agreed—after growing up on John Hughes films and *The Bad News Bears*—that bullies were the bad guys. Bullies were the jocks and the young Republicans who

would go on, unimpeded, to amass great fortunes and live consequence-free, pulling in favors and being gifted golden parachutes whenever they truly fucked up. They raped and murdered and exploited with impunity and that was the order of the conservative world. We were the sheroes and heroes, the underdogs. We rejected all the isms: sexism, racism, classism. We were, I imagined, the clear thinkers and justice seekers. That's why we'd pushed "normal" lives away. But here was the football captain hiding in plain sight; in a different costume, sure, but bringing the same old boring shit into our violent little paradise. And not only was I confused, I was pissed off.

Outside CBs, the shoving and the fights amped up. This group would pounce, five on one, on anyone who looked at them too long. Hilly Kristal, the owner, sent his doormen—a collection of bikers and the toughest of the hardcore singers—out to restore order. But that only shuffled the violence down the block and out of the sight of anyone who might stop it. I watched in disbelief as skinny kids from Ronkonkoma, excited at having taken the Long Island Rail Road to their first hardcore show after listening to records in their suburban bedrooms for years, were dragged into alleys and beaten raw.

A ringleader in this crew eventually worked his way through all available victims and took on a friend of mine, a muscly, tattooed Dominican punk rocker we all revered. Ralphyboy held himself as upright as a mountain and as

calmly as a monk. While he was only a few years older, he seemed as though he held the wisdom of punk-generations in the marrow of his bones. He was also a tough bastard and would not go down as easily as some others. The fight between the two of them lasted on and off for a week until one evening when Ralphyboy found himself surrounded and outnumbered. A young punk kid stepped in to help, motivated by that unwritten code of ethics; that we're all in this together and that that righteous purpose is worth dying for. Which he did. Right there on ninth street. Stabbed in the heart. I'd barreled into adulthood literally swinging. But when I heard the news of this murder of someone who could so easily have been me, for the first time I really wondered whether I was ready for this thing called life.

———

Another reality I had to face was the fact that Colton and I could absolutely not come up with $600 a month for rent, plus enough money for gray meat cheeseburgers and Andre Champale. That was pure fantasy. And our apartment was exactly as clean and tidy as you'd imagine two teenagers could keep it. There comes a time when a sink full of dishes is so filthy—so coated in white slime and maggots—that the idea of moving houses becomes more appealing than washing them.

But I was determined to make things work. I started

assisting a writer who worked from home. I misted her furniture lethargically with Pledge and sort of wiped it off while thinking about what I'd rather be doing. I bought her cappuccinos from a local café for what I thought was the astronomical price of $2.50. Sometimes I addressed and licked envelopes for her or accompanied her to meetings, but mostly I was there for moral support. Her husband was a film director who traveled constantly, and she emanated loneliness.

"Make me an appointment for my hair and makeup. I'm having a new passport picture taken," she'd instruct before leaving the room to take a nap.

I came in one Friday afternoon to a package sitting squarely on the kitchen table in front of where she sat.

"Take this to the street," she said, staring at it with her chin resting in her hand. "Wait until it's run over by a truck. Then take it to the post office and return it as undeliverable."

I did as instructed. It was a fine way to make five dollars an hour. I waited for a red traffic light, ran out to the middle of the wide, major road, and placed the brown paper-wrapped box dutifully in the middle before returning to the curb, where I sat with my knees folded in front of me to wait. Car after car swerved around the mid-sized parcel until finally a U-Haul truck couldn't avoid it. I darted out with the next red light, scooped up the flat thing with the tread mark across its top, walked it over to the post

office and sent it off. When I got back, my boss was still sitting at the table. Seeing me empty-handed, she nodded and left the room. She'd left me with nothing to do, so I drifted into her bathroom and found her Chanel No. 5 perfume. It had a delicious, sweet smell, like flowers and success. Any time she wasn't around, I'd spray too much of it on myself, like making a promise to myself of better things to come. Then I put on the kettle and made her a cup of herbal tea, which was sitting, cold, on the kitchen table for her when she reemerged an hour later with the story. Her husband had had an affair and that woman made the grave error of sending a present to his house that my boss intercepted and dealt with in a way that I came to think of as pure genius.

Colton picked up small construction jobs and sometimes worked as a messenger. Not a speedy, motivated bike messenger, but the kind who takes the bus. Occasionally, we scraped together the $600 for rent. But just as often, we were short, and I had to call home and clumsily ask for a loan I knew we'd never repay. Colton's mom always said "No," and my mom always grudgingly said "Yes," which made me feel too guilty to ask her often. Instead, we just fell more and more behind with our landlord, a bespectacled, quiet man named Jim who had no clue what he was doing when he rented us the apartment right above his.

We treated him like a parent because, after all, we were too damn young to know any better. We came home often,

after a night out at the Tunnel or Limelight, somehow *both* having forgotten our keys. 2 a.m, 4 a.m., scared but not scared enough, we timidly rang Jim's doorbell. And he'd let us in, blinking in disbelief. I was embarrassed every time. Colton, not so much.

We did any job we could find. Colton's mom called in a favor to get us a gig at a gallery opening. For $20 each for a four-hour gig, our only responsibility was to stand next to two huge movie lights so that nobody knocked them over. The two of us were sporting a twin look those days: black hair—his in a mohawk, mine, a spiky flattop with bangs— kabuki-white face makeup, red eye shadow, black eyeliner, and a single, drawn-on beauty mark under each of our right eyes. That, plus our uniform of torn, spiky leather and jeans, made us quite a sight and the crowd began to gather, taking pictures, mistaking us for part of the exhibit.

"I like the way she's made them both the same height. That's a brilliant choice." Click.

"I like that the girl's looking at me like she wants to hit me in the face. It suggests a narrative." Click.

No matter what we did, we were always scrambling, always falling behind. I was the one who took on the task, gulping and smiling and cringing, of begging our landlord for more time, every time. Month after month, increasingly feeling like I had shown up for a test I forgot to study for.

One Saturday afternoon, there came timid tap on our door. Normally, when a friend stopped by, they yelled up

from the street and we leaned out the window and dropped our keys wrapped in a sock so they could let themselves in. Another ritual I'm sure our landlord enjoyed. But no one had yelled up, so we didn't know quite what to make of the gentle rapping sound now. I put down my sketch pad and called out tentatively.

"Hello?"

"It's Jim," came the almost inaudible reply. Knowing we owed him rent, I avoided opening the door and instead opted for the peephole.

"What's up?" I tried to sound innocent as I swung the little circular metal cover aside. "You're gonna have to get out," he replied, meekly. He was so close to the door that my view through the little fish-eyed lens was filled entirely with a distorted, pinhead version of him, his eyes downcast behind thick lenses. But what stood out to me the most—what left me shaking and my eyes watering—was the business end of the barrel of a shotgun he was holding. His spindly arms must have been struggling under the weight of it.

It took us three days to find another apartment and three more to pack and move out.

I should have accepted defeat and begged my way back into my mom's home. But I was in love. Oh, fuck that. I was insane. Or I was embarrassed to fail. Or I'd never known what this was supposed to look like, so I was hopeless. Love was starting to look something like torture, desperation, mistrust, and worry by then.

With each successive apartment, which we, predictably, lost, we each got a little bit more fed up with each other. When *I* got really fed up, it sounded something like this: "We *have* to do better! What can we do to fix this?" When Colton got fed up, it sounded more like this: "I'm going out." And then he'd disappear for anywhere between five and twenty-four hours, returning, most often, drunk, sometimes with a tattoo.

Stumbling under the weight of our life together, we finally moved everything we owned into one single room in the apartment of a clean-cut couple studying graphic design and art history at Pratt. They were heading for success. That much was clear. They just needed a little help with the rent, but nothing was going to get in their way.

For a couple of weeks, it seemed as though things might get better. This room only cost us $200 a month, and when Colton wasn't misplacing that or spending it on booze or buying a video camera on the street with it (which turned out to be a bundle of bricks shrink-wrapped in a video camera box), we could afford it. But a couple of months into this arrangement, Colton came home with a new acquisition.

"Isn't it incredible?" He was flush with excitement, turning the object over in his thick hands. "It's a World War II regulation German dagger." He spun it slowly, admiring it from every angle. It was long, with an eight-inch blade and a decorative metal hilt. There was a gully cut

down the middle of the blade which, he explained enthu-siastically, was so that ". . . when you stab someone, you can leave the knife in while the blood drains out through the little slit. Amazing!"

I thought it was amazing too, but for very different rea-sons. It was an item that, no matter how messy our room got, I never let out of my sight.

One evening I came home from my job at a copy shop to find a frantic Colton tearing our room apart. I heard our roommates' bedroom door slam shut just as I got in.

"What are you doing?" I asked urgently, keeping my voice low as he upturned boxes and spilled their contents onto the floor, while, in his wake, I futilely righted and tried to refill them.

"I HAD MONEY HERE!" he barked.

"Be quiet." I begged. He'd been mildly aggressive before, and ever since he decided he wanted to be a singer in a hardcore band—despite having no clear talent—he'd been lifting weights and had transformed himself from the skinny beanpole of a punk I'd brought home to mom, into a thick-necked, sweaty-pitted, formidable beast. But he'd never been remotely aggressive with someone else around, and more than frightened, I was immediately ashamed.

"SHUT THE FUCK UP! There was money here. Where did you put it?" he demanded.

"I don't know what you're talking about," I said, quietly

and honestly, restoring a red milk crate, which functioned as a nightstand, to its proper place.

"Where the FUCK is my MONEY?!"

"You're gonna get us kicked out!" I hissed. "Stop it!" Then I saw the dagger, lying, still and menacing, on the windowsill, and I froze, waiting for him to spot it. But his head was down as he hunted, like an animal, for the money he'd likely forgotten he'd spent.

Quietly and quickly, I slipped behind him, grabbed it, and darted out of the room. I timidly knocked before stepping into our roommates' bedroom where they were facing each other, in a frantic, hushed conversation, and thrust the heavy, deadly thing into the boy's hands. "PLEASE hide this under your mattress!" I begged.

I saw pity. Fear. Disgust in his eyes. I looked down and slunk away.

Colton confronted me with wild eyes as soon as I stepped back into our room. "Where's that FUCKING MONEY?" And with the word "money," he shoved me.

A white rage engulfed me, and my back arched like an angry cat. I thought about our cowering roommates, the failure of my life, about this humiliation and about my hard-working mom, who deserved better, and I screamed, "NO! FUCK YOU!!" I pushed him hard, concerned only with survival. As my hand left his chest, he grabbed my wrist and swung me down to the mattress that filled our entire living space—our entire world. He was on top of me now,

his knees on my chest, making it difficult for me to breathe. Then his fist was above me like an anvil. I don't remember the pain when it came down on my eye. I only remember the sadness. I don't remember the pain of being choked either, since, by that time, I was watching my body, from the upper corner of the room, with detached curiosity as it fended for itself, twisting, and flailing.

Eventually Colton tired himself out, rolled off and sat back, spent and panting. And I reluctantly returned to the little body and entered it as it gulped for air. A rogue tear worked its way down my cheek, into my ear. On the ceiling, a map, faint but definite, formed. I saw a girl, strong and happy, independent, and full of hope. She was following a road away from this place; and this place—on the map—this place was on fire.

Every decision I made from that moment on would be done deliberately walking down that path.

ten

There it is, and my God, it's gorgeous. Its 1950s version of a "futuristic" neon sign promises lima-bean-shaped coffee tables, dangling orb pendant lights, lava lamps, and a tacky lounge where you can sip a cocktail while the same singer, who's been doing something loosely called "entertaining" there for the past thirty years, plays their rendition of "Mandy" almost entirely for themselves.

Matt makes a sharp turn into the parking lot and pulls up under the glowing sign of the Air Host Motel. We're in no rush. MCA has paid for the room, so we don't have to sneak in. We don't have a show tomorrow, so there's no

early start. We can just lounge poolside all day long if we want to. We can do whatever we like.

Matt, Gigi, and I climb on top of the van to lie on our backs and stare at the stars.

"Beautiful," I say to the full moon, but the comment is intended for Gigi who has weathered this shitstorm with us for no glory at the end of the road. I'm hoping to sway her opinion. Just the opportunity to thrift shop her way across the country. Which, to be fair, is just about her favorite thing to do.

Gigi doesn't respond, just rests her head back on her arms and looks straight up.

Eventually we work our way to the lobby, which is less charming than we'd anticipated. Matt rings a bell on the front desk and we wait. And wait. And he rings the bell again before we wait some more, optimism about the Air Host still buzzing in us. Rustling sounds come from behind a door just past the counter. Then, very slowly, it swings open and a tall, skinny kid stumbles through it, as though falling in slow motion. He blinks at us like we're the sun. His plaid flannel shirt, too large, is rolled up to the elbow on one arm, while the other dangles loose over his hand. His eyes are red and puffy and the smell of alcohol oozes from him like cheap, poisonous cologne.

"Evening," Matt starts. "We have a room booked."

The gangly desk clerk takes a deep breath and looks around as if to say, "I can't believe I'm still here!" His

head cocks like a spaniel who thinks he may have heard a grouse in the underbrush. Then he scratches the back of his neck, points in the direction of the registrar book, and mumbles, "Write it."

"Sorry?"

"Write it! There." he waves at the thing. Matt takes a pen attached to the desk by a chain and writes his name.

Swaying, it seems as though the boy has suddenly had a deep thought. "You're not gonna pah-ty are ya??" he slurs accusatorially, in a flat, Chicago accent. "Cuz if you're genna pah-ty and I getta cahl da cahps, you ain't genna get no refund!"

"No sir," Matt replies wearily. "We're just gonna sleep."

My eyes land on a dusty cuckoo clock with the bird stuck on its way out, and there's a table lamp with its beige shade still wrapped in plastic.

"If you're genna have SEX," he clarifies, suddenly alert, sticking a boney finger toward us to emphasize his point, "dat's ok! Just no pah-tying!"

"Yes sir. Got it," Matt repeats. "Sex, A-OK. No partying."

I just can't resist. "But what if the sex is really *fun*," I add, "and it starts to *feel* like a party?"

"WHAT??" The kid's eyes focus suspiciously on me and Matt shoves his elbow into my ribs.

"Never mind." I smile, my eyes watering from the mounting smell of room deodorizer—something that suggests a summer breeze mixed with week-old corpse.

The boy squints at me. "No pah-tyin'!"

There is no lounge, and on our way to the room, we see that the small, outdoor pool has been drained and is now filled with maggots and trash.

Although reassured of our good intentions not to "pah-ty," the kid has clearly handed us the keys to what is no doubt "the party room." If by "party" you mean an unmitigated disaster during which several people are slaughtered. Anything not nailed down is gone. The factory-reproduced landscapes that may have once hung on the walls have been stolen or preemptively removed, leaving just a few bare hooks and some clean rectangles on the greasy walls where they used to be. I let out a deep sigh and decide to sleep in my clothes.

We sit on bug-infested bedspreads for an hour, sipping Heinekens and JD we stole from backstage, decompressing, complaining about MCA and the shit promotion and now the (fabulous) Air Host Motel.

I seem to be the only one who notices that Gigi's gone. I can't imagine where she is. It's late and dark outside and there's nowhere interesting to go. I drift over to the door and peek out into a silent parking lot. Our van is one of only three vehicles. *Luxury accommodations*, I think. *In great demand. Cocktail lounge. Black-bottom pool. Sigh.*

Gigi's nowhere. I step into the night.

"Gi?" I call tentatively, working my way around the side of the building where I almost crash, face first, into her as she careens around the corner at speed. We both shriek.

"*There* you are!" I laugh with relief.

Her eyes are wet, and her cigarette is down to the filter.

"What happened?" I see the alley between the buildings behind her and worry. It's just a dumpster, a low burning light and a stand-alone phone booth.

"I called Mike." That's Mike Ness, singer of the band Social Distortion, on and off again boyfriend of Gigi's and a man who's battled his own ferocious addiction demons for decades.

"He screamed at me," she chokes. "'Go home now! It's not going to get any better! I'm sending you a ticket!'" She pulls a broken cigarette out of a crumpled pack and lights it with the butt of the first one which she tosses into the surrounding darkness.

I shrink, feeling wounded. I didn't think things had been so bad—didn't think Ron was being so bad—I just thought . . . they were the way they always are: bizarre but manageable.

"Why'd you come?" I ask, partly defensively, largely with genuine curiosity. I'm afraid she'll yell, "FOR NO GOOD REASON!" race back into the room, throw her bits and pieces into a bag, and leave me here on the curb. Gigi can do anything. She can find her way back to

New York if she wants to. She isn't afraid. Or I didn't think she was.

She laughs and wipes her eyes. "Because this really cool girl rode up to me on the back of a motorcycle on Avenue A and asked me if I wanted to be her band's tour manager."

It takes a second before I realize she's talking about me. Of course she's talking about me. Of course, I was the girl riding on the back of Carmine's Vintage 1971 Triumph Tiger TR6 in a skirt so short if we'd crashed and skidded, the asphalt would have shorn the skin from my bones like cutting gyro meat on a rotating spit. But it's so odd to hear Gigi describing *me* as "cool." Gigi, who is every inch a bespoke, curated, decorated, walking work of art. Gigi who doesn't seem to need anybody, whereas I feel extraordinarily needy, not built for speed, with a big weepy heart.

I smile guiltily now, knowing she's so unhappy.

"I didn't know what a tour manager does," she shakes her head, "but I figured I'd get to travel around the country with some people I like and meet cute boys." She rubs her arms for warmth. "I haven't met any cute boys yet." She side-eyes me and smiles.

We're quiet.

I'm waiting to hear her say she took Michael's offer, and the ticket is on its way. Beyond the room's door, which I left ajar, Ron is making fun of the opening band

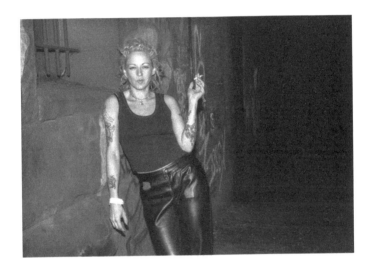

from earlier and Matt and Martin are wheezing with laughter.

"When I was little," Gigi starts, "my dad worked for the airline so we all traveled everywhere. In those days you got dressed up really fancy to fly—it was a big deal. Women couldn't even wear pants! It was ridiculous but it was kind of amazing too. It was just really special." She rubs her eyes. "I think that wanderlust just stayed in me. And boredom. I'm always bored staying in one place."

Her smoke stings my eyes, but I don't flinch. I don't want to interrupt.

"Then there are the ghosts." She's staring off now. It's not what I expect to hear, and my eyes widen. *The who what now?*

"I've told you about the ghosts, haven't I?"

I think I would have remembered.

"They've *always* come to me. In so many different houses over the years. I lived with a little child one once. It used to touch my legs when I was doing the dishes. I can't really describe what it felt like. Like . . . feathers. Or . . . a hug from a ghost I guess."

My eyes bore into the darkness just beyond the small pool of light we're sitting in and a shiver runs through me.

"My friend talked for ten minutes to a guy who was standing on the steps in my house once. Then he came into the kitchen and said, 'Your friend is a really nice guy' and I'm like 'What friend?' and when I told him that was the

ghost of the dead soldier who lived in my house, he turned green and stayed up all night."

"He stayed all night?" I blurt.

She goes on. "I've just always known that this isn't it. I've always lived with spirits who are in this in between place." She crushes the butt of the second cigarette with her platform shoe. "I'm not afraid to die because I know this isn't all there is. But I'm also really eager to live, because I've seen so many of these poor things stuck in this lonely space with no place to go. And I just have an urgency to see everything. To live. Before that's me."

Then she's on her feet, brushing off the butt of her pants.

"I love ya, Al. I can't go." She touches the top of my head. "I haven't found any cute boys yet."

With that, she joins the non-party party, and with a furtive, jangled glance back into the darkness, I follow her in.

Inside, Martin whips off his shirt and climbs under the covers. Matt and Ron do the same. I stare at them there. *The spirits are alive and well.* Gigi grabs my camera and stands over them, taking pictures. I hurl myself onto the bed and squeeze in among them. Matt leans across me and chomps down on Martin's bare chest, pulling the flesh up between his teeth. Martin screams and then we're rolling around like puppies. Gigi smokes and takes pictures and counts the money. Because that's what a tour manager does.

Ali Smith

eleven

Rolling into Lawrence, Kansas, yesterday, we all agreed. We will *not* do what everybody else does when they pass through Lawrence, Kansas. We will not try to find William Burroughs.

We will not try to find William Burroughs.

We will not try to find William Burroughs.

. . .

We couldn't find Williams Burroughs.

I don't care so much about William Burroughs, because he shot his wife in the head and that's a line I like to draw for myself. ("But you can't confuse the art with the artist!" Well, I can if I want to.) But Matt likes William Burroughs.

And Ron *really* likes William Burroughs. But we can't find William Burroughs, so we're just heading to the club.

"I called him once."

I figure Ron's lying because the meeting of two such personalities, even over a phone line, would have certainly resulted in some sort of cosmic event—like the death of a planet—that I would have read about.

"I told him I was Tommy, out of Topeka, and I was on I-470 on my way to deliver a truckload of titanium sheets to his door. 'I'll be there in an hour and you've gotta sign for 'em!' I told him."

Then imitating Burroughs's staccato, bedraggled voice with a nasal twinge, "'Don't bring 'em here,' he told me. 'I can't use 'em!'"

"So you're saying," I ask, "that he believed you were Tommy out of Topeka, delivering a truckload of titanium sheets to a tiny clapboard house on a side road in Lawrence, Kansas?"

"Well, if he didn't," Ron laughs," he must have been bored cuz he stayed on the line for ten minutes!"

When Ron sings tonight, it sounds like anguish and exhaustion. It sounds like he's doing it for Burroughs and Kerouac.

His voice threatens and menaces.

Don't ask me to show you the way. Don't ask this
monkey for a light.

Cuz I got no answers and no dress code.
Look at your own palm, read your own Goddamn
 future.
You taste a stranger's skin and think nothing of it!
Piss in a parking lot with two locals eating love.
Cop car jumps out of its skin and the pig scurries
 up the backside of life.
Cinders burn in the distance and I start laughing.
Ha ha ha ha ha ha!!

The laughter is maniacal, terrifying, even to me. It rings in my ears long after it's stopped, like the memory of laughter coming from under a hood worn by someone remorseless and doomed, strapped into the electric chair.

Death on the installment plan, so Celine said.

But that was 1940 and he was a Goddamn optimist.

After the show, Ron devours a handful of pills some kid hands him, and, unusual for him, Matt joins in.

In the morning, Matt is wearing dark sunglasses and contorting his body across the back seat, desperately seeking comfort. And Ron's head is in his hands, like an empty glass jug he's protecting from further harm.

Roadside, a combine harvester has been at work for hours, moving like a monster performing a ballet.

"How do those things work?" I ask absentmindedly.

"Those things in the front . . ." Ron mumbles, jerking his head a bit, then wincing. "Those things gather

up the cereal crops." His voice is a suffering monotone. "Then a pickup wheel pushes the crops down and the cutter gnaws the crops off at the . . ." he belches . . . "at the bottom, and then they go up that conveyor belt," he points with an unsteady hand, "and that shakes 'em up and . . . separates the grain and the stalk and then the . . . then the, the grain falls through there and ends up in a tank." He lets his head fall back into his hands and I can barely hear the rest. "The grain shoots out a side pipe to a tractor trailer up alongside, and the chaff falls off the back and then they square that off with a baler to feed the . . ." heavy sigh, "to feed the cows."

As he explains it, I watch it happen. So beautiful. So specific. Something I've never really noticed before and here it is, happening every day, over miles and miles of country.

Cows dot the grass of the next field, chewing with long, exaggerated movements. Huge, black-and-white patchwork and tan ones. "Moooooooo cows," I whisper to the glass. Faded pink, mud-caked pigs seek shade under rounded plastic huts a little further on.

Gigi clicks on the radio from the driver's seat.

". . . and evolution is a bankrupt speculative philosophy, NOT A FACT!" a self-righteous voice bleats. "Only atheists could accept this Satanic theory. PRAISE THE LORD!"

"Fuck you very much." Gigi spins the dial into the low numbers where Howlin' Wolf decrees, across the expanse

of decades, on a weak radio signal, that he'd asked for water but she brought him gasoline. His voice telescopes me to the trickle of sweat racing down the back of a burned neck that strains under the weight of a heavy head; to the soul-comfort of incantation and song. The certainty of flattened arches pressed against chalky earth, row after row, day after day, life after life. The only chance for travel, in your mind. The only way your feelings about your lot might ever matter to anyone else, through song.

Slickpoo, Idaho, and Deadhorse, Arkansas. Hell For Certain, Kentucky, and Last Chance, Iowa. There are small towns all over this sprawling country full of misfit kids who need music like they need air. Like they need to be loved. Some towns make me want to get a piece of pie at the diner, try on the local drawl, and hope to blend. Others, I don't even want to stop in long enough for gas. I didn't know what a 'Sundown Town' was until we passed a sign on the Alabama border: *Stranger, don't let the sun go down on you here.* Code words to express the worst of the worst of humanity.

Everyone knows the story of the country mouse. She steps off the bus in New York City, jaw slack, eyes bulging, and banging around her brain are romantic ideas of the city where she'll become a star. Even if she fails spectacularly, in the style of Joe Buck, she's sure she'll find redemption in a place that promises a special little circle of hell for each one of us.

The thrill. The electrifying fear of it all.

But I'm a city mouse and I'll tell you this. I still can't quite believe the flatness of North Dakota, horizon-to-horizon. The dripping seduction of New Orleans slows my heartbeat, like reading a Flannery O'Conner novel. The sway of weeping willows as they daydream on the promenades of Savannah, Georgia, bathes me in a soft-focus view of the world. Pressing my chest against the rough, sweet-smelling bark of a redwood tree on the Southern Oregon coast, arms not even reaching a tenth of the way around, gently lets me know I'm insignificant but also held in the caring embrace of bigger truths. Iowa corn fields transfix me, glistening gold and green, their rows fanning out like taut ribbons. And driving down a stretch of Arizona road, with a red rock cliff blazing in the sun on one side and snow drifts piling up on the other, convinces me that the world makes almost no good sense, but that it is beautiful. Even billboards praising Jesus and guns in the same sentence, while they piss me off, fill me up, like a bucket, with real, complex life. I'll never forget seeing any of these things for the first time.

My gaze lands on the wavering lane markers rushing by. *That line*, I think, *is leading us where we need to go.*

We stop for gas and snacks roadside. A man missing a neck but making up for it with two extra chins wears a baseball

cap, perched high and pitched forward, with an American flag and the unambiguous phrase "THESE COLORS DON'T RUN!" stitched onto its front. As Ron slowly works his way around the shop, dark glasses on, lumbering and thick, the man zeros in on him. I watch him circle Ron in the snack aisle and shake his head disdainfully while Ron fills up a Big Gulp cup with black coffee. But when Ron crosses in front of him to pay, it's all just too much for the man.

"BOY!" he bellows. "You don't. Walk. In front of a man when he's lookin' at the mints!" Ron stops, takes one large step out of the way, and gestures for him to go ahead. The man's eyes narrow. "You're in the South now, boy."

As our van pulls away, the man is pressed against the glass of the sliding rest stop door, mouth moving

soundlessly, head shaking, eyes following our bumper out of town.

"Southern hospitality" can be shattered by a face like Ron's, too indistinguishably ethnic to be "cracker-white." Or an all-black wardrobe that conjures thoughts of trouble. Or a skinny male frame, ill-suited to playing football or winning a bar fight or proving itself in any other clear or acceptably male way.

The image of that man fresh in my mind, I search for my journal and write . . .

The Incomprehensibility of Ron:

> My daddy used to say momma was as ugly as a poor dog chewin' a wasp.
> I never forgave him for that.
> Out near the outskirts of town, you could see Otis do his little dance.
> Sometimes he'd lay on his back in the grass, just thinking about everything he's never gonna do.
> —Ron Ward, "The Crybabies," Speedball Baby

> *Those are some of my favorite Ron lyrics. They aren't his story, exactly, but I hear all the loneliness of the world in them, and I think feeling alone—maybe more than some people—is the biggest way that Ron and I relate.*
> *Ron's dark complexion and heavy features seem to have*

made it obvious, to his small, rural Vermont hometown, that he would leave it young, and permanently.

At twenty, Ron was in a vicious car wreck in which he flew through the front window screen at speed, lacerating his head and face horribly. The doctor shaved his head to stitch it up, and told Ron he couldn't shave his face, which had been shredded to bits, until it healed. Ron had a summer job painting houses and was, as they would say in New England, "wicked tan." It was just after 1979's Iranian Hostage Crisis, and America was in one of its many full-blown panic attacks about people from the Middle East when Ron stepped on to a city bus with his thick, black beard, shaved head, and deep tan. The driver—taking one hard look at him—refused to step on the gas until "the Arab" got off. Conflict and strife have been with Ron from early on.

Ron's biological dad left after he was born. His stepdad, Mel, often took him to the VA Hall in Essex Junction where Ron sat in on drums in an R&B cover band, playing with guys his stepdad's age, while Mel drank at the bar. By the end of the night, it was up to a young, unlicensed Ron to drive a drunk Mel home to face his mother Joyce's wrath.

"JESUS, MEL! It's a school night. WHAT THE HELL ARE YOU THINKING???" she'd holler when they stumbled in, Ron bearing most of Mel's weight on his lank frame.

"Relaaaaaaaax, Joyce. Relax," Mel would respond, smoothing the air with his hands before stumbling to the bedroom to pass out on top of the bedspread.

By breakfast, Mel and Joyce were their usual, pleasant selves. But when he talks about his life at home, I think, You can be loved but not understood. Especially in a town where nothing you do will ever make you the "right kind of boy."

Mel told Ron often: "Be true. Be solid. Be good." It's the times Ron thinks he's failed at those three things that no one can possibly be harder on Ron than he is on himself.

An hour on and the ever-frugal Martin spots a sign: *Dixieland's Last chance 4 cheap butts!* Not a sex shop, not a brothel, but a sprawling warehouse selling cigarettes. The outside is plastered with ads and Joe Camel—the creepy, anthropomorphized, leather-jacket-wearing, chain-smoking, future-emphysema-having cartoon character—smiles slyly from one of them, as if to say, *Hey kids. Cigarettes are coooooool!* Martin sprints inside to stock up. Matt calls after, "You've got ten," then collapses back down across the seat and throws his arm over his eyes.

I step onto the dusty earth and fold in half, swaying slightly, side-to-side, fingertips lightly tracing lines in the dirt. The afternoon sun is high and hot. The movement is soothing, and I'm mesmerized by my upside-down, gently rocking view of the world.

The bland *woosh* of a few passing cars and the tweeting of a hidden bird are all that stand between me and a heavy silence, unlike any you will ever experience in a city. It's a silence that seems to pulsate and push in on you if

you focus on it too much, which I do. Which makes it begin to feel more oppressive than the loudest sound I've ever heard until it's broken, suddenly, by the sharp shock of girls laughing and my stomach clenches; an instinct left over from middle school when I just couldn't seem to get anything right. Back then, girls laughing together might mean I've proudly worn my sparkly blue leg warmers to school and a group has gathered to make sure I know how *not* cool they are. Or it could mean I've shown up to the seventh grade Halloween dance dressed as a cat, only to find that nobody else in the seventh grade still thinks it's cool to wear a costume in public. The laughter coming from a clump of girls that time was meant to let me know that I am a full-blown idiot.

You squeeze your way out through your momma's thighs and the first thing the world does is lean in close and say, "What a beautiful girl!" Or else they say, "What an odd-looking girl, I hope she's smart!" Or else, "Too bad she's not a boy." And you blink back with innocent disbelief. You're perfect as you are. How could you not be? Then they take you home and they wipe your ass and feed you and, hopefully, they love you. But the messages from every direction come fast and furious and they will never stop; are you winning or losing at being a girl, and then a woman? And while you hate the game, to lose it hurts so badly that you compare yourself, pit yourself against those who should be your greatest allies.

There have been so many times I've spectacularly failed to hide how bad I am at being cool, the winner, the "right" kind of girl. And being "wrong," when you're young, can be particularly hilarious to other people. That laughter has left quite an impression on me, and that's why, when I straighten up now, it's slowly and with the Girl Scout motto "Be prepared" in the front of my mind.

Two young teens slink in my direction. Their laughs are broken up by hacking coughs as they suck on menthol cigarettes. The minty smell fills the space around them like a smoke bomb. One of them must be considered a real local beauty—tall, with long legs and a striped tube top that has no problem containing its contents. Her blond, pin-straight hair hangs heavily to mid-back, and her pink flip-flops thwack, thwack, thwack, as she moves with languid strides. Her friend is rounder, with tight jean shorts, the insides of their front pockets showing from below where the legs were sawed off raggedly.

When they see me, they stop dead and look me over, tip to tail, in unison; the painted-on tight jeans; worn-out, dusty Converse; the brown-red lipstick on dry, cracked lips; black eyeliner that's not once been fully removed but only added to for three weeks; dyed, bright orange hair; nose ring; tight T-shirt; and a twelve-year-old boy's jean jacket from the Goodwill.

It's a standoff, high-noon style. My eyes, green and hot, stare out from deep inside of two black rings into the

blond's large, blue eyes, like marbles frosted with light blue fairy dust. My hands are poised at the level of my holster, tense, ready. The back of my neck is hot and wet. I poke at the dirt with my sneaker and privately reason that *If there has to be a winner, I'm it*. After all, I'm just passing by this dusty butt shop, but these two will be ambling to it till the day they die. Which, if they keep smoking menthols, might be any day now.

The girl with the long blond hair and the fairy dusted eyes and the confident sashay and the emphysema cough squints her eyes and draws her weapon. She lets her mouth fall open, effortlessly, and out of it comes a long, slow, deliberate "Ewwwwww!"

Ugh. It's a solid, clean shot, right to the heart and I collapse, a corpse.

The girls walk away, laughing, as I mouth to the heartless vultures already circling above:

Gotta make it to LA. Gotta survive this trip. Gotta find out if I can be somebody.

twelve

"So why," he slides into the booth next to me, "Are you *just* the bass player?" I can tell he thinks this is a compliment. "I mean, you're so beautiful." He reaches for my pint glass and takes a sip. "You should be the singer."

My eyes roll so far back in my head, I'm sure I must be looking at my own ass. I have met this guy before, wearing a new face every time. He watches us on stage and he is terrified, electrified, thrilled, calculating. After the show, he descends on Matt, carefully skirting around Ron in the dressing room. Because while he'd like to hold his hands to the fire of Ron's insanity, he is scared of getting burned. He has his own band to promote. He knows they'd be a perfect

opener for Speedball Baby. He wants to know every little thing about Matt's guitar, amp, how this or that song was recorded. He buys Martin a drink. By the time he gets to me, his one goal is to flip the power dynamic back around so that he's on top. He's just literally been looking up at me on the raised platform and he needs to quickly push me back down to a manageable shape and form. To explain to me what I am and what I should be instead. His ego must be reinstated on its throne. This is a tedious process at best and I blink, slowly, at his tiresome pantomime.

He's saying-not-saying that playing the bass isn't important. Doesn't he know the bass is the mounting thrum that comes before you do? It's the blood that courses through the veins of a song. It's the sign of life you take for granted until it's gone.

As far as beauty, one of punk's main gifts to women and skinny boys is the shredding, staining, and sullying of all that tired old, lifelong brainwashing about beauty as something meant to benefit other people. I'm beautiful because my arms are strong from swinging around the heaviest instrument in the band. I'm beautiful because I believe in transcending this mortal coil. I grew up convinced I had been born with one horrible affliction that meant I'd never be beautiful; my nose was not perky, cute, small, or otherwise "button"— a.k.a. female. It was a big honker of a nose and it was too masculine and it was wrong and it excluded me, permanently, from the realm of beauty.

Nobody "beautiful" that I saw had a strong, aquiline nose. But that's because I didn't live in Portugal, Iran, France, Italy, Spain, or any number or other countries that had different beauty standards. Nope. I was doomed. But rules are meant to be smashed to a pulp with a punk-shaped mallet. So now I think, as Ron sings in one of our songs, *I might not be pretty, but it's plain to see. I'm beautiful.*

Plus, I already was the lead singer in a band. Twice. The first time was by accident.

—

"I'd really like to have you in my band." This guy they called the Bishop was so small he had to stand on tiptoe to say that into my ear one night when I was roosting on the well-worn stools at Mona's Bar, on an absolutely deserted Avenue B and Fourteenth Street. It would still be three years until I'd meet Matt and I didn't consider myself a musician yet. The jukebox blared, the Buzzcocks demanding to know *What do I get?*

I didn't like the Bishop's band, which had perfected the sound of a pile of aluminum garbage cans tumbling off a tin roof. But by the time we each finished a shot and a pint, I'd agreed to play bass—something I couldn't really do—in his band—which I didn't like. If he'd asked me to sing, I definitely would have said no. I had this exaggerated fear of opening my mouth in front of people to sing. My voice sounded too . . . sincere, emotional, uncool. So, I kept my

mouth shut outside of my bedroom, where I tested it for myself and continued to find it lacking..

A friend lent me his bass, and the next night, I was at band practice with the Bishop. After a while, he said "Have you written any songs? I'd really love to have a girl on vocals some time."

"Any old girl?" I jeered.

"You," he corrected.

I *had* written one song recently, but the idea of singing it instantly sent spiny prickles up my back. Still, this band had set the musical bar quite low and looking around at the motley crew, the spiky prickles turned to excitement. *Sure. Let's do it.*

A week later, we played a gig in the dirt-floor backyard of a squat, Christmas lights strung between a rusted fire escape and a dead tree, two kegs bobbing in large, plastic buckets full of melting ice. A boombox tinnily blasted the Bad Brains into the summer sky, and kids with mohawks, liberty spikes, flattops, and shaved heads sloppily bashed into each other, stomping around in circles with their knees high in the air, like an army of angry, skipping children, making dust devils swirl.

"1-2-3-4!" We blazed through four songs in four minutes, me stabbing optimistically at the bass strings. "1-2-3-4!" Three more songs, as quick as you like. This seemed to be going ok. Until I heard, over the din, "FUCK YOU!" And the inevitable reply "FUCK OFF!" And then it was

a different kind of chaos as one of the keg-filled buckets was lifted off the floor, spilling dirty water and sour beer on its way to being emptied over somebody's head. Like the band on the *Titanic*, we played on. Then I heard "No! NO!!" But it was too late. And a different kind of bucket came, swinging in an arc, over the heads of the crowd. Shows like this always had a bucket set up in a corner somewhere for the more genteel among us. For the "ladies," if you will. And that bucket was called "the piss bucket." And it was that bucket that was now being wielded as a weapon.

The melee that ensued was big and threatened to take over the evening and in the midst of it, the Bishop grabbed my bass, shoved the mic in my hand, and said "Let's do your song."

Why I didn't say no is a mystery. Maybe I thought that after the piss bucket, everything else could only be seen as a step up. And suddenly Bill Murray's mantra from *Meatballs* was marching through my brain: *It just doesn't matter! It just doesn't matter!* And so, I closed my eyes and with a cavalcade of punk goddesses on parade in my brain, I opened my mouth. One minute and twenty seconds later, I shut it. And no one had hurled a brick. At least not at me.

The second time I was the lead singer, it was on purpose, in a punk/ska band. But I didn't write the songs, didn't come up with the name, didn't really get the vibe, and no matter how much I screamed or kicked or leaped around on stage—which was quite a lot—I had no clue who

I was meant to be in it. I searched under every floorboard, lifted the corner of every rug, tapped on walls listening for the hollow sound where a secret door might be, but the real me was nowhere to be found. So I just strutted like Pauline Black, flung myself around like Poly Styrene, shimmied and shook like Kate and Cindy from the B-52s, and otherwise emulated a host of people who would have done a better job of it. But I'd met Matt by then. And when he saw me play in that band—leading with heart and nerve—it let him in on the level of discomfort I might be willing to go through for a day well-lived. So that band ended up being a long audition for Speedball Baby.

———

"Al, I met someone special." Matt went to the wedding of a friend of a friend in Boston. The groom swiped the mic out of the wedding band singer's hands at the reception and began to preach and do the St. Vitus' dance, turning classics inside out. And it was like Matt heard a sound that had been rattling around in his brain for years. So he jumped on stage, grabbed a guitar, and tried to match the poetry with stabbing staccatos and dissonant chords. Ron was that groom, and even at his own wedding, he had the jittery swagger of an Italian hitman adjusting the women's lingerie he's wearing under his shark-skin suit. It's not clear whether it was a sound anyone else appreciated that night,

but Matt found a kindred spirit and immediately asked Ron to move to New York. Ron and his new bride were only in Boston because her love of all things witchcraft made her want to be near Salem, Massachusetts, home of the witch trials and modern day occultists, sorcerers, necromancers, wizards and warlocks. But she'd grown impatient with the many Aleister Crowley types floating around in capes and top hats, so they accepted the invite.

Back in Matt's apartment on Ridge Street, Ron's bursts of expression were deposited tirelessly at Matt's feet to cull from and spilled from Ron's mouth in an impulsive, excitable torrent. It was a collaboration that would far outlast Ron's marriage in the end.

Inside the small, airless, soundproof room at Matt's, it was hard to contain Ron, whose skinny frame threatened to explode or implode with each word. With his worn-out, men's pointy dress shoes and coxcomb hair, Ron cut quite a figure, swaggering through the Lower East Side like a man who confounds everyone by skipping to the hangman's noose. I moved around in the light with Matt. Ron and Matt prowled in the dark. In that way, I heard about Ron long before I met him.

"Ron and I are playing a gig. It's more like a happening than a show. We're just figuring it out. And I'm hoping, Smitty," Matt threw an arm around my shoulder, "that you might like to play bass for it."

I shifted under his arm.

"Ron's kind of . . . intense, right?" I asked, not so much a question but a way out.

Matt laughed. "Yeah. He's a lot. But it'll just be you and me doing what we always do together. No rules. Just seeing what happens."

I didn't have much else going on other than working part-time for a man whose inherited wealth allowed him to start a business selling strange things he'd invented, like an ill-conceived nose hair waxer. So I showed up on a Wednesday night to a bar called Brownies. The crowd went there to drink, but there was a tiny, low stage in one corner in the back. So if enough people got up to go the bathroom next to it, well, a band might have themselves a crowd. I showed up empty-handed, with twenty minutes of "band practice" under my belt. Matt had already set up his bass and amp for me, so I strolled in casually, sure I'd never do this again. A smattering of Matt and Ron's friends had shown up. No one seemed to know exactly why they were there.

I watched Matt for signals during what could loosely be referred to as "the songs" and stared at the back of Ron's head as he flailed around making theatrical gestures worthy of your weird uncle setting the stage for an inappropriately dangerous magic trick at your tenth birthday party. He crowed into the mic, his throat choked with beetles and cut glass.

"E. A. E." Matt shouted at me over the chaos of the first

song. Twenty minutes in, I saw Ron fly off the front of the low stage and start to shove the small crowd around, wrestling with them, latching onto one, then another. Some laughed nervously, others pushed back, and a few bolted for the other side of the room. Mostly people looked some combination of bemused and excited. Then he threw the mic down, hands held out from his sides like he'd thrown down something dirty and bad, and stumbled into the dressing room.

I looked at Matt, whose mouth was open and smiling. This seemed to be exactly what he hoped would happen. I shrugged and turned off my amp. *That's all, folks.*

Back in the dressing room, Ron mopped his head and neck with a towel, paced with long, bony strides, and laughed. I carefully avoided him, grabbed my bag, and left, sure that what had just happened was a one off. But Matt asked me to join them again. And then again. And each time, I thought it would be my last. What hooked me in was the excitement of not knowing what was going to— or even what was *supposed* to—happen. The story was unwritten.

Every bedtime of my life has filled me with remorse about the dying embers of another day. *Was this one well-lived? What if that was all I get?* I stay awake, gasping and flopping like a fish on the shore. It's that urgency that fuels me most of the time. Playing in what would become Speedball Baby seemed to be grabbing that fear and throttling

it into submission. *This was a moment. Something happened here. Good night.*

We had no real audience. No record label expecting anything from us yet. No prying eyes or outside influences giving us feedback or attempting to package us while we licked the birthing fluids off the newborn calf of our ideas. We just . . . were. And I finally felt like myself onstage. I felt like I had as a teenager in the pit at CBGBs, oddly calm in the eye of the swirling storm.

Ron's biggest inspiration for poetry was revealing itself to be drugs: drug culture, the feeling of doing drugs, the hunt for drugs, the bittersweet tragedy of addiction, and a cry for freedom from drugs laced with a reluctant nostalgia for them. Like an abusive lover you can never really quit. This would be the biggest wedge between us until the end. Always me, an irritating superego, a shrew of a lambasting mother. Always he, a twitchy little id, a tyrannical toddler. Always at odds, turning love and hate over in our hands, again and again, looking at them from every angle.

Down around Matt's, on hot nights, the beat of the Lower East Side was salsa, blaring from boomboxes and through open car windows. Entire apartment buildings emptied out into the streets, where people danced and fanned themselves in the abrasive heat. Some dragged barbecue grills curbside.

Matt started noticing a quiet girl in the crowd—thin, with long, dark hair and large, heavy-lidded eyes, in her

early teens. He called her Ferdinand, like the bull that took no greater pleasure from anything than he did from staring at flowers while the other bulls collided and competed around him.

"Poor lovely," Matt lamented after seeing Ferdinand late the night before. "She seems so lonely."

Midway through the summer, the girl stopped showing up to the stoop while the others carried on.

"Do you think she's pregnant?"

"It'd be divine intervention. I've never even seen her *talk* to anyone."

It was summer's end when the brown-haired girl made her not-so-triumphant return to the neighborhood. Not to the stoop downstairs with the families, but to the blocks Ron sometimes slipped down on his own. Shadowy blocks where lines of people stood in front of abandoned buildings, waiting for a signal from the roof. Streets bursting not with life and music but with furtive glances and sketchy figures skirting along their edges. He'd seen her there. Her long hair lacking luster. Her heavy eyelids almost closed. Her arm looped through the cold, bent arm of a much older man. A man who walked briskly, exuding panic, who dragged her along with him, speaking loudly to no one in particular. A man who never looked straight at her unless he was shouting. He saw her there, staggering in heels, a full-fledged disaster. Betrothed to that man out of desperation. An empty husk.

"Poor little Speedball Baby," Ron said.

That's what Matt and Ron named our experiment. A poetic reference to the defeated, doe-eyed girl, the cause of her downfall and all that had been lost for her. A nod to the death of beauty at the hands of the cold, cold world.

thirteen

It's the stopping of the rocking of the van that wakes me, not the dawn.

The motor shuts off and in the vast emptiness of the desert, the silence seems louder than gunshot.

Bleary eyes adjust slowly to the purple-orange horizon ahead. There are no animals, no houses or cars or people anywhere. Just cracked, bleached earth and bits of shrub valiantly trying to grow out of it. In the silence, the wrenching and scraping of the side door sliding open feels violent.

I step onto the dust in my socks. Ron is already standing outside, arms crossed, staring ahead, his

profile bathed in a soft, hazy light. I follow the sky up and over my head, watching as bands of color melt into each other—orange, then purple, then indigo. Just above me, last night lingers, stretching down to the horizon behind, ending in a black sky, abundant with twinkling pinpoints of light.

I hear Ron's voice.

The moon begins to rise, all yellow and fat, like a Flannery O'Conner moon. I can see it through my one, bloodshot eye.

I'm a lizard scurrying across the face of the earth. A nothing and everything at the same time.

The sun breaks the edge of the world. Our goal is almost in site.

Tonight, we'll play with the Jon Spencer Blues Explosion, friends from New York that we've played and toured with often. Our patron saints from MCA will come marvel at their acquisition on the grand stage of the El Rey Theatre—chandeliers (plural) dangling above, a thousand people in the crowd.

Jon and Ron are not the same creature, even though music press always wants to make them out to be. Jon is conventionally handsome, a withdrawn enigma off stage, a controlled ringleader on, polite and presentable although a quiet troublemaker. At our first show together, he sent their roadie on stage during our set—naked except for a family-sized bag of potato chips taped to his waist—to

dry-hump Ron and Matt and generally make trouble. Ron ripped the bag open with his teeth and sprayed chips everywhere without missing a beat, and when I looked off stage, Jon was crying from laughing. Russell, their drummer, is a trouble-enforcer: tall, confident, topped with wild, bushy hair. And Judah, their guitarist, is a quirky reed blowing in a troubled wind.

But Ron, bless him, is not a practical but an impractical joker who makes practical jokes cower in the corner, confused.

The Subsonics, our friends from Atlanta, will open the show. If Ron is the shady ringleader in a traveling sideshow featuring "Four-Legged Lady" Myrtle Corbin, Isaac Sprague—"The Living Skeleton," and Chang and Eng—world-famous conjoined twins, the Subsonics are the main event in that haphazardly erected tent. And I mean that in the best way. When I'm around them, I try—and fail—to act as uniquely, brilliantly, earnestly odd as they are. Their singer, Clay, is as thin as a pin and as tightly wound as a coiled snake in a ripped party dress. He leans on his mic like it's the only thing holding him up and warbles "I'm in luuuuv with mah knyyyyyyffeee!" Drummer Buffy plays her stripped-down kit standing up in heels, looking strong and cool and as red-hot as a Carolina Reaper; drag-queen glam on a girl. Over the years, we've watched them terrify and seduce this country's most hardened audiences. An LA crowd should love

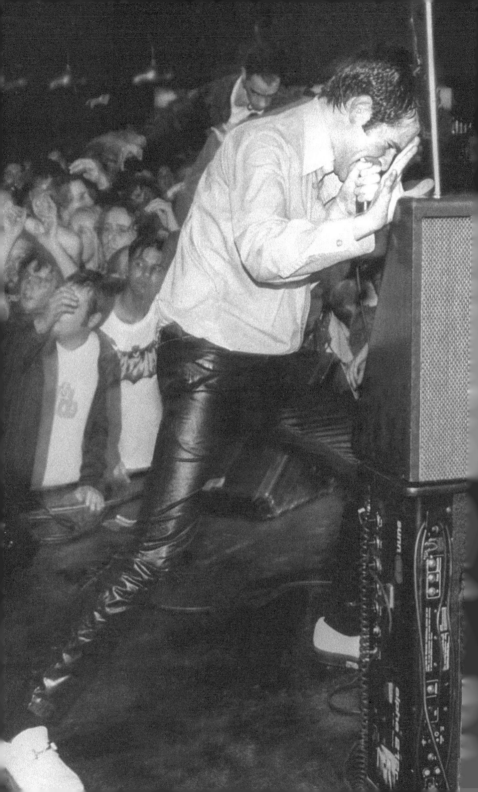

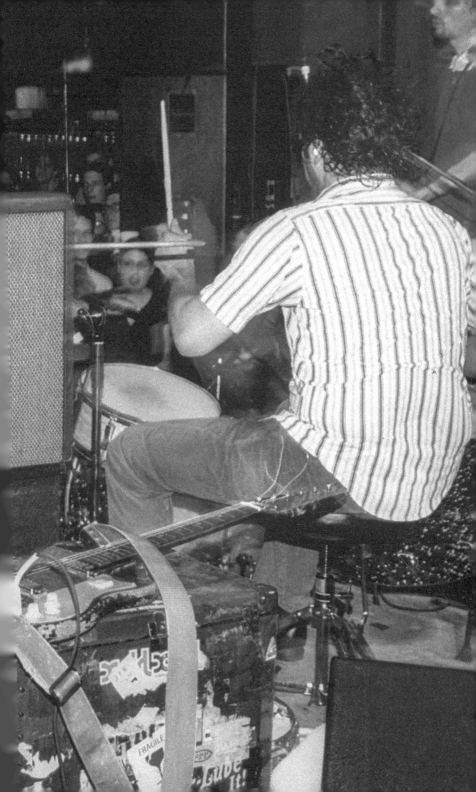

their sparkle and shine, even if it comes coated in a layer of grease.

Before the show, we'll visit the MCA offices and have a little word about the shit promotion for the gigs and the misspellings of our name in the listings.

"You're not sleeping, are you?" Matt nudges me. "Always enter a new town with your eyes wide open."

And there it is, Hollywood Boulevard, where the palm trees are taller than the buildings. Peachy marble stars are pressed into a gray marble sidewalk.

HOLLYWOOD! HOLLYWOOD! HOLLYWOOD!

Hollywood Diner. Hollywood McDonald's. Souvenirs of Hollywood. Hollywood LAPD. The Hollywood/Highland Metro. The Hard Rock Cafe of Hollywood. Rolling into Hollywood is like rolling into a coal mining town in Gilette, Wyoming. All you're gonna see at the counter in Gillette is coal miners. They're both industry towns.

Billboard. Billboard. Billboard.

Ad. Ad. Ad.

There's Grauman's Chinese. There's Madame Tussauds. There's a double-decker bus tour, loudspeaker blasting from the open-top deck where some as-of-yet-unemployed-wanna-be-actor screeches "This way to Elizabeth Taylor's house!" And I think, "Boring."

At the red light, I look down into a red convertible. The two women sitting in it don't just look healthy. They

look like illustrations of healthy people: the golden radiance of their skin is blinding; their tank tops fit perfectly around their perky breasts and reveal flat, tanned stomachs; their nails are long, with bright, un-chipped polish; and soft, long hair floats in the breeze around them in slow motion, in the sole service of emphasizing their camera-ready perfection. Beyond them, a man sits back on the marble sidewalk, his face soaking in the warmth of the sun. He's got his own impressive tan and long, stylish dreadlocks, and it takes a moment to realize he's dressed in rags with an empty coffee cup at his feet. Ignoring him is a well-dressed older woman—with leathery, tanned skin to match his—who looks like a walking cadaver with soccer balls stuffed under her silk shirt and a duck bill pasted onto her face. She, too, is some abstract version of perfection that, while it's not my kind, is impressive in the way that a duck-billed platypus is impressive. Like, "Wow, look at that. That really is some type of thing to see."

There's Los Angeles and there's New York City, and never the twain shall meet. LA is full of color and sun and shiny objects. While the history of movies and entertainment is rich here, it otherwise seems like a town they rapidly built around you as you were driving in. I can hear Steve Martin in the movie *L.A. Story*: "Some of these buildings are over *twenty years old!*" Unless you're talking about the La Brea Tar Pits, it's easy to

believe this is all just a movie set put up for everyone's amusement.

The differences may look superficial, but they run deep.

Up ahead, taller than its surroundings and backlit by a sun flare that makes its art deco metal sign look as magnificent as something that God, Herself, may have placed on its roof just for us: Hollywood Roosevelt Hotel.

Ron bursts through the door of our 1,200-square-foot suite and cases the joint. Martin tosses his bag on the carpet. "Fucking hell, MCA. I forgive you." He heads for the full bar. I race into one of the bedrooms and launch myself onto the overstuffed king-sized bed. "No floor tonight, BABY!!"I spy-roll off the other side, fling open the white, billowing curtains and the window, and holler, "Hello, you ridiculous people! We have arrived!"

There they are. Just beyond the Boulevard and the palm trees and the four-story billboards. The hills. The *Hollywood* Hills.

With a private little apology to my punk rock heroes, I whisper, "That's very cool." Then I sweep around and announce, "I'm going to the pool!"

"Maybe we should figure out what we're gonna say to MCA?" Matt suggests. But I already know what we're gonna say to MCA. We're gonna tell them they're lucky to have us and they'd better shape up and after we blow them away at the show tonight, they'll say we are right and they

are sorry and maybe they'll buy us a bigger van. Or a bus. And they'll spell our damn name right from now on. But for now, *I'm going to the pool!*

It never occurred to me to bring a bathing suit on tour, so now I slink past rows of lounge chairs, cradling perfect bodies in white, thong bikinis, while I'm wearing cutoff jeans shorts, a black tank with visible bra straps, and my Converse sneakers with the little hole that my toe peeks through sometimes. It feels like I might be tackled from behind at any moment by the handsome, out of work actors walking around holding drink trays. "How did that homeless prostitute slip by the front desk?!"

I look down at my legs which look as though I've pulled pasty, white sausage casing over them, and my shoulders slump a bit. Twenty minutes into dangling my feet in the water, I press my fingers into my bright red shoulder and determine it's probably time to leave. As I slink away, I take a moment to look back and think, *You might think I'm nothing now, but that's all changing tonight.*

"Just know," Matt says as he pulls our broken-down, graffitied van into a spot between two Mercedes Benzes, "what we're dealing with." He shuts off the engine. "Which are crooks and idiots."

Just off the elevator upstairs, a wall is plastered with posters boasting MCA bands: New Edition, Sheena Easton,

Al Green, the Hooters, Elton John, Gladys Knight, Lynyrd Skynyrd, Meat Loaf, Alanis Morissette, Olivia Newton-John, Steely Dan, the Who. And there, on top of them all, definitely added that morning with scotch tape by an unpaid intern, is Speedball Baby.

"Hey guys!" A man I can only assume isn't a twelve-year-old boy because he's got a job, runs toward us clutching a clipboard in one hand, other hand poised for a high five that Matt reluctantly indulges him in. His khaki shorts stop below his knees, he's wearing a green Lacrosse shirt, and his shaggy hair is dyed a matching mossy green. This is our publicist. The one we have to thank, I suppose, for the ads listing the wrong show times and dates and the creative misspellings of our name. He walks us through a kitchen, past another wall of band posters that Speedball Baby is conspicuously on the top of, to an office where we wait for his boss with our arms crossed and a sinking feeling.

He stops in the doorway. "Coke?" he chirps. Ron spins around and I nudge him. "He means soda."

There are framed, gold records on the walls, Grammys along a shelf, and another Speedball Baby poster, taped hastily to the wall, which makes me laugh.

"SPEEDBALL BABY!" booms a voice from the door. A midfifties man sweeps in, his pink button-down shirt tucked into flat-front chinos, boat shoes, thick-rimmed glasses, and a deep, bronze tan that makes his teeth look

too white. His thinning hair is golden, brushed back, and worn just long enough to prove he isn't one of the squares. "We are SO EXCITED you're here! WE CAN'T GET ENOUGH OF YOU!"

Each time Matt mentions a problem, the pink button-down shirt looks concerned and learns forward on intertwined fingers. "Uh-huh! Uh-huh! We're gonna get right on that!" the pink shirt nods. "You're one of our favorite acts. That is NOT gonna fly!"

Lunch is by the beach, at a chrome and white-tiled restaurant. Our mossy-haired publicist clutches his clipboard and refers to it as he talks about "big plans." Three young girls with no obvious role to play smile at us and agree that the plans are *very* big, indeed. Everyone

from the label will be at the show tonight. They are all "SUPER EXCITED!"

Ron charms and terrifies them with his stories—his calling in life. Buzzed from a lunchtime pint, I slip outside. The sun is low, golden, and warm on my face. A palm tree waves at me, and I think of the trees in Tompkins Square Park, in my neighborhood back home, which look desperate, like broken arms urgently reaching for each other. Palm trees are like figures dancing on a beach wearing headphones with their eyes closed: solitary, confident, and a little bit weird but free.

Another convertible drives by. The people in it are enraptured with life. I imagine myself a success, paparazzi popping out of the bushes. Like everyone in Hollywood, I'll pretend I hate it. "Come on, you guys." I'll urge, "I'm just a human being!" And as I spin away, I'll let my head linger over my shoulder just long enough for them to get a good shot.

We leave lunch with lots of high fives, back-slaps, and awkward shoulder bumps. We will all "catch each other later" at the show. This night will be amazing. I can feel it.

"Hello, you Goddam gorgeous people, so shiny and clean. I can smell the body lotion from here," Ron barks at the packed room.

A small burst of "Whoops" and "Yeahs!" come from

Ali Smith

our MCA people at the side of the stage. Beyond them, standing as far from us as they can manage, clusters of people continue their conversations, some with their backs to us.

I'm addictive.

Destructive.

I'm addictive.

Yeah!

Ron works the length of the stage, sweating, swaggering, turning himself inside out.

Matt plays so hard he breaks a string on the second song. I leap onto my amp, then jump off it, then move over to Matt to bounce next to him, then contemplate playing from on top of the bass drum.

Nothing we do matters to the crowd. In fact, everything we do seems to make people talk louder. They chatter during songs. Chatter in between songs. They only stop chattering long enough to look disdainfully toward us, annoyed that we're interrupting their damn chattering.

And then it happens. Somebody yells "Shuuuuut uuuuupppp!" from the darkness and I know that look on Ron's face. Things like that don't usually bother him. They usually fire us all up. But dammit. This night is special. Or rather, this night was supposed to be special. But it just sucks. And these people are terrible. And this mission has failed, spectacularly. And Ron is pissed off. And now he's

like a pit bull tugging the end of a frayed rope, back and forth, insult for insult.

Leave it alone, Ron.

Get 'em, Ron.

My mood swings wildly.

The set ends abruptly, and I meander backstage where old mossy-hair and pink shirt and the three chirping girls from lunch, plus a handful of higher-ups, shuffle their feet and avoid direct eye contact with us. The Subsonics opened the show, and Clay shimmies up to me in black vinyl pants, high-heeled boots, and a tight, silver T-shirt. The crowd had, in fact, not taken to their way-out glamour.

"Thay used up thayr apathy on uuus," he drawls, *"n' saved awl thayr animawsity fer euuu."*

The Blues Explosion is on next, and I watch from the side of the stage. Now this is something the crowd can finally get behind—cool but not scary—and the audience is flipping its collective hair and shimmying in designer clothes and rattling their jewelry and I've had enough. I'm not going back into that dressing room to feel embarrassed in front of those morose, long faces, even if that's where the free booze is. Instead, I push through the crowd toward the bar. This would normally be the time of night when people either grab me to shriek "You guys are incredible!" into my face, or part the sea ahead of me because they think I'm a little bit frightening. But this is like mud wrestling with blond hair. They either don't see me, or don't want to see me.

Someone taps me very firmly on the shoulder. I spin around and am suddenly snout-to-snout with a sour, displeased face.

"I just want to tell you," the hole in the face says, "that YOU SUCK!"

Now *that's* a person who thinks everybody gives a shit what he has to say. The blood starts boiling in my feet and shoots up into my head where all the venom is—from the humiliation of the night; from the certainty that MCA no longer cares and will surely sink the record we worked so hard on; that they will not buy us a bigger van and will not fix the misspellings of our name; and that they think, rightly or wrongly, that we are New York City trash, and not the good kind.

"Let me guess," I spit through gritted teeth, "what you did today." I take a step closer to him. "You worked on a thought about an idea for a screenplay that no one will ever see or make."

He blinks at me, highball glass stalled halfway to his mouth.

"And this screenplay, it's about you, isn't it?" I snarl, "It's the story of you and your little spoiled friends." Now I'm storyboarding this thing in the space between us. "And the story is all about the funny little antics you get up to driving around Beverly Hills in your mommy's convertible. Because it's not easy being you, with your little ideas and your money and your convertible. It's just not easy being as important and good at everything as you are." I'm soaring now. "Well, *guess what*?" I seethe into his vitamin D-filled face. "You *paid* to see me tonight, SO WHICH ONE OF US IS THE ASSHOLE NOW?!"

I walk away shaking and wondering whether I'm actually "the asshole now." But also, I feel more alive and real than I have since we rolled up to this sparkling, artificial town. Fuck pearly white teeth and palm trees and homes of the stars and tans and shiny sidewalks you can snort coke off of and clipboards and salads and if this is success, I'm going to have to sharpen my talons for it. Because what I really am is not that. What I really am is a balloon full of mustard gas. Watch out. This girl might explode.

We're heading home now. Back to the grubby streets of the city I know. The ones that have shaped me. Where nobody cares if your teeth are yellow as long as you're the kind of person Mel wanted Ron to be—true, solid, good. And if you can't be good, you can at least have a lot of fun being bad.

part 2

new york city

fourteen

I roll off my mattress and tiptoe to the bathroom to inspect my face in the mirror. Days' worth of black eyeliner has built up, and my tongue is speckled with white dots. I exhale heavily and sit down on the toilet, resting my head—which feels like it's full of wet cotton—on the cool corner of the sink.

My roommate and I were up all night because we live over a bar and between 3 and 6 a.m., things really kick off down there: people shout, the Waylon Jennings music gets turned up to eleven, and everyone sings and stomps along to it like they're in a fucking pathetic urban cowboy movie.

In the middle of the night, I called the cops (who never came) twice, and the bartender (who couldn't give a shit)

four times. Finally, I just stuffed my head inside my pillowcase and fumed, while my roommate did what he always does: plot an as-of-yet unrealized revenge which usually takes the form of dropping cherry bombs down the bar's toilets.

In the kitchen, I'm motionless, staring at the stovetop, waiting, until I hear it: a slight rustle. *It's back.* A month ago, a rat gnawed through the wall behind the stove and decided to live under our burners. While it was back in the wall one night, I stuffed the hole with Brillo pads and wire mesh and shook powdered detergent over the whole contraption. But our rodent squatter just ate through the thing like I'd laid out a buffet for it, and settled back in, rent free.

I'll buy coffee out.

I quietly scoop my camera off the folding card table we "dine" on and slide the strap over my head and across my chest like a bandolier.

It's 11 a.m. and unlike me, Clinton Street is bursting with energy. People shout to each other. A man is talking quickly, trying to get anybody to care that he's selling a watch. "It's real. It's real!" He sticks it between his teeth proving something, I'm not sure what. A woman sits on a plastic, woven lawn chair, fanning herself. A family of five pushes a supermarket cart filled with car parts. There's fresh graffiti on the roll down gate of the pawn shop next door.

In the window of the Santo Domingo Bakery, the same

three-tiered cake—a Barbie doll stuck, knee deep, into its center—has been on display for over a year. The sun, intensified by the window glass, has begun melting Barbie's face into a horrific grimace.

Inside, I order *café con leche*. They don't ask before heaping spoonfuls of sugar into it, and I don't argue. The soft roll I order is toasted on the open grill and oozes butter.

The sky is blue and for the next five hours—before work—the world has no plans for me. I decide to take my camera to the East River.

On Ridge and Rivington, I hold my breath passing the poultry slaughterhouse on the corner. Its security gates, stretching two stories high, are open day and night. Inside, cages full of miserable, scraggly poultry are piled to the roof, creating a little stage set of horror and rot, with a stench that shuts my brain down. I imagine the character "Wrecking Ball" from the Knitters' song inside—the bullet-headed one who takes great pride in stomping "roosters and hens, and all their feathered friends," to a poultry pulp under his boots.

Farther up Ridge Street is where Matt lives. Below that is the corner bodega that smells like bug spray and dead mouse. I can hear Ron's voice in my head: "They keep the little bags of cocaine in there behind the canned peas, and the heroin is under the creamed corn."

After the night my first boyfriend Colton strangled me in our room in Brooklyn, I quickly devised a plan for us to

move in with several boys we knew loosely, members of a band called the Radicts. I figured their presence would keep me safe. They lived near us in a firetrap of a tenement in Bed Stuy, Brooklyn, and I made the argument that we could all afford to move into Manhattan if we chipped in and lived like puppies piled on top of each other. Curt was the guitarist, long, lean, funny, and charmingly trashy. Karl, the bass player, was so good-looking—strong jaw, cheekbones, perfect black pompadour—that the fact he was also incredibly nice made the universe seem a particularly unfair place. Todd, the singer, was short and scowling; like Joe Strummer before him, he believed he would lead the unwashed masses (that's us) through the desert of society's moral corruption, to the promised land of anarchy and punk redemption. And Johnny, despite the dyed black hair, leather jacket and tattoos, was clearly the most upwardly mobile of any of us, having graduated college with an impressive degree—something we were reminded of constantly when student loan debt collectors called the house for him.

My plan to squeeze Colton out of the ranks worked fast. Everyone hated him, which made it easier for me to hate him and to finally kick him out. After which, life immediately exploded into technicolor.

It was Curt, Karl, Todd, and Johnny who took me to a party at Matt's where I met him for the first time.

The bodega I pass now is where we bought a cheap

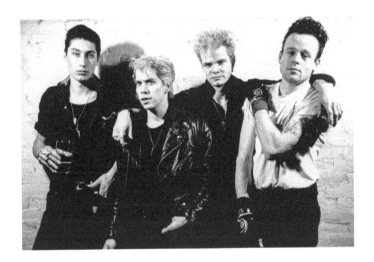

six-pack of Tecate to take that night. I smile—memories of the scene flooding back—and wipe dripping butter off my chin.

———

Matt's apartment was bathed in red light that night, and packed tight with an array of leather and black-jeans-clad night-crawlers, including us. The music blasting was unnerving, thrilling. It sounded like someone had shoved a feral cat down the bell of a saxophone. James Chance and the Contortions, I'd later learn.

Instruments littered the one, big room: a vibraphone, drums, multiple keyboards, and beautiful guitars I would come to know well, which glittered on the walls like faceted jewels. Across from the kitchen sink was a fridge-sized vintage tape machine and a five-foot-long mixing board. Behind that, a window was cut into a wall, and I looked in on the little sound room we now spend our entire lives in for the very first time.

A woman held court in the center of the room: impossibly tall, wearing a furry, turquoise shrug, chunky high heels, and little else. With olive skin, dark, dreamy eyes, black hair in a little ponytail, and plump, red lips, she had the boys flocking around her like hungry gulls. She shimmied and shook to the music, and, once in a while, reached out to touch a fingertip to a lucky admirer's cheek with a smile that seemed to say, "You're welcome!"

Karl introduced me to a handsome man I couldn't help noticing was exactly my height. He had a tiny whisp of a soul patch below lips which were bowed into a small purse that came across as a smile, where most of the boys in the room seemed to scowl. He wore a tatty, ripped T-shirt that read "THIS AIN'T THE SUMMER OF LOVE," pointy, worn leather shoes, and just behind his dark, friendly eyes, I recognized a spark that I had behind mine: a ferocious promise to ourselves to turn this life into something we might be excited to live. This was Matt and I was drawn to him immediately.

"Who's that?" I gestured to the gorgeous woman in the turquoise shrug, with a blend of awe and curiosity.

"Ah!" Matt touched my shoulder. "I'll be right back." And he slid over behind the girl and kissed her gently on the back of her neck.

Karl leaned in toward me. "That's Ashley."

Ashley was Matt's girlfriend—half Cherokee on her daddy's side, raised on a farm in Norman, Oklahoma, where she liked to pull fat earthworms out of the dirt with her red-painted nails. She had, I'd discover, a strict zero tolerance policy for all things she hated—boredom, bragging, too much talking—and an unwavering devotion to the things she loved—cats, dancing, going to shows, making (really good) art, and Matt. Still, devotion didn't mean she couldn't enjoy soaking up all the available attention in the room, and so she did. Which Matt didn't mind at all.

It wasn't long before Matt and Ashley were inviting us

over for regular brunches and more parties, and Matt was shoving beautiful instruments into my hands.

"But I don't play anything. Not *really*."

He said then what he always says now: "NO RULES, Al! No rules."

Matt and I quickly became inseparable. There was just an alchemy about us. A deep and instant understanding. A shared, bonkers sense of humor. A bigger meaning behind having met.

"You're the sister Matt always needed," Ashley later told me. Everything she said, she said as stone-cold fact.

——

The putrid, acid tang of blood-soaked pavement outside the slaughterhouse slaps me back into the moment and I gag, tossing the rest of my roll into a garbage can.

At the next corner, the Koolman Ice Cream truck slowly rolls by, its siren song a warped serenade for certain locals. It's an open secret that the driver deals cocaine and heroin out the side window. Everyone knows that. Except, that is, for the sweating, sugar-starved kids chasing it down, desperate for a lick of the nonexistent soft serve in the back. The only thing sadder than watching that truck *not* stop for them is watching when it does.

A man arranges fruit outside the Mini Market on Pitt Street.

The methodical, hypnotic, metal-on-metal chug from the train crossing the Williamsburg Bridge above comes in rounds of two. The word that comes to mind for the sound is "Chachoo. Chachoo. Chachoo."

A grown man swerves around me on a child's bike with a silver banana seat and high handlebars.

Paper bags and used food containers blow around my feet.

A patrol car rolls slowly, going the wrong way down Delancey Street.

Garbage bags are piled high everywhere, broken open, spilling rice and milk onto the streets.

Passing under the bridge, I move quickly, alert. It's dark and filthy. A few bodies twitch under blankets on

the ground. The carcass of a pigeon with a fork in it. Once I'm across the highway, the river butts up against a shore made of broken rocks, collapsed piers, and rubble from old buildings.

I step onto a plank of wood that bridges two large rocks over the water, wobbling, then steadying myself. The Brooklyn skyline across the East River is low and feels like it exists hundreds of miles away from the bustling island of Manhattan that I'm just clinging, like an ant, to the edge of. Eddies curl below my feet, rainbow colored, iridescent oils twisting on their surfaces. The effect is hypnotic, compelling, drawing me in.

This city. It's all I've ever known. I can travel, but I'll never wrench it out of my insides. It's broken and jagged and frightening. It's merciless and cranky. The abrasive noises, the random, desperate cries. "THEY KILLED JOHNNY!" That was one of them. A man waving a bloodied shirt in front of himself to prove it. And I just marveled as I walked by him. I can dance this dance all day long and on into the night. I know the rhythm and the rhymes. I'm magnetized to the madness of the city like I am to music. Like I am to Matt. But occasionally—teetering, not so sure-footed, unsteady—I wonder whether it will turn on me, suddenly, and swallow me whole.

The eddies swirl. My eyes lead me down to the water.

"It's springtime," a croaky voice startles me, and I turn, careful not to fall.

A white-haired man grips a homemade fishing pole in one hand—just a string on a stick tied around some sort of hunk of meat. His hair is wild, thick, long, and pushed back off his face. He's shirtless, wearing cutoff jeans shorts and no shoes. His features look Polish or Hungarian, and the squint he holds against the strong sun ages his large, impressive face. He might be sixty or eighty, but his chest and arms are strong. In his free hand, he delicately holds the smallest butt end of a hand-rolled cigarette between indelicate middle and pointer fingers, and when he drags on it, the lines around his lips fit perfectly together into a familiar, puckered pattern. Around his neck, he wears a single strand of white pearls.

"Springtime's when the bodies show up," he finishes his thought.

I nod, trying not to look as nervous as I feel, and carefully step off the plank. "Uh-huh. Which bodies, exactly?"

"Whichever ones get dumped in the river upstate," he counters, as casually as if he were giving directions. When he sits down at a comfortable distance from me on the edge of the rocky shoreline, I relax a bit.

"In the winter, they go down." He uses his cigarette-holding hand in a motion like a failed rocket launch; first up, then arching down. "Stick a few rocks in the pockets, whatever. They go to the bottom."

"Uh, huh." I grip my camera tightly.

"They lay there a while, decomposing." He whips the

fishing pole back and sends the meat-string into the river. "Then in the spring, the gas inside expands, makes 'em float, and they come right up—POP!" His thumb jerks up like a desperate hitchhiker. He considers the end of his fishing line thoughtfully. "Then they float on down here, and the cops pluck 'em out."

"Huh." It's all I can think to offer as my eyes scan the murky water.

He takes a drag off his cigarette, which has burned right down to the edge of his yellowed, calloused fingertips now, and lethargically casts his line again into the water. The meat hunk slaps the surface before slowly sinking.

"That's why I stopped swimming in here," he adds. "That and the water rats." Now he looks directly at me and laughs a short, sharp bark.

I swallow hard, look at him squarely and say the only thing I can think of. "Can I take your picture?"

"Ha!" he snorts, smoke puffing out from some inner furnace. "Whatever you want, little lady."

fifteen

At 4 p.m., I'm behind the bar at the Reggae Lounge. The irony of trying to clean a filthy bar with an equally filthy bar rag is not lost on me. A day shift at a bar like this is basically just a great opportunity to sit and think about other jobs you'd rather have, because it's definitely not a way to make money.

I dig around in my backpack for my journal, sitting on a high stool behind the bar, feet on the lower rung to avoid the rats that pass through here like it's the FDR. I write:

> Shit Jobs I have had:
> 1. Hospital Cafeteria: Now that was a shit job. Not just because of the tragic hair net and blue smock and

gloves, or the unrecognizable food I had to place on each tray before it got sucked into a hole in the wall and sent, I assumed, to delivery carts that rolled the trays to the rooms. But more so because of the number of times I had to scrape puke off the trays when they came back.

2. Answering phones from 8 p.m. to 4 a.m. at a nightclub called the World. My office chair was a velvet couch, placed directly across from a satin-sheeted bed. All night long, club kids stumbled in, high and sloppy, and a photographer, who humbly called himself "a global phenomenon," took pictures of them—ones I imagine they will someday regret—on that bed. A formidable, treacherous hole opened up in the back staircase that led up to my "office" at some point. The police and fire marshals showed up, stern faced and authoritative, around midnight one evening. By the time they left the manager's office a half hour later, they were smiling, laughing, and patting each other on the back. And the hole in the staircase was repaired, but several days later, with a stunning lack of urgency. My job was to pick up the phone when it rang and answer, "Hello. This is the World."

And wasn't it just.

"Littel sistah. Two." A drink request snaps me back. He holds up two fingers in a V-shape and I uncap two cold bottles of Red Stripe and slide them over. The room is almost empty. The only customer, besides this guy and his friend,

is an old man talking to himself at the end of my bar. My shift pay is $20. Everything else is tips. I wonder why they bother opening this early as I give some glasses a quick dunk in the sink. You plunge the glass down on the built in scrub brush and the remains of everyone's drinks go in with it. You give the glass one or two pumps and then let it drip dry on the metal corrugated sink top. Once in a while, you run a little fresh water into the sink to spruce up the supply.

3. *Strawberry picker: When Colton and I were flat broke—like, steamroller flat—living on our own and failing to pay the rent on time every single month, a Greyhound bus dropped us off in front of the Hendrix Motel in Roscoe, New York. That sounds cool, right? Hendrix Motel. Wrong. For $175 a week, we got a bed so narrow we had to both sleep sideways on it in order to fit. There was an empty fridge we couldn't afford to fill, and a stove tucked in so close to the door you had to make sure the other person wasn't heating up their gravy fries in it when you came in lest you might rocket them into the oven's gaping maw, Hansel and Gretel style.*

The plan was we'd stay for a month, earning $5 an hour, picking strawberries on a farm six days a week. We could taste the riches.

We were warned. "The truck pulls up at five-thirty in

the morning. It honks once. Be ready for it. There won't be
a second honk."

My God, we were unprepared for the reality of field
labor under a midday sun. I remember that first morning:
bounding out the front door, a plastic wrapped, gas-station
blueberry muffin in hand, wearing a tank top, tight black
jeans, and Doc Marten boots. Colton flew down behind
me in a T-shirt with an army jacket, black jeans, boots,
and nothing covering his freshly shaven head. There were
already six people in the flatbed of the open truck. Each
had a leathery, weathered face. Each was a man. They all
crouched—some with heads hanging down in crossed arms,
others leaning back just staring. Each wore a wide-brimmed
hat and a long-sleeved shirt. Desperate to bond, I clambered

in enthusiastically, smiling and offering small waves and timid good mornings that came across like an office worker saying, "Mondays, am I right?!"

The workday, it soon became clear, was to be spent crawling slowly down row after row of stubby plants, plucking sometimes fat but more often, withered and puny strawberries out from among the leaves. I worked bent over, scurrying along like a crab, growing increasingly slower. By nine a.m., my back was screaming with pain, my jeans were soaked through, plastered to my legs, and the back of my neck was bright red and hurt to the touch. The repetitive act of picking, combined with the heat, overwhelmed me, and by ten, I was hiding in the shade of a tree to recover. I scanned the field for Colton and finally saw him, halfway down a row, lethargically eating berries from his basket, his shaved head starting to blister under the brutal sun.

We fell comically behind the others and our baskets were never as full as theirs.

Day one. Day two. Day three, even. Until, sun-poisoned, blistered, and sheepish, on the fourth day, we ignored the first honk. As promised, there was never a second one.

A woman and a man have come in. They haven't ordered anything; just arguing in the corner. It's 5:30 p.m. I've made four dollars in tips.

The door swings open so hard it hits the wall behind

it and Liam stumbles through. I've seen him around a lot. He's hulking and tattooed and gets into fights with strangers all the time because he's consistently drunk and persistently miserable. His expression now looks like it always does—as though he might burst into tears and punch himself in the face if there's no one else nearby to hit. I don't feel particularly threatened, just pre-emptively exhausted by his visit. I nod and smile—which feels like my main purpose here.

Halfway through his third Jack and Coke, he leans forward and asks for a kiss. He does it with the jangled nerves of a teenager at a school dance, which both repulses me and breaks my heart.

"No, Liam." I shake my head. "I know your girlfriend and she's really nice."

His eyes are wet as he stares into his glass. "See. That's so nice of you." His throat clenches. "THAT'S WHY I WANT A KISS!" He howls.

It's 7:15 p.m. I've made seven dollars in tips.

At eight o'clock, it's finally time to get paid, if you can call it that. This is my least favorite part of the whole experience.

A very narrow, very dark staircase leads down to the boss's office. At the top of it, every instinct tells me to turn and run. It's not that I don't like my boss. He's ok. He's direct and polite with me, doesn't look at my boobs when we talk, doesn't stand too close. It's just that his arms and neck are riddled with keloids from multiple bullet

wounds. So while he's ok, I wouldn't necessarily call him a "nice guy."

The desk in his office is covered in stacks of cash. There's a second guy in there. I don't know what he does except for stand behind my boss with his arms crossed. The whole thing makes me want to bolt.

"OK, that's it for me," I chirp.

He looks up as though he forgot I was even working and I wonder, again, why they bother with a day shift.

"All right." He peels a twenty off the top of a pile. The guy with his arms crossed stares at me. I slide the bill into my jeans pocket, smile and back out.

I can't wait to add this job to my list of shit jobs I have had . . . but no longer have.

It always feels like I'm one wrong career decision away from wearing a sandwich board for a living. Which is then one, small step away from wearing a barrel with suspenders for clothes.

Out on the street, the evening is hot and it's loud. I head down to Matt's place, past Ludlow and Rivington. I peer into a packed bar that used to be an empty store front and every time I pass it, I laugh to myself about the time I was almost murdered by Hare Krishnas here. "Krishna-skins" technically (yes, it's a thing). I don't know why skinheads started becoming Hare Krishnas in New York. Maybe it was the hairdos. But somehow it happened. One of the heads of this movement was in a hyper-violent New York

hardcore band whose name I'll leave out to protect the innocent. (That's me. I'm the innocent.)

A quasi-friend that I was nice to mostly in the hopes she wouldn't beat me up—violence being her favorite pastime—told me at a bar one night "You have to come to a Krishna meeting!" Which sounded more like a command than a suggestion, so I went and sat cross-legged in this very storefront in the middle of the afternoon surrounded by people I knew better than to look in the eye. It seemed as though lots of people who liked to beat people up had gathered tightly together in this very small space. To be fair, everyone acted nicely and seemed at peace for once. The small crowd hung on every word of the leader's speech, which appeared to advocate for a balanced blend of peace, love, and violence—or maybe that's just how my nervous, hyper-vigilant mind put it together. The meeting was wrapping up and I felt I'd come through unscathed when a large, communal pot of soup started being passed around with bowls and spoons. I'd gotten it into my head somehow—maybe it was some "Scared Straight" type afterschool special—that *that's how they getcha.* That's how a cult makes you join up. They put something in the food that turns a normally discerning mind into mush. And so, when the soup got to me, I politely declined, which was the wrong thing to do. All eyes were suddenly on me, and the muttering began. I must have broken an unwritten rule about hospitality or camaraderie or, maybe, how to get

the mind-mushing meds into a new person. All I know is that after sitting through what felt like five years of intense scrutiny, I slowly stood up, making myself as reed-thin and inconsequential as possible, and gingerly pecked my way out through the doorframe (there was no front door). Until I got to Houston Street, I was sure I'd turn around at any moment to find a line of skinheads running after me, fists in the air, yelling "HARE KRISHNA, YOU MOTHERFUCKER!!!"

Outside Matt's building, someone's pulled a Bar-B-Que grill onto the sidewalk and is roasting chicken and sweet corn. People are dancing. Little kids kick a ball into a goal marked by two garbage cans. One chases the ball outside of the pooled light from the streetlamp above, and a chorus of adult voices rings out to bring him back.

Upstairs, Matt puts on a record. "Listen. Hear that little sound. Ding. Ding. Ding. So cool, right?" Matt can get lost inside of any sound he likes—on instructional math records from the 1950s, or a recording in Swahili.

When he was little, Matt's dad moved the family to Istanbul where Matt became enchanted by the echoing, haunting sound of the call to prayer that rang out through loudspeakers five times a day. It's the sounds nobody else notices that compel him to pick up the record needle and drop it, over and over, on a part he likes, making a little sampled loop to revel in.

On nights like these, we usually listen to records for hours before falling asleep on the couch in front of *Zentropa* or *The Simpsons*. When we wake up, we head out to a

show or for margaritas. Then we come back here—with a group or alone—and play music and record until we can't keep our eyes open.

Since they broke up, Ashley's presence hangs over the place like a benevolent specter. There are splatters of paint on the walls and glitter on the bathroom floor. For me, her absence is like her presence: ethereal yet rooted, and evident in the tactile nature of everything. For Matt, she's left a trail of tangible, bittersweet fondness in her wake.

But we're playing CBGB's this weekend with the Jon Spencer Blues Explosion, so tonight is the night I privately dread the most. Tonight is the night we poster.

sixteen

Matt's alarm is very unwelcome when it rings at 2 a.m. Martin is there by 2:30. Somehow Ron has managed to squirrel his way out of this tonight. I wish I had. But I know that whenever one of us does, the rest of us secretly hate them for it. So here I am, privately dreading what's to come and I have the advantage of getting to act self-righteous for not begging out.

We leave the house with a large bristle brush, a roll of silk-screened posters, and a ten-gallon bucket of wheat paste. At Avenue A and Houston, we find a residential building with a good, virgin front. Matt uses the brush to cover it in paste, and I quickly smooth a poster on top. Matt covers the poster with more paste while insisting we take

over the whole wall to make an impression. This always make me nervous as it requires dawdling around in one spot while Martin holds the bucket and watches out for cops. We work our way up Avenue A that way until a patrol car races past us, up Third Street, going in the wrong direction and we instinctively branch off. Matt bolts toward Avenue B with the brush, I head uptown with the posters, and Martin casually strolls downtown with a cigarette and the bucket. This is the game of cat-and-mouse every band plays with the police. It's not clear what the rules are.

But playing the game makes it easier for us and for the police, who don't really care all that much and can't, unless they need to meet a quota, be bothered to write out a report for something so boring.

The true fuckery of that game is that we get to play it largely because we're white kids. I've gotten away with so much with the police—flipped them off, yelled at them, even chased one down in a yellow cab to yell at him *inside* his precinct when he wrongfully arrested Colton. And, to be clear, I was right, every single time. But I often forget that I get away with it mostly because of an accident of birth.

By four a.m., the forty blocks—from Avenue A to Third Avenue and from Houston to Fourteenth Street—are overwhelmed by our beautiful, pink-and-blue silk-screened posters. Come Saturday night, 10 p.m., CBGB's is packed, bow to stern. The crowd wraps around the stage from

behind and is thick all the way past the long bar to those swinging doors at the front.

The Blues Explosion is a great band and when we play together, we egg each other on in a light-heartedly vicious snatch for the crown. At midnight we're on stage, and it's instantly chaos. The CBGBs stage, for all the glory of who's played on it, is a really bare-bones affair. Almost like one you'd build in your garage out of wood stolen from a nearby construction site.

The walls, ceiling, and stage are covered with band stickers, graffiti and posters, layer on layer, decades old. There's no forgetting the history of the place because you're surrounded by it, standing on it, breathing it in with the thick dust. The low ceiling over the stage is a snarled web of wires and old, gelled stage lights covered with what looks like brown fur but is dirt. There are two enormous speakers used as monitors for the band, hanging from the ceiling from heavy industrial chains and hooks. The insides of those are covered with stickers too, but it doesn't muffle the noise which is as loud as an air raid siren at full blast in your one ear. Which ear will lose its hearing first depends on which side of the stage you stand on most. The other ear struggles to hear the rest of the band and the singer, who sometimes can, but more often can't, be heard through the smaller monitors that are easy to fall over on the floor at the front of the stage.

When Colton and I first came here for the hardcore matinees, those monitors were always being kicked off the stage by a passing boot during a stage dive or flung as weapons.

There are always about twenty mic stands—most of them broken—lingering around the stage. Some are "boom" mics: two-part, bent ones for guitarists. Others are straight ones with heavy weighted bases for singers. Ron likes to swing those ones around, which is why I still have a hole in my left shin.

Anybody daring to use the disgusting bathrooms must walk close to the band, past the stage to get to the nightmare downstairs. So when you're playing, either people are surrounding you—even sitting on the weird shelf behind the drummer—and it feels almost sexual, or else you're knocking yourself out to impress on stage, and when someone walks urgently past, you understand that you're kind of just in their way when they need to pee. It can be very humbling.

Tonight, the crowd surrounds us. The more daring are pressed against the stage, so when Ron jumps into the crowd or falls into the crowd or steps on the heads of the crowd, they dip and weave with him. The whole place surges and undulates like a wave. The hanging speaker is splitting my left eardrum open, and a constant, high-pitched squeal comes from the front monitor, almost as loud as Ron's vocals. You'd think after something like forty years of being a world-famous venue that helped launch the careers of countless legends—the Ramones, Blondie, the Patti Smith Group—they could get the sound right on this stage. But maybe they try harder for some than for others.

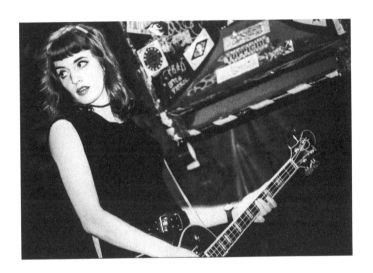

Martin and I take our cues to stop/start/change from Matt who watches Ron intensely. Ron swings the mic stand behind him and I narrowly escape the base. Then he holds it over his head before slamming it down onto the stage, snapping the shaft off the base like a brittle twig. He throws that to the side and snatches Matt's boom stand away from him in the middle of his backing vocals. He wrestles with the two-part, collapsible thing, and the mic cord which is entangled in both the stand he's now using *and* the one he's broken and thrown to the side. Fed up, he eventually pulls the mic off the top of the broken stand and hurls the second stand aside too. The whole tangled contraption collapses into a heap. The mic cord is still entangled, though. So as he's jerking around, doing the St. Vitus' dance, a pile of broken mic stands violently jerks with him, like a clumsy puppet show. But he pulls all of this off with swagger, style, and a definite, albeit destructive, sort of grace. This is exactly why Ron has been choked, sincerely and with great gusto, on stage during a song before by a soundman. But he means every step— and misstep, he ever makes—and I just think that's a certain kind of beautiful.

The crowd loves it. Predictably, the soundman, less so.

"Last song," he shouts through the monitor. WHAT? *We're, like, five songs in.* We ignore him, launching seamlessly into "Rubber Connection" at the end of "Pocket Fulla Fish."

"All right, that's it!" comes a stern warning when that one ends.

Ron presses into the crowd and crows "They want us to stop, but we don't wanna stop!" The crowd roars and claps in approval and we start "Fucked Up Town." But half a verse in, everything sounds weird. All I hear is Martin's drums, the dull plunk plunk plunk of my bass, and a tinny jangling coming from Matt's guitar. The power to all our equipment has been shut off. Then the stage lights snap off. But let me tell you, we don't miss a note. Ron climbs onto the closest monitor and, grabbing peoples' shoulders in the crowd to steady, himself, shouts into the room.

here comes the man i can see it in his eyes

And a couple of hundred voices shout the words along with him. And a few hundred feet stomp in time to Martin's drums. And it's magic.

my eyes into hers . . .

hers into his . . .

his into mine . . .

He pauses.

I'm gonna tell you . . . it's a fucked up—

And on the word "town" a Molotov cocktail explodes. The sound man must have given up, and with the flick of a switch, the stage lights and amps come to life and it feels like we've won a war. It feels like nurses and soldiers should be (consensually) kissing in

the streets. It feels incredible. Not just for me, but for everyone.

Except the sound man.

I look at Matt and laugh. This is my life with Matt. No rules. No limitations. No fear.

Matt is freedom.

Matt is life.

seventeen

Matt's mom dies on a Tuesday. By Friday, she's in the same state of disrepair—dust and ash of bone—that we're all headed for, and Matt and I are boarding the Staten Island Ferry at midday.

In among the khaki shorts, pastel shirts, and binoculars hanging around the necks of tourists, we stride together: Matt in a suit, looking like Marcello Mastroianni in *La Dolce Vita*; me, wearing a black mini dress with a high collar and long sleeves.

Halfway across the New York Harbor, we step out onto the deck, where I take a photo of Matt as he gently tips a small, white envelope over the side and the husk of his

mom is carried on the breeze, to settle, like silver dust, on top of the shimmering, blue water.

Matt's mom was difficult. Maybe in a way common to lots of smart, talented women when they suddenly find themselves defined only as "somebody's mom." But Matt said it was more than that. The chemical soup in her brain made happiness an impossibility.

My mom had that chemical soup. Lots of moms seem to. Considering what the world demands of them, it's harder to believe any of them don't.

After my parents' divorce, when she and I lived on our own, I'd let myself in to an empty apartment after school during my mom's long hospital shifts. When she finally got home, she'd let her purse fall down her arm to the floor and kick her white nurse's shoes off to the side, desperate, I'm sure, for some peace. But I'd beg her; to play, to read, to dance with me. As she foggily mounted her defense, I'd run to put on my favorite of her records—*The Pennsylvania Polka!*—and seeing the smile on my face, she'd reluctantly push herself to her feet. We'd face each other, hands on each other's shoulders, until the first few overly enthusiastic moans of the accordion began and we were off. Right. Right. Left. Left. Hop. Hop. Tilt. Tilt. Our knees crashed together, I pulled left when I should've pulled right, and we laughed and shouted, "Ouch!" and "No! No! This way!" And at the end of the song, she'd fall back onto the couch, panting, and I'd fall on my back on the floor, watching the

ceiling spin in a way that only kids like because later in life it makes you so sick you want to die.

I'd sit next to her recliner and polish her white, nursing shoes; sexless things, built for uniformity and sterility. I loved the sweet chemical smell of the Sani-White shoe polish with the drawing of a happy nurse on its blue box. I'd turn the glass bottle over a cotton ball and fill it to capacity with the stuff before spreading it over her shoes and buffing them, proudly, to something like a streaky, white-gray. My arms and hands were caked with polish by the time I'd finish and place them next to her. When she looked down during the commercial break of *The Carol Burnett Show*, she'd smile, and it made me feel I could be useful to her. I could make her happy.

We sat in front of the TV a lot. It was the 1970s. I'm not sure what else we were meant to be doing. *Love, American Style* and *The Love Boat* taught me healthy things about relationships. Like "Never trust your husband when there's another woman around." Once a year, we'd watch a parade of sadness and bulimia called *The Miss America Pageant* when we'd bet on girls like we were at the track. "NEW JERSEY FOR THE WIN!" Then the poor girl would stumble out like a newborn fawn to discover she couldn't answer a political question while wearing a bikini and platform heels. And just when it seemed it was all over for her, she would hula-hoop while singing "The Star-Spangled Banner," and she'd win the hearts of the crowd back.

And we'd laugh and we'd laugh. Laughing was our favorite thing to do together. It was times like those—watching TV and laughing—that I saw her. Dimensional. Real. Not crying but smiling with all her beautiful, white teeth exposed and her short, dark hair pushed off her face, and her olive skin, soft and inviting. And I loved her so much. Then she'd pull the warm laundry out of the dryer and gently bury me underneath it as I curled, like a cat, on the couch. There has never been anything, ever, more comforting than that.

All those years my mom existed before me, without me. She left her hometown, lived as a young, single woman in New York City, started a career and earned her own money, met a man and, whether or not she meant to, had a baby. She would never be taken care of, never be treated like a prize by her husband. I'm not sure she would have even accepted that. I wonder how she views younger women— how she views me. How it might feel for her to be a brave, thinking woman looking across a divide at possibilities and freedoms she just missed out on because the calendar grinds brutally slowly for people who know they've been wronged and deserve more. I wonder if that leaves a stain.

Who knows how Matt's mom felt following her husband's career to Istanbul. She took photos of her young sons riding on spitting camels. She held tight to their record collection—full of anti-establishment folk heroes— even after it made them a target of unwanted attention from local authorities suspicious of Westerners' rebellion.

And she never forgave Dylan for going electric. She rolled back the rug and danced on her own in their sparse apartment to those anti-establishment records, and now she's dead from cancer before reaching seventy.

Matt and I both know what it is to love a mother who can't quite love herself and who snaps at the world like a cornered animal. We know how to twist ourselves into pretzel shapes so that people—so that *they*—might be happier. And we know what it feels like to fail at that. We know about the buckshot that that failure fires into you and the holes that it leaves. And we know, instinctively, how to fill those holes in each other.

Back on shore, we find a quiet area where the rocks meet the water next to a broken pier. In our fancy clothes, we clamber down over them. I trip and scrape my knee. Matt reaches out and takes my hand. Out of a handkerchief from his pocket, some found driftwood and a stick, we build something like a child's toy sailboat. We place the remaining ashes into a dip in the boat's center and Matt gets on his hands and knees and gently pushes it out into the water. It bobs precariously on some small ripples that are lapping the edges of the rocks, but eventually makes it past, upright. I wrap my arms around Matt's waist and lay my head on his shoulder and we watch as our little Viking funeral ship drifts out of sight.

"She was loved," I say. "I hope she knows she was loved."

eighteen

This is what I have to say about myself as a waitress. If you do NOT want me to stick your two-hundred-dollar bottle of Merlot between my knees in order to wrench only *most* of the cork out of it before pouring some of it into your glass but also quite a lot of it onto your white tablecloth, that's something you're going to have to clarify for me ahead of time. It's all about expectations. Something I found out about myself the hard way is that I belong behind a dive bar, and not, in any way, working the celebrity-filled opening night of a fancy restaurant. But the Reggae Lounge was pointless, so here I am, again on a day shift, at an Irish bar called Sophie's. It's dark

and cool inside and there are knife nicks in the surface of the wood bar which smells sour. That feels familiar and comforting.

A mug of draft costs a dollar. If a junkie passes out in the bathroom or makes my life hell at the bar, one of the regulars—usually soft-spoken Bruce, a former Hell's Angel—gently escorts them out by the neck, like an efficient maître d'. "You shouldn't have to deal with this," he'll smile at me from under his bushy mustache, his thinning, long, brown hair covering his shoulders.

Mitch shows up every day between 2:30 and 3:00. He's around seventy, gentle and quiet and he blows me kisses when he catches my eye. "How ya, doing, sweetie pie?" Mitch drinks McSorley's light.

At first, I imagined Jimmy Tokens got his name in the mob. Like his calling card was when he whacked a guy, he placed subway tokens on their eyes. But no, Jimmy works in the booth at the F Train's Second Avenue stop. Selling tokens. He's Mitch's age, but with black-framed 'Buddy Holly glasses' and a long cigarette holder, he gives me a bit of a Hunter Thompson vibe—not soft like Mitch, but hard-edged and sharp. Jimmy Tokens drinks a shot of vodka with a Budweiser chaser.

Charlie wears a Russian fur hat—a ushanka—and rarely talks to anybody. The guys make fun of him about it, but only gently because I think he stopped talking when his wife died. He stares ahead ignoring them all, slowly

sipping Jim Beam on the rocks, tonguing his loose dentures free, and rolling them around in his mouth.

But my favorite is DJ, which stands for "Degenerate John." He shouldn't be my favorite because he's a pig. He comments on my legs and if I bend over for something, forget it! But he's also under five feet tall, and in spite of himself, he's kind-hearted. He was much taller once, but a mail truck backed up into him, smashed him into a loading dock, and broke his back, leaving him L-shaped and needing a cane to walk. His flirtations and kisses from the end of the bar feel like soft ball attempts to feel vital again. To feel like a full person. DJ drinks Jack on the rocks and a mug of McSorley's light.

There's Little Jimmy, Donald, and Caveman too, plus a cast of revolving extras.

Charlie to Jimmy Tokens: "What are you, taking a bus ride again?"

Jimmy to Charlie: "Yeah. Why? You writin' a book? Skip that chapter!"

Charlie to Jimmy: "No. I wanna drive the bus . . . OFF A CLIFF!"

The bar phone rings.

Jimmy Tokens to me: "If that's my wife, tell her I'm not here."

DJ to Jimmy: "What makes you think she's calling for *you*?"

And so on, and so on, for an eight-hour shift. More like babysitting than bartending, but never boring.

The trickling in of their coins—nickels, quarters—adds up and I make decent money. My main service is to talk with them. The problem is the NYU students that start to roll in around seven. They're tactless and rude and they don't tip. But worst of all is what happens to my regulars. These men who, all day long, have been joking and laughing and arguing and yelling and coming to mild, drunken blows. I watch as each of them disappears. As twenty-year-olds push past them like they're furniture. As they lean into them, subtly bullying them for their barstools. I watch for an hour until, one by one, my day regulars give up, slide off their chairs unceremoniously, and stumble home. Tomorrow it will start again. Tomorrow they will all be lions

again and they will roar. But by 8 p.m., they're all ghosts.

Soon after the disastrous LA showcase we played with the Blues Explosion, MCA dissolved its relationship with Fort Apache—having not discovered Nirvana through it, literally or figuratively—and a roster of cool, interesting bands were dropped, including us.

But we've actually continued to tour a lot, just back on a smaller scale. And this job lets me leave when I have to. Plus we've done what a lot of bands don't and I'm proud of it. We survived the death of our major label deal without in-fighting, without (additional) overdoses, without blaming each other. Maybe that's because we never really thought the deal made any sense in the first place. In some ways, we just sort of rolled over it, checking, in the rearview mirror, to see whether the stink meant we'd just run over a skunk. And we did get a tiny payday. We'd signed a two-album deal with them and felt we were owed something. Their response was a very condescending "We think you've done pretty well already for a band like yours." To which the lawyer Matt hired responded with the legal equivalent of "*Oh hellllll no!*" and we walked away with a modest but very helpful settlement. So in the end, I do feel like we went in as outsiders, robbed the joint, and left victorious. Which tempers my genuine disappointment I'll never play on *Saturday Night Live* for my mom to see.

If any local bands feel triumphant about our being dropped, they haven't said anything about it to me. I had

one bitchy exchange, but that was with a guy who's always bitchy anyway.

"I heard you lost the deal with MCA."

"Yeah, but we're fine. The whole thing was kind of a crap shoot anyway."

"I mean, Matt's filthy rich," he countered, snidely, "he'll be fine, I'm sure!"

I winced. "Matt's not filthy rich!" To be filthy rich in our scene is a dirty secret. An ultimate betrayal of the proletariat. To be plain, it's very uncool.

"Oh come on," he'd scoffed. "How do you think he built his studio? Why do you think he doesn't work? How does he have all that vintage gear? How can you afford to tour without a label?" The accusations, masquerading as fact, came like machine gun fire. And the rub of it was I know how he's afforded those things and it wasn't by growing up as a trust fund kid. But it isn't my secret to tell, and I'm hazy on the details anyway.

This is what I know.

Matt went to an uber-liberal college, Oberlin, where he received a first-rate education in how—but more importantly, why—the patriarchy is a thing that deserves smashing. There, he fell in love with playing guitar and visual arts and burrowed deeply into both; like a child, elbow deep in candy.

After graduation, Matt and a distractingly handsome classmate, Jasper, got what can only be described as the

1980s version of the best job in the world.

A man named Rupert Smith started as Andy Warhol's assistant and became head of the Tribeca warehouse— separate from the notorious Factory—where most of Warhol's silk screens were produced. Matt likes to say that some of the people—like Jasper—were hired to be charming and beautiful, while others—like Matt—inherited all the work. But what incredible work, meticulously producing Warhol's silk screen prints.

Matt worked hard and watched a cavalcade of characters swirl around the Svengali King of Pop Art, desperate to make a lasting impression. On the few occasions he met him—Warhol was notoriously health conscious and avoided the Tribeca studio, with its overwhelming noxious ink fumes—Matt remembers a man that was pleasant, gentle, and maybe, he guessed, autistic.

He was inspired more by Warhol's relentless work ethic and seemingly boundless flow of ideas than by the superficial glamour of the scene. The way art dealers functioned reminded him of how drug dealers do: seduce people in order to profit off them, but treat them—the artists, in this case—as disposable. Everybody was using everybody else.

So he felt no qualms in taking advantage of this world full of cons when, walking along a particularly rough stretch of Twelfth Avenue near Hell's Kitchen, he spotted a pile of garbage curbside—items being emptied out of an

apartment. In among the piles of clothes and furniture, his well-trained eye spotted a stack of drawings. The confident marks of oil stick and Sharpie marker on planks of wood— old shelving—he knew, without a doubt, had been made by Jean Michel Basquiat, who had died just weeks before.

The man unloading the items onto the street appeared with another armload. When he noticed Matt's barely con- cealed interest in the art, he offered to sell the stack to him for $100, having no idea of their real worth. Matt countered with an offer of $80, all the money he had in the world at the time. Both men left satisfied, Matt, with a pile of art under his arm he was certain had been done by one of the most important artists of the twentieth century. How those Basquiat pieces ended up in an apartment that was being emptied onto the street isn't clear. But Basquiat was ru- mored to have, from time to time, exchanged art for drugs. It's certainly possible that whoever made such an exchange with him may not have fared so well in the end. And that somebody else—a landlord—may have been grudgingly dealing with the aftermath.

On the long walk home to the Lower East Side, a stretch limo pulled up alongside Matt and a man stuck his head through the open window, offering him much more than $80 for the stack of work clearly visible. Under his casual approach was the jittery eagerness of a man in the know, and taking that clue, despite needing the cash, Matt refused.

The rumor of Matt's incredible find made its rounds through the underground art scene, and, eventually, to a prominent art dealer. The perverse valuation system of the art world—and maybe the world in general—is that we suddenly value people more when they go away. So Basquiat's value was skyrocketing and there was a ferocious hunger for the work.

Matt was talented on guitar, but plenty of people have talent. Some of those people get opportunities to prove it, and a handful of the people who get those opportunities figure out how to capitalize on them. Fewer still can tolerate the war of attrition and stay in the game long enough for that to matter. And only a couple of those who wait it out long enough have the funding that can bind the ingredients of talent, luck, and fortitude. When the dealer made Matt an astronomical offer for the artwork, the final piece of the equation clicked into place.

Matt moved into the apartment at 106 Ridge Street, where I met him, built the soundproof studio himself, and started buying beautiful guitars, 1950s ribbon mics, and incredible instruments and recording equipment to fill it with. He listened tirelessly to Duane Eddy, the Clash, Link Wray, Marc Ribot, Tom Verlaine, John Lee Hooker, Captain Beefheart, Ornette Coleman, and Miles Davis, watched films like *Un Chien Andalou*, and voraciously consumed Philip Roth and Southern Gothic writers.

Out of all this came Matt's guitar sound, like no

other—alternately stabbing and hypnotic, one of his own phenomenal making. Matt's playing goes up when you expect down. It's a theremin made from a badger. A water-logged player piano. There's nothing like it.

And it's true that Matt is living off that money. But it's also true that Speedball Baby—the touring, the equipment, even some of the longer rehab stints for Ron—is quickly depleting his funds like a drunken spouse with a gambling problem.

But that isn't my story to tell. So instead, when the jealousy seethed, barely concealed, out of this compatriot, who seemed to think he was defending the integrity of the entire underground music scene by putting Matt down, I just said, "Well, I've gotta go."

nineteen

"Pork?"

"Pork!"

". . . Pork . . . huh."

I'm trying to wrap my brain around the gig that Matt's booked.

The streets of the Meatpacking District on the West side are not a place for the faint of heart. There's one diner there, Florent, which is where the neighborhood's prostitutes, artists (famous and broke), lefties, radicals, and tourists end their nights with 4 a.m. burgers, eggs Florentine, or snails in garlic butter. And there's one music venue we play called the Cooler—set up in an old meat locker.

You have to literally wade through streets running with animal blood and withstand the reek of rotting flesh to get to these places. Which helps keep it a relatively private neighborhood where older gay men, mostly into hardcore, leather bondage, can live their lives without judgment or fear. Bars like the Mineshaft, the Toilet, the Anvil and the subtly named Glory Hole cluster there.

Not long ago, lampposts and construction sites in the Meatpacking District were suddenly plastered with xeroxed flyers warning about a threat from within. For months, a top—as in dominant sexual partner—had been prowling these clubs, taking home bottoms and torturing them, often for days. There were stories circulating about men being chained in dungeons, given forced alcohol enemas, and drugged. The details were horrendous. The community rallied to protect its own, distributing hand-made flyers and setting safety protocols. Men would introduce their anonymous hook up to the bartender before leaving with them so that if they dropped off the map, someone could describe the guy they left with to the cops. Who, let's face it, may or may not take the whole thing as seriously as they should.

When the "Dangerous Top" was eventually identified as a Senior Managing Director at Wall Street's Bear Stearns—a "respectable citizen"—that story had everything to appeal to a storyteller like Ron. It was extreme, bizarre, and the "good guy," as defined by mainstream society, was

rotten to the core. He wrote a poem about a masochistic vigilante, so dangerous himself that he's out cruising to find the "Dangerous Top." A character so nihilistic even the madman himself would fear him. The band set that to a subversive punk-disco rhythm, added crooked, stabbing guitar riffs and a bass line like an accelerated heartbeat, to write "Dangerous Top," a song that's become a small underground hit.

That song is why we're booked to play the Lure, a leather bar that boasts a permanently installed "sex-slave-training-cage" suspended from its ceiling. On Thursday nights, a collective of young, queer artists hosts a party called "Pork."

We mix a bucket of paste and leave the house, again, at 3 a.m. in a campaign to deliver our punk scene from the Lower East Side to the hardcore gay leather bar scene of the West.

The night of the show, we load in at 11 p.m., rolling amps past four severed pigs' heads stuck on spikes outside the front door; decor easily found in the neighborhood. The club is packed with an older crowd. Bass is thumping, lights are red and low, and the air is misty and thick with sweat. Above the horseshoe shaped bar hangs the infamous "slave-training cage." Red lit rooms splinter off the main one, and as I roll my amp by, men disappear through their open doorways smoothly, encased in shiny black leather. There are strong, fit asses hanging out of

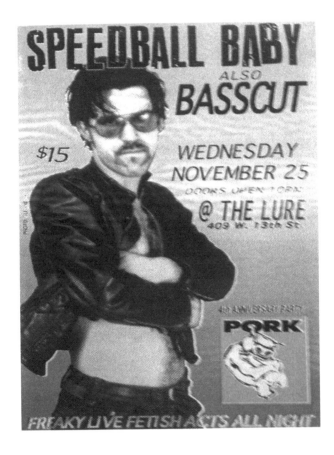

chaps everywhere you look, and thick, black mustaches under black, leather military caps. It's freeing but immediately a little isolating to be here where everyone is intensely focused on everything other than me, the only woman in the place, as I try to push through the thick, unyielding leather.

I deposit my amp and bass and weave my way to the bar through a sea of sweaty bare backs for a strong drink before crouching with it next to my equipment, waiting, trying not to stare at the crotch of the young man in the cage in front of me who's undulating, with both motorcycle boots up against the bars.

Matt's face pops out of the dim light in front of mine, flushed and excited.

"What ya doing back here, Al?"

"Sweating." I smile, feeling a bit lonely. I can't quite find my way into this scene where no one meets my eye even when I smile, needily, at them.

By midnight, a younger crowd starts to filter in, wearing leather pants and rubber shirts. These are the "Pork people." After them filters in faces I recognize: Leslie, Lisa, Christina and Ashley; James Chance of James Chance and the Contortions, who'll be playing with us tonight, throwing his saxophone off the proverbial cliff; Maria Zastrow—friend to Nick Cave, notorious member of Berlin's underground music scene, and dead ringer for Ron, with her strong features, messy black Rockabilly quiff, and

sharp but threadbare men's suit—who'll play organ on "Suicide Girl;" Kid Congo Powers—former member of the Gun Cub, the Bad Seeds, the Cramps and, most impressively to me, one of the nicest people I've ever met on the music scene, despite having a mile-wide naughty streak you can see in his crooked smile and sparkling eyes; and more and more and more until the normally distinct crowds are shoulder to shoulder. I don't know why underground scenes tend to bubble up so separately, but this feels promising.

It's a tiny stage—just two go-go boxes and a folding platform, with a sparkly, fuchsia curtain hanging, as small as a glamorous shower curtain, just behind Martin. Red and blue lights swirl, like a police raid. When Matt and I leap onto our go-go boxes to play, our heads disappear in among the low-lying ceiling pipes.

I bounce around in my mini dress and knee-high, leather boots on top of my box and watch the different groups—the older men with huge mustaches, the younger boys wrapped in rubber, the tight black jeans and combat boot clad people from the Lower East Side—remain disappointingly separate. One man shakes toward the stage a little, then retreats. Then another, from the next group, tries to make something happen before it fizzles out. But with the opening notes of "Dangerous Top," everyone seems to forget who they came with and the place erupts with a sense of urgency.

Cruising the streets
Making the club
Looking for that special
Kind of love

And everyone's mashed together in a glorious melee of leather, flesh, T-shirts, chest straps, heavy boots, cowboy hats, skirts, and chains. A current starts with Matt's guitar and passes, body to body, through the room, through me, through Martin, and shoots out of Ron's mouth like a high voltage strike, the promise of electrocution in the air. I jump down off my box and play from inside the crowd. Matt does the same.

Life is lived at the front of my face now; the real me is smashed up against the mask, looking out through alive eyes.

I bounce around through the crowd afterward, tipsy and excited, the place no longer rejecting me. A goateed man, wearing tight white underpants and motorcycle boots, nods at me as he lights fire to the surface of a tin of shoe wax before sensually spreading it over the leather boot of another man sitting in front of him on a raised chair, smoking a cigar. Behind a scrim, the silhouette of a frighteningly well-endowed man in a biker's cap fellates a twenty-four-inch dildo.

Leaning against the bar, I see a familiar face nestled into a booth. The face is kissing another man passionately, moving in and out of view. I squint, struggling to place

it; the blond, tufted, spiky hair; the leather straps pulled taut over a bare chest; no pants, just a leather jock strap; heavy eyeliner. A concrete memory is just out of reach. The two men grope each other, all tongues and licking and leather, until the face I recognize pauses for a breath, looks up, glassy-eyed, sees me, and freezes. We're locked in a visual embrace while my memory rapidly constructs itself around an image. The clothing is different. The spiky lock of hair is new. He'd been bald before. Then I imagine him grunting, scowling, his thick arms punching the air around him, and it's like easily placing the last pieces of a jigsaw puzzle once it starts to make sense. WHAM. He's one of the skinheads who helped ruin hardcore matinees for me years earlier. One of the violent ones—loathing of weakness and femininity—who'd stomped around at the front of the stage and ganged up on kids in front of the club.

Neither of us can look away. He's vulnerable and exposed and old feelings of fear and anger flare up in me. Then quickly, a new feeling surprises me—empathy. For what it might have meant for him to walk through life exploding with the fury that comes with self-obliteration. All those Sundays he'd spent kicking people in the face, seething with toxic masculinity, may have been avoided if he'd been accepted as himself. Who knows. Maybe.

I turn away. *Don't worry*, I think—to him, to me, I don't know. To everybody, I suppose. *Just . . . don't worry.*

part 3

not america

twenty

"What would you say if I asked you to go to Europe?" Matt asks over halloumi eggs at Cafe Mogador.

I answer through a mouthful of scramble, "I'd say what the hell are we still doing here?"

"You may remember," Matt spoons labneh and hummus onto a pita bread with what I can tell is going to be too much of the powerful house-made hot sauce, "that MCA, in its infinite wisdom, decided not to release *Cinema!* in Europe because they said Europeans wouldn't 'get it.'" He pops the bite into his mouth and immediately regrets it. As his eyes water and he fans his face with flapping hands, I add, "Well, I mean Europe's only the home

of surrealism and Dadaism. How could they possibly understand us?" I pat him gently on the back.

Once he's recovered, he stirs his Turkish coffee, causing the heavy grounds to swirl to the surface. To me, his whole meal seems like something you'd eat on a dare. "But a label in the Netherlands 'gets us,'" he raises his eyebrows, "and *they're* putting it out!" He claps his hands together and announces, "Smitty! SPEEDBALL BABY IS GOING TO EUROPE!"

The only place my little failing nuclear family of three ever really traveled was to Massachusetts and DC to see family. Dad would throw a few bags through the side door of our blue-and-white VW camper van, mom would lie baby-me in a crib they'd rigged up where the back seat should have been, and I'd bounce around, for several death-defying hours, like a little piece of popcorn, while we barreled down the highway. (Much like touring now, come to think of it. Except that my touring life is defined largely by where I can go to the bathroom. Perhaps I should go back to diapers.) My parents weren't "Let's fly to Europe" people.

So watching the New York skyline tilt out of sight only a few weeks later means that music has transformed my life.

"Business or pleasure?" an immigration officer asks at Heathrow.

"I'm touring with my band!" I blurt.

"Haven't you done well." She sounds amused as, with

the loud "kerchunk" of her stamp in my passport, she un-knowingly marks the start of a new chapter in my life.

When we flew out of JFK, every inch of available space was covered with ads written in advertising code. But their messages were received loud and clear: "THE REASON YOUR LIFE STILL SUCKS IS BECAUSE YOU DON'T OWN THIS YET, YOU LITTLE RAT-FACED TROLL." By comparison, the ads at Heathrow are more modest. As though perfume and jewelry companies are tapping you gently on the shoulder. "Pardon me. We think there's a chance you might like our product. But honestly, no pressure. You probably have someplace to go. We'll just be here."

The airport police are noticeably tall, fit, and, most alarmingly, unarmed. Matt tells me all the cops in England are unarmed, which is so far from the reality in the US, it sounds like the set up for a joke.

"Why are all the cops in England unarmed?"

"So they can save money on sleeves!"

Or something.

I study them in disbelief. All they carry are batons and what looks like the clear ability to chase you down and subdue you with their bare hands, probably while apol-ogizing. Most cops in New York City are so out of shape, they look like they'd have no option but to shoot you in the back if you ran because chasing you just isn't in their wheelhouse.

Stepping off the plane, we're greeted by Johan, sent

by the label to act as tour manager. Johan is tall and Dutch, with long, dirty blond hair that falls well past his shoulders, and a tiny, square, blond mustache. His half-mast eyes make me immediately think he's stoned, but he seems too efficient to be. He wears loose-fitting army pants and a band T-shirt his lanky frame swims in, army boots with the laces open, and, right there in the airport, he presses a tight, hand-rolled cigarette between his lips, twitching for the moment he can light it outside.

He shakes each of our hands and gives us book-bound tour itineraries that detail our lives for the next month and a half. I eagerly open mine:

London, UK

Manchester, UK

Newcastle, UK

travel day—ferry Newcastle to IJmuiden (seventeen hours, overnight)

Amsterdam, Netherlands

Heerlen, Netherlands

Groningen, Netherlands

travel day

Århus, Denmark

København (Copenhagen), Denmark

Hamburg, Germany

Berlin, Germany

Bielefeld, Germany

Köln, Germany
travel day
Zürich, Switzerland
Biel, Switzerland
La Chaux-de-Fonds, Switzerland
Luzern, Switzerland
Genève, Switzerland
Milano, Italy
Roma, Italy
Rimini, Italy
Firenze, Italy
Zagreb, Croatia
Ljubljana, Slovenia
travel day
travel day
Madrid, Spain
Lisboa, Portugal
Porto, Portugal
Vigo, Spain
Bordeaux, France
Paris, France
Aalbeke, Belgium
Brussels, Belgium
Leuven, Belgium
Utrecht, Netherlands
London, UK
This is my life. Holy fuck!

The stereotypical American idea of people who live across the pond is that the French are rude, the Germans have no sense of humor, and the British can't stop apologizing. In other words, some Americans have learned everything they know about other cultures from *National Lampoon's European Vacation*. What I know is that I know very little. Other than most of the musicians I've ever had a major crush on—Roland Gift, Paul Simonon, Ali Campbell, Nina Hagen, Hazel O'Conner, Pauline Black— weren't American. So, I have great expectations.

Johan drives us into London in a van that looks like the Koolman Ice Cream truck back home: white, tall, and boxy, with no seat belts. Our equipment is, for once, safely separated from us by a partition in the back. Very civilized.

"Yah," Johan gestures nonchalantly, "So it's Big Ben there and of course that's the Thames, but we don't really have time for that."

Eventually he pulls up in front of one in a row of pristine, uniform white houses that surround a square park. I pull my bass case, and my grandma's vintage, brown suitcase with the oversized orange flowers on it, from the back. Would a backpack have been more efficient on the road? Of course, it would have. Would it have looked as cute? Hell no!

A woman with a straight back and short, finger-combed hair, leads us up a stairwell so narrow you have to pinch

your broad, American shoulders together not to brush the walls, which are papered with flowers and birds.

We're given three small rooms along an equally narrow, carpeted hall, dimly lit by delicate, crystal wall sconces. When Matt and I step into ours, I race to open the white lace curtains that lead onto a small balcony.

"Matty! This is amazing!" I lean forward against the balcony railing to peer at London through my yellow tinted sunglasses. Maybe the Beatles stayed here. Maybe adorable Poly Styrene worked at that chip shop or Siouxsie Sioux peed in that bush. The possibilities are endless, and now I'm a part of endless possibility!

I find my camera in my suitcase, balance it on the dresser with the timer set, and take a picture of me and Matt, arms around each other, smiling between the billowing curtains.

Konkurrent is a tiny label compared to MCA, but they put us right to work doing phone interviews.

"You are Speedball Baby, yes?" the writer asks excitedly over the speaker phone. "That's us!" Ron answers.

"You are SICK ROCK 'N' ROLL GROOVY SEXY GOOD TIMES, YES?!"

"Um, yes?"

"I AM GLAD TO BE DIGGING THAT CRAZY ROCK 'N' ROLL SOUND, ALL RIGHT!!!"

Swinging London. England's Dreaming. The punks who snuck into my bedroom when I was twelve—who

shook me by the collar and slapped me awake to the world—all scurried through the streets of London before anyone cared who they were. Skinny and strange, causing traffic jams in Piccadilly Square, making "bobbies" ha-rumph, and prim, old ladies clutch their purses. A plane brought Chrissie Hynde to live in a no-water, no-heat squat in London from way-to-go-Ohio at twenty-two and turned her into the great Pretender. Morrissey swaggered out of Manchester singing "Issit wrung not ta ulways be glehd?" And so many before him, and so many after him from that working-class town.

That night, it's the 100 Club, one of the best punk venues in London, we're told. It's small, tight, and dark, just like we like it. I can't be sure, but it seems as though a few people bouncing around in the front have some idea of who we are, the way they seem to be mouthing along. Afterward, the merch table moves a massive number of CDs and T-shirts.

The next night in Manchester, it's the same thing. Based on these two shows, I can only assume that British punk crowds love chaos. The pits are madness.

It's more of the same at the Station in Newcastle, a city where they brew beer and breed tough-as-nut characters called "Geordies" who tell me after our show, talking as fast as speed freaks, "Howay lass, ya band waz propa class like, propa mint". (Translation for the uninitiated: "Dear lady. I thought your band was a veritable *feast* for the ears.")

I don't just feel like I've landed in a new country, but that I've planted my flag on a new planet.

Johan drove the van onto on an enormous ferry this afternoon—it's the overnight crossing, Newcastle to Amsterdam—and while I'm excited, I've never felt more like cargo.

This ship has what I'll call "Eastern-bloc glamour," with an almost aggressively deliberate lack of niceties. It seems barely held together by rivets the size of your palm, and I've yet to spot a lifeboat. I try eating dinner at one of the long metal tables in the cafeteria, but half a sausage-floating-in-bitter-oil later, I weave and bob back out onto the deck with

Matty, eyes fixed desperately on where a gray sky meets gray water at what I'll assume is the horizon.

"Please stay up with me all night, Matty. I can't face the reality of our cabins." But by ten, it's freezing, and we both look green. So instead, I pop a Dramamine and we follow the narrow stairwell, leaning this way, then that, that leads down to our berths. Considering they're three floors below sea level, let's call them what they really are— coffins. Watery graves. A ready-made burial at sea.

Matt and I lean lethargically toward each other for a good night kiss, when the ship suddenly lurches and we crash foreheads instead.

I really should have taken the Dramamine the second our van's front wheel rolled on board, but I was afraid I'd get sleepy and miss the decadent glamour of my first European ferry ride. Now I'm praying for sleep or death, whichever blesses me first.

I knock against one wall of the unfathomably narrow room, and then into the other before making it onto the toilet. Then I undress under a sallow, fluorescent light before I'm practically hurled into bed, lurching and fumbling. It's the bottom level of a bunk bed and the last thing I see before the Dramamine finally takes me in its merciful embrace is an enormous swastika carved into the wood of the bed above.

Sweet dreams, princess.

———

I set a heavy boot down on a cobblestone street in Amsterdam for the first time and I'm Christopher Columbus—without all the greed and the genocide. Vasco de Gama—without all the . . . greed and the genocide. (Why can't I think of any female explorers?)

We drop our gear off at the club and our bags in the rooms above, where we'll be staying after the show, and within the hour, we're all stoned. Even me: the person who's always the *only* person in the room not doing the cocaine circling its way around a party or taking hits off a joint in the dressing room. But it's Amsterdam and pot is legal and it's so incredibly novel that now I'm stoned. It almost feels like it would be culturally insensitive not to be.

In Amsterdam, they sell pot at places called coffeehouses—not to be confused with coffee *shops,* where they just sell plain old boring coffee. Menus boast names like "Blue Mist" and "Marigold Dream" and describe the "notes" as though they're fine wines; "fruity with a strong hazelnut profile and a slight aftertaste of used baby diaper"; and their likely effects: "has a mellow lead-in with a spiky finish." Joints are served up on saucers, like espressos, and you start to think "Is this really different than having an espresso?" And you smoke some, like everyone else.

On the way back to the club, I walk by a vintage clothing store with a lamp shaped like a chicken covered in pink fur in the window. I stare at it for a while. Next to that, there's a flower shop, colors bursting in bunches. Then a bakery,

trays filled with tiny, beautiful petit fours and buns with cream oozing out of their sides, glistening with sugar glaze.

I'm feeling fuzzy and dreamy when I get to the next shop which has a young blond woman standing inside its display window, stiff as a mannequin, which is what I think she is at first because it's so completely strange to see a naked woman standing in a window in the middle of bustling, afternoon shops. I notice a few men pass, slowing down when they get to her, hands in pockets, just browsing. The boys told me about this. Window displays filled with women in a city where prostitution is legal. Back home, prostitution is about as legal as murder and often thought of as worse. I want to feel empowered by this. I want to feel like it's a good thing. But I just feel suddenly very uncomfortable, and I hustle by.

Back in our rooms, we dress for the show although it's still hours away. The sun goes down. I can see it's dark from the window and it fills me with a mix of excitement and dread as the boys begin to disappear into the night. Ron, Martin, Matt, each off on their own, in an unusual way, with little talk and no fanfare; just disappearing into this strange parallel universe. I sit alone in our room—a long room full of identical, sparse cots—wondering what to do. It's only 6:30. It's ages to go before the show.

I arm myself, pulling my camera out of my suitcase. There's an external staircase on the building used to move equipment in and out the club. I head down it slowly. It's

more like a sturdy fire escape. Halfway down, I realize I can see into the storefront windows from here.

There are a lot of women out now in the dark, their window displays glowing red. Rows on rows of them. I crouch down and get the best view I can from a crack between two parts of the staircase. My heart beats faster. I'm nervous and excited.

All kinds of men are out now, strolling past the windows. Old and young, every ethnicity, height, and shape. Some travel in packs and they're drunk or stoned, and they bang on the windows or press their faces up to the glass and make each other laugh. Others move slowly, solitarily, adjusting their glasses, sizing up the "goods." Then some of them disappear through the shop doors. There's electronic music coming from somewhere.

I raise my camera to my eye. Snap. Just a red blur with black shapes blurring in front of it. It's too dark and my hand is a little shaky. I so badly want to feel good about this. I so badly want to feel that each of these women is empowered. But I can't get past how much it looks like an amusement park for men. Anything they want to ride whenever they want to if they can afford the ticket. Total control. The privilege of never having to think about any aspect of it other than what they want from it. From these women. In a strange way, instead of relating to the women, I envy the freedom those men have. I so badly wish I felt entitled and spoiled for choice

like that. That I didn't have to think about people's feel-
ings or imagine the repercussions. I can't imagine a
world where my needs feel so unabashedly catered to.
Free from conscience and complexity about sex. But the
overwhelming feeling I get when I see the women ca-
tering to these men is that I want to ask them, each,
whether they're really okay. Whether they're in school
or have dreams or a good family and what they feel like
when their high school teacher or their father's work
partner walks by.

Click. Another blurry picture of a red box with a waving
shape and a blurry shadow. How to make sense of it all.

We're all buzzing and hot by show time. It's a small
club and packed, my favorite kind of place to play. Has
the whole crowd been out in the red lit streets today? It's
a passionate response and I feel like a star standing in my
own version of a window display. But with my guitar, I'm
never still, never silent, never passive.

Ron jumps onto the crowd, into the crowd, hugs the
crowd, kisses everyone on the lips.

Johan is in charge, giving us a light show worthy of a
stadium, and we swirl inside the psychedelic cosmos of
it together.

After the show, Matt and I dance—colored lights trail-
ing round us, joy filling the space between. Funk Soul
Brother is all the rage.

A guy named Marco zeros in on me. "I'm in love!" he

slobbers, and when he smiles, I see a couple of back teeth are missing and that the ones still in his head are a bit gray. But he's cute, with his skinny jeans, tight T, leather jacket, and shaggy hair. He follows me to the bar.

"You are so keeuull!" he leans against me when he says it.

"IIIIIII'm really not," I say, proving it by snorting when I laugh.

He buys me a drink. "Tell me everything about you!" His face is like a full moon hanging low in front of mine. Matt appears, puts his hand on Marco's shoulder, studies him and says "Hey, man. How's it going?"

"HEY MAN!" Marco shouts, and spins around to collapse onto Matt in an embrace. Then gesturing to me, "She is so beautiful, isn't she?!"

Matt smiles and shoots me a look that says, "I'm across the room if you need me."

I shoot a look back that says *I am in charge. I am free. It's my turn to choose from the red lit Windows!* and I shoo him away.

Marco spins back around, takes my face in his hands, and presses his lips against mine. It takes a moment to realize what he's doing and another to realize that, bad teeth or not, I like it.

He's a tour-bus guide and I should call him in the morning for a private tour of Amsterdam. Here's his card. He draws a smiley face and a heart on it.

"My heart is yours." Then, "I go to the bathroom now." And he kisses my cheek and races away.

I'm feeling light and dreamy when a girl is suddenly close behind me, grabbing me by the shoulders, whispering into my ear. She smells like cotton candy and sweat. "Look out for Marco. He has SPERM in his eyes!" She disappears quickly, leaving me to imagine a doctor delivering the news to him: "I think we've found the cause of your blurry vision, sir."

I've barely registered what she's said to me before a second girl is on me, with a tight, black-fingernailed grip. "Marco's no good. Be careful." Then she's sucked back into the crowd and Marco's sitting next to me, smelling like sour beer and dirt, much more amped up than before and rubbing his nose vigorously.

"So!" he flops around in his seat. "Tomorrow I show you the whole city!" He spreads his arms wide and knocks me across the face, then tries to apologize for it by grabbing me by the cheeks and petting my nose. With my head in his wet palms, I sigh. Maybe there's a row of red windows for me out there in this town where skinny boys in jeans and band T-shirts offer you chocolate, listen intensely to your feelings, and respond, shaking their heads and shrugging. When you ask, "What's up?" they sigh, "I just think you're amazing, that's all." A red-light district for the soul. The problem is, I probably would have picked Marco out of the window displays.

Goddammit.

I crave romance, but it's the romance of myself in the world. Like Maya Angelou singing in nightclubs in Paris. Or Simone de Beauvoir writing *The Second Sex* in outdoor cafés. Like Chrissie Hynde getting off that plane at Heathrow and inventing herself from the ground up. The romance of savory smells traveling on the air in Italy, and of myself, swaggering through London fog in a Maryt Quant PVC rain mac. If I finally settle down some day, I never want to have to wonder what my life would have been like if only I'd lived it.

Loading the van the next afternoon, I do what every other woman on the street seems to be doing; I keep my gaze averted from the women in the windows so as not to add to the leering eyes of all the men who are already roaming, wild and free. What I want to do is knock on the glass of each store front and wave and ask every woman whether I can buy her a coffee, and to warn her about Marco. But I think she probably already knows.

Johan navigates the extremely narrow side streets out of town and now I understand the wisdom of the skinny van.

With a final look back at this unusual, challenging, exciting city, I find my journal:

The Unbearable Lightness of Being . . . a woman who wants to help all female kind:

 I kidnapped a little girl once.

I mean, there's no other word for it, really. I'm sure that's what the authorities would have said had anybody thought to call them. Which they didn't.

Colton and I were walking through a scuzzy park uptown that everyone called Needle Park and there was a woman in a rage, shouting and pounding her fists down on a little girl sitting on a bench in front of her.

"You fucked up!" she screamed. "You cost me money! You're a dumb little bitch, aren't you!" Two small boys, around four and six, stood by watching, emotionless, holding hands. I got the sense this wasn't the first time they'd watched this scene unfold.

When I walked past, I caught sight of the little girl's eyes which weren't pleading or panicked, but dead. Blank. Before I knew what I was doing, I'd thrown myself onto the woman, looped my arms under hers, clasped my hands behind her neck and had her immobilized. There wasn't a plan, just a very strong urge to help that little girl at any cost.

"STOP IT!" I shouted at the back of her head and shook her.

Other people gathered now. Other addicts and homeless people from the park. Colton turned to them, ready to fight. If there was one thing he could offer, it was that. But nobody moved forward. Just watched, mildly interested.

"FUCK YOU!" the woman yelled at me and wrenched me one way, then another, but I held her tight. "That girl is mine. I do what I WANT!"

I struggled to contain her. She was my height, much older and far tougher than me. But I had determination and a purpose on my side, and I couldn't forget the dead eyes of that little girl.

Suddenly the woman burst free, and I stepped back, prepared for an attack.

I'd never been in a fight before, only small pushing and shoving matches with Colton at that point. But instead of turning on me when she broke loose, the woman just grabbed the arm of the older boy and dragged him behind her away, leaving what was clearly her daughter behind. The older boy dragged the younger boy behind him.

"That fucking little bitch has caused me too much goddam trouble today!"

I looked at the little girl on the bench. She must have been around eleven. She just sat slumped there, unprotected. Her legs weren't bent up in front of her, her arms weren't crossed over her head. It didn't really look as though she'd done anything at all to protect herself; just sat there under the weight of those big, angry fists.

"Is that your mom?" I asked her, shaking.

Her face was streaked with dirt and she just stared at me.

"Come on." She took my hand when I offered it to her. The fact that she trusted me no more or less than her own mother—enough to leave with me—broke my heart.

"What are you doing?" Colton chimed in, but I was already walking away with the little girl. We walked very

fast for about a block, hand-in-hand, adrenaline pushing me on, her stumbling beside me, silent.

"You know . . ." What was I about to say? I wanted to pour confidence into her. I wanted to pour all the wisdom of the world about how she deserved to be safe and loved and how she deserved more than that. But there was nothing to say that would make her life all right. "Nobody has the right to do that to you." That's all I could come up with. And I wanted to burst out crying when she looked at me, tired, emotionless, long gone, baby.

"Nobody." I repeated.

Then a screeching came up from behind us, like a bird of prey descending fast on a field mouse.

"that's mine you fucking bitch!" And there was her mother. And she was holding a knife in front of her. Straight out in front of her in a way that, if I had any knife-fighting skills at all, probably would have made her very vulnerable to me.

Of course, I didn't have any sort of fighting skills, so I tried to use the only weapon I had. "You can't treat your kid like . . ."

"THAT'S MINE!" And she snatched the girl away from me by the arm. What could I do? I had accomplished nothing, and I could do nothing to change things. And as I watched her drag the girl away, wrenching her arm back and forth and twisting her shoulder, I hoped, desperately, that a few words may have taken root, like seeds, in her mind.

twenty-one

It turns out Amsterdam was just a gateway drug for Hamburg which, if you're uncomfortable with having every form of sexuality shoved into your eyeballs at all times— signs and magazines boasting "teenage anal," "animal," and "BIZARRE"—I'll warn you now against visiting "die Sundigste Meile," or the "most sinful mile," where we're staying.

After checking into our austere hotel, with its surprisingly clean, white walls—*perfect for wiping down?*—and spartan cots for beds, Matt and I take a stroll before sound check.

"You sure you want to see it?" Matt raises an eyebrow. "It's kind of hardcore."

I *do* want to see the Reeperbahn's most infamous street. I left Amsterdam upset with myself that I couldn't find vicarious freedom in the choice of women to do what they want to with their bodies. It made me feel square and close-minded and I'm determined to claw my way back to being a hardcore liberal.

"Yeah, I can do it. It's just, like 'a lady museum' full of empowered, young women making choices about their rights and their futures, right?" I hope to convince myself.

"Yeah, I think, maybe, it's a little different here."

I don't say no, so we walk until we find a side street barricaded from the main road by large, metal gates. You can't see over them, so Matt pushes one open. It's eleven a.m. when we step onto the cobblestones of the Herbert-strasse, and all I can think is that we should be getting coffee instead. The air is cold and damp, and it looks like everything's been given a recent hosing down. On either side, a relentless row of shop windows in short, squat build-ings with pretty little canopies over them. It's too early for the glow of the notorious red lights that made Amsterdam feel dystopian and futuristic. We start to slink down the row, standing dead center, as far from either side as pos-sible. With quick side glances, I check out the displays. As we move past, a young woman dressed in a Catholic school uniform stands up off a stool and moves toward the glass. She fades back into the dark as we pass by.

Another woman, probably my age, nibbles her cuticles

absentmindedly, swaying her hips back and forth as she teeters on patent leather boots with 7-inch heels and pointe shoes for fronts. The scene is humorless and eerily quiet.

Up ahead is a middle-aged man in high-waisted chinos, a sloppy, gray button-down shirt, and a fanny pack. He's pressed against the glass, hands up like a child salivating over a candy display. I can see his expression as we move past and the woman beyond him (in so many ways) bound to a chair by wrist and ankle cuffs, encased in tight leather. He looks at her like she's a sculpture or a painting. Something that he no doubt admires in some remote, distant way, but not at all as though she's human. More like she's something he might like to purchase to keep around the house to admire from time to time. To get use from.

His bland, dumpy appearance and blank, mechanical expression remind me of a man who followed me onto a subway car in New York when I was fourteen. It was the middle of the afternoon, and the subway was packed. But that didn't stop him, in full view of everyone, staring at me with that same, distant look, opening a newspaper in front of himself, and masturbating.

He never took his eyes off me and nobody, least of all me, did anything about it. I wish I'd known at the time that it was an option to yell "Take that dick in your hand and use it to go fuck yourself!" But by the time I really knew what was happening, it was almost over. Afterward, not one person pulled me aside to say, "Nobody has the right to

do this to you." I had had my public-masturbation-cherry popped and everyone around me acted as though it was a predictable rite of passage.

I can't believe that this is the system. That any schlub can go into a doorway and plop down a little bit of money for what I would consider a whole lot of person. Maybe these women don't see it that way, but I just can't get over the privilege of being able to do that like it's nothing at all. I'm walking faster now, eager for the ride to end.

In the last window is a much older woman. She's wearing a housecoat and vacuuming her little diorama space, and before I can decide whether it's a "sexy domestics" fetish or whether she's just house-proud, we're spit out the other end of the street through another set of heavy, imposing gates.

God, I so badly want to feel good about this. I think that's how I'm supposed to feel, coming from the underground scenes of music and punk and all things anti-establishment and being unapologetically feminist. But all I feel is miserable. In the deepest part of my soul, I want to protect these women. I want to protect myself. I want us to feel safe and cared for and meaningful and *human*—above all, human—and full and real and I'm sorry but nothing about performing whatever sexual act a man with a fanny pack and the shifty presence of a serial killer can afford makes me feel safe and happy. It makes me feel sad and angry.

"What do you think?" Matt asks, a bit flustered.

"I think," I say, pausing. "I think that it's a really fucked-up world."

We walk a bit in silence before I add, "I also think that I would choose 'sexy domestics' if pressed."

Back at the hotel, we splutter to Johan about where we've been, and he looks mildly surprised. "Didn't you see the signs?" he asks.

"You mean the ones in German," I say, "that we couldn't understand? Yeah, we saw those."

"Well," he answers casually, licking the paper he's rolling between his fingers, "You're lucky then." He seals the small tube by pinching it. "Because they say, 'No Women Allowed' and the pimps usually beat the hell out of any woman who walks through there." He plucks some stray tobacco from an end which he twists before sticking the long, thin cigarette in his mouth and cupping his hand around a lighter, "Or the ladies throw the 'penis water' on you."

Matt and I are shocked still for a moment. "I don't even want to know what that means," I say. "I just want to take a shower." Then quickly add, "In penis-free water."

That night before the show, the promoter, Wolfgang, cooks us beef stew and pours red wine into us in his little attic apartment. While he chops onions, his wife strums on a guitar and his six-year-old beckons me to a large aquarium: "Joe Strummer," he smiles, pointing to a fish. "Einstürzende Neubauten, and," he beams at a

fantastic looking thing—purple and iridescent blue—with a red, extravagant tail and fins trailing behind like a blood-soaked-gown, "Nina Hagen!"

Wolfgang is much older than us, burly and balding, and as he slashes away at the onions with an eight-inch kitchen knife, I catch a glimpse, in the fury of the movement, of a faded Sid Vicious tattoo snarling at me from a hairy forearm. He cuts and he cries, cuts and cries, and Sid does a little hula.

With the stew bubbling in a pot on the stove, he spreads shot glasses out on the kitchen table and fills them to the point of overflowing by upending a bottle of Jägermeister and waving it around.

"PROST!" He raises one.

I pick up a glass, my fingers sticking to its outside, and raise it to his. "PROST! DANKE!"

The voice of Édith Piaf fills the small space, and the cough-syrupy sludge warms me on its way down.

"What are those words, Matt?" he asks urgently. "'At first I was afraid, I was . . .' What is this word, Matt?"

"Petrified?"

"AHH! YA! YA! 'At first I was afraid, I was PETRIFIED.'" He stops to swipe the chopped onions into the pot.

"Na na na, Matt. What are all these words to this song?"

Matt and I start slowly, each remembering a lyric here or there until we get to the chorus. Then Wolfgang, his wife, and the four of us explode into the biggest, most fabulous,

most Studio 54 version of ourselves, while the little boy laughs wildly at us.

Martin pounds out a thumping disco beat on the kitchen table and we crash into each other in the small space.

And I'll survive, I will survive, hey, heeeeeeeeyyyyyy.

Ron's version sounds sinister. Martin's, very camp. Matt's is low-rent drag. And mine? . . . I knock back another sludgy shot.

I really mean it.

twenty-two

"Brakes gone."

That's all Johan says, and he's so casual about it that by the time I understand what he means, the front of the van is engulfed in black smoke.

Johan doesn't even drop his cigarette as we careen between unyielding rock faces on either side. The piercing screams of four people fill the van as he lets us sail straight down the Alps before suddenly turning left onto a roadside patch of grass that's slightly inclined. The van bucking like a bull, he downshifts, throws the emergency brake into place, shuts off the engine, and waits for us to settle into a dip in the ground. He

takes an extra-long drag. "It's gonna be a very long afternoon."

I step onto the grass and flop down, cross-legged, panting. The air is full of the bitter smell of burning rubber. I lie back and pant at the sky. I squeeze the grass through my fingers to calm down. I gently take hold of one blade and slide it from the sheath it grows in, like my mom taught me when I was little, until the white end pops out whole, and I nibble on it, a nervous little rabbit. After a while, I hear Matt's guitar, light and gentle, and look at the sky, which is brilliant blue and full of fat, puffy clouds. Life is incredible. Either you drive into the side of a mountain or you don't. Either way, the sky remains blue, and the birds sing.

I can't remember the names of the types of clouds. I think the plump ones are cumulus. But I *can* tell you that that one is, without a doubt—the one right overhead—a turtle wearing a crown riding a skateboard. And that that dragon is holding a chicken leg.

"I'll be back with a tow," Johan calls out and I wave my hand in the air in his direction. Where could he be walking out here? To find a . . . yodeler that can summon help?

Hoooooooo. Hooooooo. A deep, hollow sound mixes with Matt's guitar, filling the valley. I push up on to my elbows, looking for a wounded moose, and—*you've got to be kidding me*—it's a guy playing one of those horns so long it has to rest on a stand. The type you'd imagine seeing on a postcard from the Swiss Alps. I grab my camera from the van and take a picture of the dot on the mountaintop blowing into the long tube.

"Al." I spin around and Matt has a butterfly balanced on his fingertip. I take a picture. Birds tweet nearby, pleased with their lot in life.

Ron jumps and flails about in the middle of the road, pretending—pretending?—to lose his mind. Martin laughs. "Fuckin' hell, Ron. You dance like you've got wooden legs and real feet!"

There are worse places to be stuck. I trade my camera for my journal and lean against a warm rock to write, letting my head fall back. I think about my favorite roadside adventure of all time:

When I was eight, my dad took me to Atlantic City to visit his friend.

During the day, this friend was the perfect host, taking us on the water in his small motorboat with a cooler of sodas, buying me a pretzel back on shore, and winning me a stuffed bear in a ring toss game. Sucking on a Pepsi next to his Dodge Charger—Dorothy Hamill bowl cut framing a face full of freckles; brown cords, yellow tee and red Pro Keds—I thought Does life get any better? But when the sun went down, life got a whole lot worse. All day, my dad's friend had been pulling cans of something out of the soda cooler. I hadn't seen him without one in his hands the whole time. He even won my bear for me one-handed. By midnight, he was wasted; a raging, roaring maniac, breaking glasses on his living room floor while I cowered in the guest bedroom, listening to my dad try to soothe him in hushed tones through the flimsy door.

Then suddenly my dad was in the bedroom, sweeping everything we'd brought into a suitcase, wrapping my jacket over my nightgown, and sliding on my shoes for me. He rushed me out the front door, past his friend who was crying and begging, "You're scaring her. Come back, man!"

Outside, the suburban streets were silent, desolate, and dark. We moved between small pools of light from streetlamps, and long patches of pitch black between them, my hand in his. I'd just seen Paper Moon and the idea of a daddy/daughter team swindlin', rasslin', and on the run,

was just about the best thing I could imagine. We padded
along under a spray of stars and, of course, under the paper
moon with the cardboard sea not far behind. My small
fingers felt, in the imposing dark, for comfort in the familiar
flatness of his thumbnail; in how the knuckles on his thin
fingers wrinkle like an elephant's knees—like mine do now.

No sounds but a soft thp thp thp on an empty sidewalk.

"Well," he said eventually, smiling down at me, "I
guess we've got an adventure on our hands."

And it was. Right up until the moment we heard the
bwoop of the siren, and the trees around us turned blue
and red, and two police officers wanted very much to
understand what a grown man was doing walking on the
side of a dark suburban road, hand-in-hand with a little girl
in a nightgown right around midnight.

Until that moment, it was a perfect night.

Where in holy hell could Johan have possibly gone? I
take a picture of the sky and of my feet in the grass.

"If I don't get out of here soon, I'M GONNA BLOW!"
I hear Ron holler.

They Were the Worst of Times:

My worst roadside adventure happened when we
broke down in Kentucky on tour.

Martin and I took off to find a gas station, while Matt
and Ron milled around our panting van with Lisa, another

of my friends who'd come with us that time. Lisa is a tough, wise-cracking girl from the suburbs of New Jersey. Jet black, glossy ponytails and straight bangs frame a porcelain white complexion and red, pursed lips. And if Lisa isn't wearing black head-to-toe, it's only because a rip has been torn in the fabric of the universe.

I watched Lisa tear the extensions right out of someone's hair once. The girl punched her hard in the face outside a bar—laughing and showing off for her friends— and not only did Lisa not flinch, but she reached out and snatched the whole hair-do right off the girl's head. Then she went back inside and handed it to the bartender who placed it, trophy-like, behind the bar where it stayed for ages.

"My grandmother," she told me casually while navigating a chaotic highway once, "was buried with the wooden spoon she threatened us with our whole lives. Her casket was surrounded by these giant floral arrangements in the shapes of her favorite poker hands. And my mom," she added while leaning on the horn, "was buried, I shit you not, with coupons from ShopRite Supermarket because she loved that place so damn much. And dad went to the great unknown in a casket stuffed with Budweiser."

"NO!" I protested.

"YES!" She nodded. "We're quite the family," she concluded before sticking her head out the window and yelling at a passing driver "THERE ARE TWO THINGS BLIND PEOPLE SHOULDN'T DO: HUNT AND DRIVE!"

Lisa throws the biggest parties and drinks the most without falling down. And while everyone else is puking on street corners or just getting by bartending and dreaming about future fame, she makes shit happen for herself; as a well-paid dispatcher in charge of an army of bike messengers delivering pot throughout NYC; as a "roommate finder," like a matchmaker but without the romance; and most recently, as a big muckety-muck for a bizarre new show called the Blue Man Group. As our tour manager, she got us where we needed to go relatively on time, sold the merch, intimidated the creeps, got us paid, and transported us so we could do it all again the next day.

Broken down on the side of the road, Lisa had to contend with the one thing she despised much more than being punched in the face. The one and only thing that renders her speechless. The insufferable, summer heat.

The white undershirt I wore on our quest for help did nothing to prevent the sun from burning my shoulders beet-red as Martin and I walked along the empty road. After a while, the hot tarmac softened the glue on my cheap sneakers so much that the front of one loosened and began to flap freely at the toe. Soon after, the other followed, and I could barely keep the things on my feet. With no garage or gas station in sight, I pulled them off and decided to turn back on my own, barefoot, while Martin carried on to bring back help.

The asphalt burned my bare feet, and the small rocks that had been pressed into it by cars' wheels were sharp.

The roadside dirt was also treacherous, full of rocks and broken twigs fallen from the dense patch of trees that ran along the road. So I scurried along, sticking to the trees' shadows where I could, hopping between hot road and prickly soil. The only sounds were my feet slapping the ground, my cursing when it hurt, and my heavy, labored breathing, echoing like a tornado in my skull.

Suddenly a new sound: the hum of an engine as a car pulled up and began to crawl, slowly, at my heels. A furtive glance back suggested two figures in the front seat of a truck, in shadow. I tried to keep a steady pace, marked by the slap, slap, slap of my soles. Sweat stung my eyes, pouring off my brow.

The truck stalked me, as stealthily as a cat slinks behind a mouse that hasn't yet decided whether to run. The shuttering purr-r-r-r-r of the engine and the rhythmic crackle of car wheels popping over scattered gravel shot adrenaline through me and sped up my ragged breath.

Goddam it, Ali, I admonished myself. Bad decision!

A story I heard once about a band from Detroit popped into my brain. The members were two girls and a boy who, onstage and off, all wore spiked heels and gold lamé bikinis. Combined with their hard-living, Detroit Motor City vibe, the overall effect of them was formidable and fearless. Packing the van with gear after a show, one of the girls found herself surrounded by strange men in a back alley. As the group closed in around her, not sure what to do, she suddenly threw herself into convulsions—lurching, speaking

in tongues, rolling her eyes back in her head—until the men, confused and visibly shaken, scattered. I wondered whether this might work for me and quietly mimed those things to myself as I continued walking on the side of the road.

Where will I run if they stop? I fretted. I knew someone who was dragged into the woods and beaten to death for the high crime of being a woman alone. Could I use my dead sneakers as a weapon? Only if I wanted to give them a rash from a slap with hot glue and melted rubber.

Just as my barely contained panic reached a fevered pitch, the engine revved, and the truck sped uneventfully past, leaving me in a plume of hot, gritty air. I watched the back of it intensely until it finally disappeared over the road's horizon. Then I began to shake. And as I shook, I cursed the unfair nature of a world that makes a quiet walk a potential tragedy for a woman.

Ten minutes later, I could make out the wavy shape of our gimpy van, poised at an angle. From the hilly field next to it, a tiny dot popped up, like a flea off a dog's back. Relief flooded me, and I ran toward the dot until, when we finally met, Matt threw his arms around me.

"God!" he said. "You looked so vulnerable out there."

From a distance, while I couldn't hear what he was saying, I saw Ron marching up and down the empty road next to our van. He spun around and flailed his hands and on the ground in front of him, helplessly plastered to the side of the grassy hill on a blanket on her back, was a bright

red Lisa, delirious with laughter and sunstroke. I could hear her voice thunder from a distance, "RON! IF YOU KILL ME LIKE THIS, I WILL COME BACK AND HAUNT YOUR ASS!"

When I got close to her, she looked up and her eyes flashed. She pushed herself onto her elbows and squinted into the sun at me. Neither of us said a word, but I could tell she recognized my lingering fear. And before I knew it, she'd swept me off my feet and pulled me down to the blanket where she threw her arm over me and whispered, "If you want me to rip the hair off of Ron's head to make you feel better, just let me know."

May all the Goddesses bless my friend Lisa.

I put down my journal and wander over to Matt now as he softly strums his guitar on the mountainside.

Baby, he croons. I join him for the harmonies.

Love is strange

Then Johan's clapping behind us. "Okay people. We gonna get out of here. Just a hundred more hours or so." He's riding in the cab of a tow truck, and he and the driver chuckle when they see us; blissed out, lounging lizards in the sun.

twenty-three

"Huh."

But not like a question. More like a "Would you look at that."

I guess I knew we'd be coming to Croatia, but now that we're actually on our way, when I read it on the agenda I just say, "Huh."

When newscasters in the US talk about Croatia, I've only ever heard them use words like "shocking brutality," and "ethnic cleansing" when talking about the Croatian War of Independence, which has only been over for about two years now. But in that short time, Croatian youth has, apparently, developed an insatiable appetite

for disjointed poetry with an anarchic backbeat. So here we are.

It's been pouring for twenty-four hours, and the incessant *shhhhhhhhh* sound of wheels on wet road lulls me into a trance. I try to sleep, but my head hits the window. I try to read, I feel nauseous. Matt can read—volumes of books, reams of papers—anywhere, anytime, no problem. Yesterday, he handed me his well-loved copy of Gabriel García Márquez's *One Hundred Years of Solitude*—which, by the way, is exactly how long I would need to get through that damn thing. (448 pages, my ass!)

Many years later, as he faced the firing squad, Colonel Aureliano Buendía was to remember that distant afternoon when his father took him to discover ice. At that time Macondo was a village of twenty adobe houses, built on the bank of a river of clear water that ran along a . . . That's when the bile started knocking at my throat and I had to hand it back. Now I'm staring straight ahead to stop the dizzies.

It's quiet in the van except for Joe Strummer, who's screaming that he's bored with the USA.

I hear you, Joe.

I yawn. Stretch. Lay my head on Martin's shoulder, but the van's bouncing makes my temple smash into it, so I straighten up.

"Johan."

Shhhhhhhhhhhh.

"Johan," I lean forward and curl around the driver's seat. "How much longer?"

"Eh. . . I'm thinking, maybe, till the end of time? Or at least that's how it feels." He cracks the window enough to light another cigarette, and the wind and the rain whip his stringy blond hair against my face.

I slump back. The van bullets down the highway, filled up, as though with liquid, to capacity, with the sound of Joe Strummer's demands for a riot of his own.

Despite the loud music, Martin's tired head lolls around on its neck-stem until its dropping stuns him awake. This happens enough times to be entertaining until, tired and bored, I climb over to the back seat and spread myself across it.

The total absence of shocks in this ancient ice-cream-truck-looking-thing means I feel every pebble like a boulder in my back. The bouncing reminds me of my time as a baby in the old VW-Camper-van-crib, the *shhhhhhh* from the road, like a lullaby.

The van slows. The rain has stopped. I must have slept. There's nothing around but short bushes and a single, small cinderblock building.

Johan's never tense, but he's driving slowly and carefully now.

"Be cool," he says over his shoulder, as though he, and maybe everybody, expects Ron to say or do something wildly inappropriate. But you don't grow up in rural

Vermont—not with a face like Ron's—without learning when to shut your mouth around authority.

Johan brakes smoothly—hand-rolled cigarette stuck to his lower lip, long, blond hair clinging wildly to his wet shirt-back—when a guard, machine gun slung across his front, approaches with his hand raised in front of him.

"WHAT THE BLOODY HELL DOES HE WANT?" Martin says too loudly before Matt snatches the headphones off his head and shushes him.

I start tying my black Converse.

The guard beckons and Johan rolls down his window. I can't hear the words, but the guard's tone is unfriendly, and Johan's is a bit more shrill than usual. He hands over a folder of papers that explains who we are, why we're here, and that we have work permits and passports and people waiting for us who will notice if we disappear. The guard leafs through them, head cocked, expression hidden behind tinted glasses, before turning abruptly and disappearing into the little cinderblock building.

Huh. It's the only word I've managed to conjure up so far when thinking about Croatia.

The sun is merciless now and it bakes the van. Johan's eyes dart front, side, back, all around. Even Ron sits quietly.

The lonely trill of a bird. No reply. The crisp rustle of breeze through a low, dry bush.

We jump in unison when a guard bangs hard on the side door.

"Out!" comes the order.

My attitude toward cops in New York is one of mis-
trust but not much fear. In my circles, we clash with them
a lot—mostly at protests. So when three guards direct us
out of the van now and start carelessly tossing our bags
into the dirt after us, it's still hard to feel too panicked.

"Who?" one demands, pointing to a bag. Martin steps
forward to answer for the contents.

Another throws Matt's effects pedals bag into the dirt
and leaves him to explain away what looks exactly like a
bounty of bomb-making material.

Next, a large guard with bulky, veiny arms plucks out
my grandma's little vintage brown suitcase with the big
orange flowers on it.

"Who?" He swings his weapon to the side to hold the
odious thing up and away from him like he's plucked a
dirty diaper from a garbage pile.

"That's me." I raise my hand and chirp, far too cheer-
fully, hoping to ingratiate myself.

He balances the bag on one meaty paw and unzips
it with the other before riffling through. My knees start
feeling rubbery.

"What is it?"

"A diary. Journal. I write in it." I mime writing, which
looks like I'm asking him for the check. I can feel sweat
gathering on the back of my neck.

Then he finds my box of tampons. It's a large box. The

kind of box a woman brings from America when she'll be gone for two months and wonders whether the tampons she'll find in Europe will be as skinny as their hand-rolled cigarettes. He holds it close to his face, like a jeweler judging the chunk in his hand as diamond or glass. Inquisitive. Hopeful. And then it dawns on him. I have never, before now, seen a line of deep red embarrassment literally crawl up a person's neck to the top of their head. When he's filled up with bright red, he throws the box aside like a black adder that's bitten him, drops my bag into the dirt, and hurries away toward the small, concrete building without saying a word.

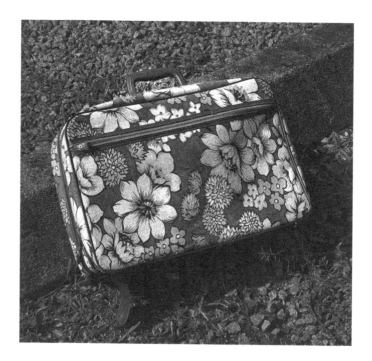

I'm wide-eyed now. *Did anyone else see that? That was so insane. That was . . . a problem? Is that a problem? Did I just embarrass a man with an automatic weapon?* I know armed men generally don't really like to be embarrassed. I feel the heat, the sweat, the still air. We're not in Manhattan. I don't really know where we are. And these aren't your run-of-the-mill, New York City cops.

I look down, mournfully, at the tampon box which lays coated in dust, its contents spilling out through its torn top.

Thirty seconds. One minute. Two minutes. I shuffle on the spot, afraid to move much. I tap my toe against the dirt a bit and notice that dust has worked its way into my Converse through a little hole. Around me, other guards continue their intense search and Johan flutters around them like a worried mother hen, communicating in hushed, reasoning tones.

Ron is the one of us who's had the most frequent and most unfortunate brushes with the law. They've found him on dark side streets on the Lower East Side. They've found him driving 110 on a 65 stretch of road. He fidgets now out of habit.

Then I see her. A lone female officer—she looks small under the weight of her enormous weapon, and she may be even younger than I am. She walks straight toward me, and I stand at attention.

Just as she reaches me, another guard rooting around in the back of the van where the equipment is hits what he's sure is "the jackpot."

"WHAT IS THIS?!?" he shouts triumphantly to the room at large.

Ron has really been trying to stay clean lately. He checked into rehab a few weeks before this tour, and he's done well. Instead of heroin, he's taken to obsessing over gourmet food and fine wine, which is annoying—because it involves a lot of listening to him about gourmet food and fine wine—but a welcomed change. He's swung wildly in the opposite direction and started taking a lot of supplements—vitamins C, E, and B-complex, echinacea, worm wood, etc. He's been carrying this collection of pills around loose in an oversized, clear sandwich bag, and it's this bag of about three hundred pills that the officer now holds aloft like a marlin he plans to mount for his wall.

Martin blurts out nervously, "It's VITAMINS!" Only, with his British accent, he pronounces the word "VIT-a-mins," not "VITE-a-mins," and all hell breaks loose.

"AMPHETAMINES!" the guard, having misheard, bellows. There's the buzzing excitement of an impending kill in the air.

"You're going to jail!" one says looking straight at Ron and, for the first time, smiling while clapping his crossed wrists together repeatedly like he's being handcuffed, to illustrate the threat.

It all happens quickly now. I watch as the boys are hustled, with shoves and machine guns, into the building,

Johan nipping at their heels, softly pleading and reasoning. I'm left alone with the female officer.

We stand together, face to face, in the discomfort of the sudden silence, until abruptly, she gestures toward the building. Inside, she corrals me, from behind, to a small, empty cinderblock room. The only light comes weakly from a row of squat windows near the ceiling on one wall and dissipates into gray haze halfway to the floor. The door's lock clicks behind her and I start to sweat; a strange, internal sweat, like sweat is gushing behind my eyeballs. A private, hellish little panic.

I shuffle, awkwardly, to the center of the cold, concrete floor, stop and look sheepishly in her direction. Surely soon she'll raise her finger to pursed lips to make sure we don't get caught before offering me a pull of Rijeka from her hip flask. We'll fake the sounds of her flogging me. "NO! STOP! PLEASE!" I'll wail as our shoulders shake with stifled laughter about all the macho bullshit going on outside this room. We'll roll our eyes about how she'd been sent to deal with the embarrassing messiness of my womanhood. I'll promise to compose myself before meeting back up with the others. And it'll be just like a sleepover with a very socially awkward, mean-eyed girl your mother made you invite over who showed up with a hip flask of booze and a machine gun. Right?

"Off," she gestures. I raise my eyebrows. *Oh. So we were really doing this.*

She leans against the door, stone-faced, as I slowly unzip my jeans and lower them. I can see now she's probably a couple of years older than me—maybe thirty. I consider inviting her to that night's show. Then I remember that even under the best of circumstances, our band isn't for everyone.

With my pants crumpled around my ankles, I give a little shrug and smile weakly.

"Up!" she commands. I tilt my head, like a confused dog, then slowly lift my T-shirt, exposing a road-weary bra. I stand there, wavering slightly in the soft, gray light of the room, my pants down, my shirt pulled up to prove there aren't any pouches of heroin strapped around my waist. Her hands clutch her machine gun.

Everything good and fun and enviable is outside of this room and, for all I know, has driven—or been dragged—away. I can't hear anything out there. Who will come to get me now? In the seconds that pass like years, I study my captor. Has she chosen this job or has it chosen her? Has the war hardened her past the point of return? Does she like music? Does she like anything? When she looks at me, does she see a spoiled, privileged American living a life of freedom she can't, and does she hate me for it? And what might that hate look like if nobody comes to rescue me from this room?

Then, unexpectedly, I'm overwhelmed with gratitude, total and complete. Because even though this woman is

comically unfriendly, fate has not put me in this cinder-block cell, alone and half-naked, with a man.

Just as the silence, the cold, and the nerves threaten to consume me, she sweeps her hand up and I dress quickly.

Everyone except Ron is waiting by the van. Johan sucks hard on the stub of his cigarette. Martin crouches beside him in the dirt smoking too. Matt is running his hand slowly through his waxed hair as he gathers scattered items from the ground, repacking them with tenderness. He shoots a thin, labored smile my way.

Then I see my box of tampons, still in the dirt. I bend down and cradle them, like you might an injured bird. A sweet, beautiful thing that's fallen out of its nest and has no idea of the gravity of what's just happened. They're largely unusable, some flattened from careless footfalls, others, their applicators packed with red and black dirt. Their little strings seem to plead, in a trembling chorus, "Please. You can still find use for us. We used to mean something to you. Don't leave us here. Not with them. Not now."

I think about the power of what I hold in my hands. I should carry a box of tampons everywhere like a Molotov cocktail. Men will think *My god! That woman might explode at any moment, and not in a way that I find attractive!* I imagine walking into embassies, past police tape into crime scenes, straight into bank vaults with total immunity. I hold the box close to me and, finding my little brown vintage suitcase with the oversized orange flowers

on it, tuck it back away, on top of the T-shirts, dirty underwear, and my journal.

When Ron emerges a half hour later, guards trailing behind him, his wild expression makes it clear he's had it worse than us. They'd tested the bag of pills and now they look disappointed and forlorn. We climb back into the disheveled van, a guard tosses the folder of papers back to Johan, and we roll slowly across the border into Croatia. They keep the sandwich bag full of hundreds of vitamins, which we are glad to see go.

The sun, low in the sky, casts a mellow orange light as we drive in silence until Johan flicks his head. "Over there's Italy."

The Adriatic Sea glistens, stunningly blue. Small, rippling waves catch the bright sunlight on their ridges. Now there are trees and a cool breeze gently urging them to dance. I roll the window down and follow a V-shape of birds in the sky, letting my hand surf on the wind.

We set up on a stage set inside the ancient ruins of an amphitheater. That night, our music reverberates off crumbling, two-thousand-year-old walls, escaping into the black sky above, hanging up there with the stars.

The kids in the crowd have been through a war, and now they're vibrating with newfound freedom and the certainty that this moment is worth living. It's on their faces and in the way they dress—like they've cobbled

together looks and ideas from magazines, album covers, and, most importantly, their war-torn dreams. One girl has drawn on two thick, black eyebrows. But she's drawn them two inches above her natural eyebrows, which she hasn't shaved off, and the result is a fantastically bizarre, four-eyebrowed glamour. Pure punk. No rules.

No clothes from Trash and Vaudeville or Betsy Johnson. Just total reinvention from the ground up and it's exciting to be around.

The last notes of beautiful, haunting "Corn River" trail off, dismantling into the stardust, and as I listen to them go, my heart pounds; I am alive.

twenty-four

"This can't be right!" Johan is driving while studying a long print out of directions, unfurled like a scroll.

Continuing with our tour of former Communist Bloc countries, tonight's show is in Slovenia. I believe the words "outdoor festival" may have been used by the promoter. We've followed his directions to the letter, so when we take a final right turn into a thick patch of woods and the directions stop, we don't quite know what to do. It's black all around us except for where the van's two weak headlamps attempt to light a narrow path with reed-thin, wavering beams of yellow light. As we bushwhack our way through gnarled trees, the sound of twigs snapping

makes it sound like we're being fired on with arrows from all sides.

Just as it seems most likely we'll end up stranded in a Slovenian forest with a dead car battery, I spot white lights strung in a tree.

"LIGHTS!" I point, inanely, and everyone nervously laughs.

We turn right at the lights and the woods immediately open onto a Fellini-esque scene bathed in the ethereal light of a thousand white, strung bulbs. Stew bubbles in large pots over open fires; punks, hippies, and bikers stumble around, guzzling clear liquid from mason jars. When they notice the van, they descend on it, rocking the awkward thing back and forth until it feels like it might tip, and thrusting mason jars of clear liquor, that smells like lighter fluid, in through the windows, which Ron takes without hesitation.

He turns around in his seat and laughs. "It burns!"

The stage is a rickety thing with a small roof nailed onto four beams in its corners, set, dramatically, at the bottom of an enormous, earth pit. Clinging to the dirt sides of the pit, kids make out, drink, roll around, eat stew, scream, and laugh.

As soon as we stop, someone on the outside opens the back door and a line of kids pulls the equipment out—as efficiently as army ants—and drags and rolls it, unrequested, down into the bowl of earth and onto the stage.

Johan shrugs and sets up at the small soundboard perched on a folding table.

It's hard to say whether we're the best thing they've ever heard, or whether this is the best party they've ever been to, and we just happen to be playing.

When Ron sings "Everybody knooooows it's a fucked-up town" for the last song, these children of war-torn Slovenia may know what he means in a way we never will.

When it ends like most of our songs do—abruptly—Ron drops the mic and tips off stage. Matt and I jump off after him but get pushed back on for an encore. And then another. And then another. When we leave the stage for the third time, the chanting starts.

"Speed. Ball. BABY. Speed. Ball. BABY."

But the mood has intensified, from friendly to frenzied, and a few shoving matches break out by the stage.

Now we're playing songs we barely know, and it doesn't seem to matter.

"That's all we've got," Ron finally asserts. "Meet you over at the stew."

To back him up, this time I turn my amp off before jumping off stage. But when I step down, two bikers block my way. They're wasted and their leather vests are covered with iron cross pins and motorcycle patches.

"You play more!" urges the drunker one.

"Oh no!" I sputter clumsily. "We can't. We *literally* don't know any more songs!"

"You play more," the other one leans in, the smile erasing itself from his face, "or we kill you!"

I wish I could say this is the moment I act heroically. That I think of the perfect retort, clever enough to soothe this beast. What I do instead of that is I reach out for Ron, who is coming off the stage behind me, and I pull him between me and the bikers. And then I run.

Ron can handle anything, I rationalize.

I find Matt. "I think we need to go." The next fifteen minutes is a blur of trying to load the van without drawing attention to ourselves, trying to get Ron away from the bikers who—it seems from a distance—he is now good friends with, and trying to get out of the woods we could barely find our way into before our van's battery dies. And we are so close. Matt has extricated Ron and pushed him into the back seat. Martin is riding shotgun, tapping his finger anxiously on the dash. I'm nestled in behind Johan who is, as quietly as possible, starting the engine. All is going perfectly until just as the van starts moving, a little slip of a thing—a very gentle, very young girl—bounds up to the van like a fawn, her finger wagging in the air to get our attention. In halting English, she calls out "I love your . . ." THWACK! That's when we hit her with the van and she falls, flat on the ground.

Johan brakes. We all stop breathing. The leaves stop rustling in the breeze. The moon looks down on us with pity. Then, like a zombie in a horror film, she sits up.

"YOUR BAND. I LOVE YOUR BAND!" she finishes.

"FUCKING HELL, GO!" Martin yells. Johan guns the engine, and I watch the girl in the rearview mirror stand up and giggle.

We drive back out on that same dirt road, much quicker this time and in silence, until somebody, I don't remember who, begins to laugh. And then we're all laughing. And then no one can stop laughing. We laugh our way out of the woods and down the dark, Slovenian road. We cry from laughing so hard. We laugh and we laugh until our headlights flicker and die, leaving us stranded on the side of the road in Slovenia in the middle of the night with a dead battery.

I sit down in the dirt, roadside, while Matt and Johan prop the van's hood open and wave a flashlight over its innards. Their lit faces stand out against the dark sky as they poke around, loosening and tightening things. They jump back to avoid a jet of escaped steam, and I look past them, to the nearby field and its moonlit farmhouse.

This really is a beautiful place.

From low in the sky, I'm sure I see the moon wink at me.

twenty-five

It's 1917 when two horses arrive pulling a long, open-top wagon that trundles along on wooden wheels. In the front, at the reins, is a tall man with a mustache, shirt sleeves rolled to the elbows, wearing expensive, tweed pants; a telltale sign he's not local. He's driven for days to find this small cluster of stone buildings and barns that is Solveira, Portugal, a village that isn't on any map.

There are families expecting him, so when he reaches the village square—where the buildings meet around a water pump—they are already standing in small, nervous clusters.

He pulls the reins to stop his horses, who don't resist.

They've been up and down the Trás-os-Montes—the mountain range that divides Portugal from Spain—for hours and are happy when he hops down and leads them to a trough below the water pump.

There are no waves or excited welcomes for the man.

Inside of each cluster is a young girl holding a very small bag. Anna Gonçalves is one of these girls. She's seventeen years old, with olive skin, big brown eyes, and soft wavy black hair that reaches her chin. She clings to her mother's arm. Her mother Ana's eyes are pained and wet. Her father, Antonio, stands stiffly by, and when the man leading the horses approaches their family, her father throws his cigarette to the ground and holds out a small receipt from Mr. Guillerme M. Luiz of the Northeastern Cotton Mill Company, 438 Bay Street, in a place as far away as the moon called Fall River, Massachusetts.

Anna's number: 13262.

Date of payment: January 9, 1917.

Few words are exchanged. Everyone knows why the man is here. Those details were sorted out months ago when a payment arrived for the twenty-first century's equivalent of around two thousand US dollars per family— a fortune that would change the fates of the villagers.

As he moves closer, each cluster tightens around the young girl in its midst, before the hands of the fathers and the reluctant hands of the mothers gently push each girl away.

Anna's friend, Hilda, helps her over the side of the wagon and she nestles down on the wooden bed of it and pulls a red floral scarf over her head to protect her from the sun and to hide her face.

The wails of the mothers and the sisters can be heard as far as Spain as the wagon slowly rumbles away and Anna takes long, last looks at the gray stone buildings and the sobbing women and the nervous, pacing men—including seven brothers and sisters she'll never see again—and she softly cries.

The wagon takes two days to reach the coast where Anna boards an enormous steamship, the size of which she could never have conjured in her dreams. That journey takes over one week, and Anna spends most of that time crying on her cot in a small room far below deck. There are seven other girls from Solveira with her—Hilda, Emilia, Maria, another Anna, Alcina, Aucinda, and Lucinda.

The ship lands at the New Bedford Wharf on the morning of June 10, 1917, and Anna steps into her new life, alone.

——

We've driven through the countrysides of Spain and Italy. So why, rolling over the border on a side road into the countryside of Portugal, is the light different? Why do the birds sing differently—with "saudade," a Portuguese word meaning something like "melancholic longing,"

"yearning," "incompleteness." A word there isn't even an English equivalent for, but which the Portuguese feel so often they needed a term for it. The difference, for me, comes from my gratitude to Anna, my grandmother, which is overwhelming.

Anna worked her ass off—at the cotton mill, as a house cleaner, then running a boarding house—so she could send money home to a family she'd never see again.

She raised three daughters from three different men who either disappeared or drank themselves to death. Her first two daughters lived with her like travelers until my mom came along. Where her sisters, Hilda and Emily, quit school to work in factories like Anna, my mom became the first to finish school, the first to start a career, the first to choose to move away from her hometown, and the second to live with the nagging guilt of having left her family behind for the American dream. Anna and my mom both cried a lot. But when they laughed, they laughed with their entire bodies and their big, beautiful teeth flashing defiantly to the world.

If Anna hadn't done that—*all* of that—I wouldn't be here now, returning to Portugal, in search of thrills, in search of myself, and with a sense of entitlement to find those things. And just saying it out loud now, that old family guilt is kicking in. But only just a little bit. Because I think Anna would be proud.

Farmers have rolled their hay into six-foot-high wheels and dotted their fields with them like a perfectly geometric art installation.

We drive through a village so small the windows of some houses butt right against the road, and a lack of curtains seems to say the locals *still* refuse to believe this major road will be coming through here. At the top of a hill looms a grand cemetery, physically out of all proportion to the

size of the small village. An older woman, in a soft, cotton blouse and an apron, may just be stepping out for some fresh air, but she seems to be heading up the hill. Knowing that all roads lead to the top of it, she walks slowly.

In Porto, the twisting, medieval streets are mysterious and exciting to wend through. Arabic azulejo tiles that cover the buildings in Lisbon make the whole city look like doll houses crafted for a giant's child to play with. Widows all in black stare at our passing van as though from a distance not only of meters, but of centuries.

My mom's labor was induced on October 29, two days early by a doctor who was eager to start her vacation to Greece, and only nine months after Anna died. And what was the first thing my mom said to me when her brown eyes met my barely open ones?

"Hello, mom."

Hello, Anna. Wherever you are.

twenty-six

Thirty-four days in.

At the start of this journey, I felt the curve of the earth before me, promising one, after another, after another opportunity for glory and amazement. Now all I feel is very, very gray.

Nothing on the outside of me has really changed. There is still promise. The shows are great. In Manhattan, people are hard pressed to travel above Fourteenth Street to get to a show, and forget about it if there's public transport involved. But in Europe, people will enthusiastically drive across several countries to see a band they think they might like.

"Yah, ees no big deal. I just drive four days, den to ferry,

den stay overnight on campground where I meet couple living in caravan and help dem sell dere hemp and bean stew for two days before I get on other highway and ferry and den dis dirt road and den I AM HERE!"

And this tour has been undeniably fun. Konkurrent loves us, press loves us, we've sold more merch than on any other tour. But I can feel the fog descending on me. An anthropomorphic fog that says, "You little bitch. You thought I didn't know how to get to Europe?" And it's laughing now, and it's sitting next to me in the van, backstage, on the toilet, always there, always nagging. "You are not enough. Make no mistake. You thought you could reinvent yourself here as Anouk Aimée. As Iggy Pop. As Ari Up. As anybody but you. But you're the same old boring, tepid talent you were in New York City." Then it leans in close to whisper, "And I'm. Still. Here."

I never know when the fog will show up. It's like the one that enveloped my mom at unexpected times. The one that, when I burst into the living room and threw balloons in the air that I'd secretly, laboriously blown up for her fortieth birthday, made her cry. Not with joy, but despair. Foggy, gray, ambiguous despair. That fog, apparently, had a kid, and that kid got assigned to me. "Never let her out of your site," was the instruction. "Let her feel good for a while so when you descend, she's caught off guard."

And now it's here. And lifting my equipment onto the stage feels like a chore. And the bass over my shoulder feels

heavy and pointless. But I do everything I can not to let this show. The idea that the chemicals in my brain might be bad chemicals—that's embarrassing. Terrifying. I ran away from that possible fate like my ass was on fire when I left my mother's home. And if I've got bad chemical soup for brains too, it was all for nothing.

So I act excited and happy and thrilled and sassy and tough and funny. But when we pull up in front of a field that smells like cow dung, it's hard to keep up appearances.

"Holy shit, Matty! Is this a farm?"

Sure, they've set up stages and tents. But from the smell of it, they've only just finished hiding the livestock in the surrounding woods.

"If it is a farm, you know what that means . . ." he taunts.

"Goddammit, Matt!" He's got me and I brighten up for a moment. "You know I love a baby cow!"

So yeah. Forests, cow fields, church yards, any old place you can hang a sign, I guess. "Oh, but Matty, it stiiiii-inks!!" I pinch my nose and roll up the window as Johan pulls up behind the stage, and Matt leans in close to my ear. "Baby coooooow."

Seven hours later and we're still waiting to play. And Matt has not found me even one cow—adult or other-wise—to admire.

I adore cows' dreamy eyes, their long lashes, full of flies. And their whippy tails that lazily slap at the flies on their backs. Did you know a cow can pee thirty gallons a day and

poo out the weight of a small child? And that sometimes, cows get "Cow Bloat." And that to keep them from exploding (it's actually imploding because the gas builds up till it crushes their internal organs), desperate farmers will punch a screwdriver or a nail right through their side to release the gas?

That's how badass a cow is. You can punch a hole in it, and it may just say "moo." But that's not why I love them most. I love them because they're casual. They're not always bouncing around, looking for your approval. They eat, they shit mounds the size of dinner plates, and sometimes they explode / implode. And they're all ladies and they're incredibly strong. When they give birth, they lick all the goop off the calf, nudge it up onto its shaky legs and get back to work, chewing up an entire field of grass and slapping at flies. If you find yourself squished between a fence and a cow that's absentmindedly backing into you, you'd better pound on that thing before it crushes your legs off, leaving your cursing torso pinned to the fence. And as you flog it, it will just gently brush at you with its tail like you're a bothersome fly. Gentle but strong. Unimpressed by people. That's what I like about cows the most. I like less the poop piles, like the one I've just stepped in now.

I'm snapped out of my cow reverie by a growl. "Check this out!"

We've been drinking the whole time we've been waiting to play. The last time I saw Ron he was lying in the middle of the audience in the grass next to an empty bottle.

Sure, I'm bored. But apparently the wait's been intolerable for this guy, the guitarist in a notorious New York hardcore band who descended on us when he found out we were from NYC too. I've known about them for years and I warned the boys about staying on their good side.

The thing that seems to get in the way of their band's tours, album releases, and shows most often is that one or the other of them is always landing himself in prison. I don't know whether they've timed it—got it on some sort of rotating schedule of shared irresponsibility—"I'll go in next week for beating an old man with his own cane if you take next month's shift for jerking off in the pizza sauce at your job. Deal?" We've basically drunk ourselves dizzy with him in the hopes he'll like us enough not to beat us up at any point.

And with that little explosion, he's off, running up behind a stringy little hippy boy and bustling him into a porta-potty where we can hear the unmistakable sounds of a beating I can't even fathom the logistics of. I'm a little hazy from the booze, and just sort of stare, slack-jawed, at the shaking plastic toilet-box. I'm so shocked that when Matt moos into my ear, I can't even think about cows. Not even baby cows.

"I mean, is there somebody we can tell?" I look around. Johan shouts from the back of the stage. "We're on."

I'm gonna say the show is ok. But the haze I'm in, and the toilet beating I witnessed, and the humbling smell of

animal shit in the air, and the gray fog on top of me, conspire to make me feel deeply alone. I watch Matt for signals and cues, and I hit them with Martin, and I watch the back of Ron flail and burn. But I can't feel any of it.

With the last spiky note of the final song, I'm on the verge of tears. I manage to unplug my bass, wind my cord, shove bass and cord in their case and make a dash for the backstage tent which is, mercifully, empty except for bags and gear and tables with bottles of whiskey, and beers floating in garbage cans full of tepid water. I hear people coming in fast behind me, so I duck behind a dividing curtain before everything falls apart.

Loneliness is like cancer. It can go into remission, but in the back of your mind, you know it might come back when you least expect it. Just once you've gotten the idea of yourself as someone who is "lonely-free," you may go for a test, like being in a crowd. You might start out okay, but after finding you can't have a meaningful conversation with anyone, your mind floats away; to an aerial view where all of you look like nothing but a virus on the face of the earth. Ants drowning in a puddle—their agonies, fears and struggles imperceptible, inconsequential. I feel this world view should make me more appreciative, not less. Make each second of life count more. But tonight, on a night I've come out of remission, it doesn't. I have been swallowed up by it and feel both anxious and corrosive. I'm an empty vessel that needs filling up with something,

anything. With meaning. Hope. Love. Purpose. Satisfaction. Joy. Something.

I wish that I bled when I was lonely. When there's blood, someone is bound to yell "STOP THE BLEEDING!" or "If you're bleeding, there's a problem." But some of the things that have ever left me feeling the loneliest didn't involve any blood. There wasn't even any blood when Colton and I decided to burn each other's initials into our forearms as a sign of our unrelenting, forever-love. Just the smell of pork frying through the whiskey-induced haze, and the white, bald scar, still there, where no hair will grow. But no sense of belonging to or with somebody. No sense of love. There was never any blood when my parents, living together mostly in silence, broken by intermittent jabs at each other, finally separated. And none when I moved Colton into my mom's apartment like a whipped dog I'd found in an alley. If there had ever been any blood, someone may have known the extent of the problem. Someone may have stepped in to help.

I'm on my knees now, behind a curtain, crying quietly. On the other side of the thin fabric, Ron is loud and funny and charming. I peer at him through the slit in the curtain. Ron is destructive and Ron is tortured, but Ron believes in Ron. His arm is draped over a girl whose eyes never fully open. Her two front teeth are so big that her upper lip hangs on them. *Beaver teeth*. I've always wanted beaver teeth. Ron went home with a girl once on tour. In

the morning, he came out in his underwear to find her biker father at the fridge. He turned to Ron with little to no concern, and proved the type of father he was—the type of man he was—with one line that we wouldn't stop repeating in the van for years to come: "I don't care if you fuck my daughter. Just don't drink my beer!"

There are lots of boys on the other side of the curtain, talking to Matt about their bands and our band in different accents.

Who fucking cares, is all I can think. I want to go home.

The backstage is full now and there's no way for me to slip out from behind this curtain without looking like I'm performing the anti-climactic finish to a magic trick nobody realized they were watching. I decide I don't care. That's a great thing about being in a band. If you show up for a meeting at your day-job drunk or passing out, or if you jump up onto the table when you get there, it's generally frowned upon. But when your job is to be in a band, you can emerge from a curtain, your black eye makeup smeared down your face, your eyes red and bulging and sorrowful, listing to the side from the shots you've drunk, and, if anything, people will say, "She looks so cool."

I whip the curtain aside, down some whiskey from an open bottle, and grab a beer before marching out of the backstage tent, back into the crowd, wiping my wet eyes defiantly on the back of my hand.

The sound coming from the band onstage —DM Bob

297

& the Deficits— matches my mood: jangled, lo-fi, and strange. The girl on guitar is beaming and powerful and she feels, to me, like a charitable gesture from the universe. I lean against the low wood fence that's penned us in and I let the whiskey work.

"You know she belongs to Django Reinhardt" I turn, and a boy clinks his beer against mine. If that's a pickup line, that's got to be the strangest ever. "Cheers!" the cute boy says, his mop of brown hair hanging in his face, his friendly eyes shining.

He looks up for a second, then corrects himself. "I mean, she is related to Django Reinhardt."

My gray fog softly nibbles on the back of my neck. *He's a loooooooser. A junky, for sure. Remember the one in Rotterdam? The one who seemed so cool until he peed his pants? Or the nice, shy waiter you invited to the show in Zurich and he brought his girlfriend who licked your face and tried to pull you into a sloppy three-way?* The fog hisses, *Never forget. They're all the same.*

I scour him for telltale signs. There's no gutted expression, dark eye-bags, or broken picket fence for teeth. No leather jacket or too tight T-shirt. Just a button-down hung loose outside of jeans, and a cigarette dangling from his smiling lips.

Who smiles like that? A sociopath, that's who. I turn away.

The band is good.

She's a great guitarist.

Crying has left me wrung out and raw, and it takes a lot of energy to stay disinterested, so soon, we're shouting at each other over the music. And laughing. I can hear my gray fog hiss, *I'm not going any-fucking-where!* But now this boy and I are almost cheek to cheek trying to hear each other and a gentle brush of his hair awakens me. I look at him—so friendly, so kind, so handsome in the glow of the stage lighting—and, warmed by the relief of him and by the whiskey, I lean in and kiss his cheek, then turn back to watch the band. A hand touches my face, spins it around gently, and we kiss.

Tonight, when I leave with Tom after the show, it's Ron who's squeezed with me into a tiny, clown-car sized Renault Kangoo. I'm sitting on Tom's lap, my head crushed by the low roof, watching the Belgian countryside roll by in the dark. Ron has a girl on his lap who, I discovered backstage, likes to take her shirt off at the slightest provocation. "Nice to meet you." Shirt falls off. "Pass the salt, please." RIP! Right off over the head.

"Hey Al!" Ron spins around from the front seat. "This is funny, right? Just you and me on an adventure together. That's *never* happened before!" He raises his eyebrows, then tosses his head back and lets loose with a loud cackle that cracks the sky. I smile and marvel at how, while I generally consider the ramifications of everything, Ron considers the ramifications of absolutely nothing before

diving in. And I wonder whether I've just made a wise de-
cision, setting off into the night, drunk and wired on a
post-depression high, with a boy I've never met before,
and with Ron, who, just two weeks ago, was arrested for
calling a couple of Swiss "polizei" Nazis.

Well, it's too late now. I breathe, deeply, the earthy
smell of cow poo in the night air, and remember Matt
saying, "If you wait, instead of jumping at everyone that
comes along on tour, no matter how mutated they are,
you'll eventually end up with the decent one in a hundred."
Here's hoping.

twenty-seven

When I wake up, Tom is gone. I lie in his bed, in the calm, soft light filtering in through a skylight above.

Lured by gentle tinkering sounds from downstairs, I pull on my pants and slide my T-shirt over my head.

"Good morning!" When he sees me, Tom races over and hugs me tightly. I stiffen, only because it's a nicer reception than I'd prepared myself for. "People shouldn't do such things when they've just met," he kisses my cheek, "but I'm so happy you're here."

I pass through the kitchen—leaving him cooking eggs and singing—and walk outside. An ivy-covered trellis frames the entry to a garden lush with buttercups,

bluebells, and primroses. Ron lies back on a garden chair, remarkably placid.

"Good morning there, my friend," he gestures to a table piled high with freshly baked rolls, a French press of coffee and a glass bottle of silky white milk. This is not how I expected the morning after my wild night out with Ron to look.

The girl he's with slides over and throws an arm around me. She reeks of sour sweat and her shirt is off, but she is kind and inviting when she says "Come join us in the garden of Eden."

I look back toward the house. The outside is painted vanilla white, the peaked roof is red terra-cotta tiles, and the outside frames of the shutters and the doors are all painted bright red. I wouldn't be at all surprised to discover doorknobs made out of gumdrops. There isn't another house anywhere in the vast surroundings, just tall, wild grasses swaying in the breeze. I sit in a deck chair, cradling my oversized coffee cup, and all the weight and strain I've been carrying around falls off of me, to the ground. My gray fog is nowhere to be seen. *Matt would like Tom*, I think.

Tom and I lay in the grass with the warm sun on our faces, until Johan rattles up in the van and I reluctantly pull myself away. We've got a three-hour drive to a festival in Leuven, where we'll play with Ringo Starr. It's a strange pairing to be sure, but I must admit to being a bit excited about sharing the bill with a Beatle.

Tom says, "I'll meet you at the show tonight!" I don't believe him for a second, but say, "That would be great." And I give a last look to the gingerbread house in the magical land called Oz.

When Tom arrives in Leuven that evening in his brother's Renault Kangoo, I'm dizzy with happiness.

"I told you I would," he smiles.

When showtime comes, he offers to carry my bass to the massive stage, but I like carrying my own bass, so he carries my pint. I tuck it around the side of my amp, knowing that even though the stage is large, Ron may still trample every inch of it, and I've lost too many drinks that way before. It's a good thing it's three in the afternoon so I have no trouble seeing Matt way at the other end, watching him for cues for impromptu stops and starts.

> *Do the blackout baby*
> *Do the blackout baby*
> *Kinda goes like this*
> *Kinda goes like this*

Ron charges back and forth, working the length of the stage, which is also very high, limiting his ability to engage with the crowd or leap onto it. Instead, during the third song, he backs up and jumps onto Martin's bass drum. But he does it with too much velocity, and when he tries to compensate, the drum skids out from under him, bucking

him off, and he lands with a crunch on the back of his neck. This isn't the first time, of course, that Ron has been turned upside down or cracked open during a show. So we play on, for four more counts, eight counts, an entire verse, as we watch him lie there, motionless. Eventually, Matt stoops down to investigate, while Martin and I keep the beat going.

"Ronnie? Ron?"

Matt bolts to the side of the stage, and the beat Martin and I are playing falls apart as two young men emerge from backstage with a stretcher and quickly load an un-conscious Ron onto it. I lean my bass against my amp and jump off stage to follow, as they carry him to a makeshift emergency tent. As a well-intentioned medic tries to fasten a puffy brace around his possibly fractured neck, Ron's eyes start to flutter open and he immediately begins wres-tling with the thing, bristling against the brace.

"Okay," I turn to the medic. "So he's *not* going to wear that thing. Is there anything else we can do for him?"

Confused, the man says quite seriously, "Well . . . he *must* wear this!" And as he attempts to fasten the brace again, Ron wriggles violently and peels it off.

"Right," I say. "I know that. But he's not going to. So . . ."

Ron bolts upright, rips the brace out of the medic's hands, throws it to the ground, and wobbles out of the tent, leaving the poor guy mystified.

I smile feebly at him. "Thank you for your help."

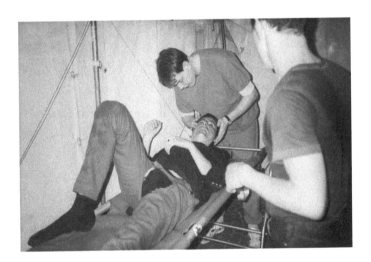

Driving three hours to play three songs might sound like a bust, but not for me, as the rest of my evening is spent with Tom. We eat in a restaurant nearby. When we sit at a table by a window and I part the curtains for some fresh air, a group of passersby who saw the show erupt, "SPEED-BALL BABY. IT'S YOU!" And they chant in unison, "SPEED. BALL. BABY. SPEED. BALL. BABY." And they cheer and applaud. Either they already knew us, or those three songs really rocked their world.

"They love you!" Tom beams sheepishly, taking my hand. This is not a man afraid to let me have all the attention. And, of course, that makes a nice change.

We walk through Leuven, on narrow, cobblestone streets, coming back to the festival in time for Ringo Starr who we quickly, grudgingly, decide is terrible.

Turning away from the stage, I slip on a piece of garbage. When Tom steadies me, I look down to find that the discarded, slippery waste that has tripped me up is a festival program opened to a two-page spread of my face.

I almost broke my neck tripping over my own image. I think, *If that's not fame, I don't what is.*

twenty-eight

Since we left Leuven, the gray fog is twittering away in my ear again.

Lately, I've been selfish. I don't wrap up my cord after I play but leave it for Matt to do. I don't put my bass in its case, I leave it for Matt to do. I say "Matt, where does this go?" or "How does this work, again?" too many times, about just about everything. I don't know why.

"Jesus, Al. You've got learned helplessness!" he snapped at me this morning, like he's never done before.

"*I do not!*" I countered. Then, "What is that?"

The tour is almost over; just one more show. Then it's

back to New York. Back to bartending. Back to the grudge match of dating. Back to . . .

What's it all about? The fog nibbles on my earlobe.

We'll be back here soon! Back in the bigger world! I growl back.

Don't count on it.

Maybe a little gumdrop cottage with a garden in Belgium is the answer. Maybe a nice boyfriend like Tom is the answer.

Who am I kidding? I was forged in the burbling cauldron of destruction that is New York City. Like it or not, it has made me who I am. On my better days, it's my superpower. I've bumbled through threats and danger and menace because I can make my needs invisible. I am porous.

The flip side of that superpower is isolation. The flip side is not being seen or known. The flip side is aloneness. The flip side is the gray fog.

When I get in the van this morning, I hate everybody. And I mean *everybody*.

I hate Johan's stupid, tiny mustache and his cheerful attitude. I hate Martin's British cynicism that passes for humor. I hate Matt, who I can see, now, has manipulated me into filling the role of fellow self-flagellator because he needed a pair of boobs on the stage. And most of all, predictably, I *really* hate Ron, the raging storm I used to fear would die in front of me. Now it's clear, he's not going

anywhere. *Oh my god. He's going to kill me. He's going to kill me!* He will outlive us all. Like a cockroach.

I overheard an old couple in a Chinese restaurant once. Mid-meal, the woman leaned back in her chair, threw down her napkin, sighed heavily, and shook her head. "It's not the egg roll, Morty," she admonished her husband. "It's the last forty years!" Sometimes it's not just the egg roll anymore. It's every-fucking-thing that bothers you.

I push bags and books aggressively out of my way to find my journal.

Falling into the Chasm

 I used to think of me and Matt as two babies, holding hands on the side of a mountain during a mudslide, wearing diapers, shaking our rattles at the world. Blissful in a life of our own creation, nothing could touch us. But I fear the solid ground we've stood on for so long is groaning under the weight of us now. I feel like I did when I was seven. When my parents divorced and nobody explained what was happening and one day, my dad and I stood together at a crosswalk waiting to cross the street when I heard a sickening "CRACK." A fissure started at the opposite corner and a chasm worked its way quickly toward us, swallowing the road as it came.

 Stay on this side with my dad, my mom is left alone, drifting away on the other tectonic plate. Jump to the other side to be with mom, leave my dad here with a

belching hot fury between us. *All I saw was sadness and
loss on both sides. Then the pedestrian light blinked "Walk"
and I stepped cautiously into the street.*

*Today, for the first time ever, there's a chasm forming
between me and Matt. From inside the belly of the world,
I feel a powerful rush of hot air and fire. From above us,
an arctic wind blows, trying, unsuccessfully, to quell the
billowing rage below. The heat and cold twist together to
form a hurricane, and lashings of rain drench us, leaving
me terrified and utterly, utterly disappointed with life.*

The van rolls silently toward our last show in Utrecht, Netherlands. I'm counting the hours before we board that plane that will take us back home to a city that, every time I return to it, seems like it's been in perpetual motion since I left. It hasn't missed a beat, hasn't missed me, and will welcome me back as long as I'm willing to run and jump onto it like a moving freight train. It's not slowing down for anyone.

"Who are we playing with tonight?" Martin breaks the silence.

"I think it's the Horribles," Matt answers. I feel no warmth for him. Never in my wildest imaginings does it occur to me he might be sick of me too.

"Ohhh, I don't think they'll be showing up tonight," Ron chuckles.

"I think they will, Ron," Matt says. "It's a label show and they're on the label."

"Yeah," Ron smooths his waxy hair back. He's got that look on his face; one of barely concealed delight. "I think they might not be coming. Seeing as I called them around 1 a.m. and I may have told them they were kicked off the label. I may have been a little drunk."

Now he's excited. "I told them I was Henrich from the label and that they're off the tour because we had a meeting, and we all think that their band name is stupid."

Nobody says anything.

"I said we'd decided they should go home and think up a new name that doesn't remind the audience of how horrible they are every time they say it."

Matt stares at Johan who looks ahead at the road. Martin rolls his eyes, and I study Ron's hair, spiked like the comb of a rooster that's fallen in a vat of grease. He's unapologetic, remorseless, bold.

And then I smile. And then I catch Matt's eyes and he smiles and pretty soon we're all laughing. Because it doesn't fucking matter. And maybe that's what Ron has been here to show me all along. None of the small stuff matters. He's been my id and I've been his superego and each of us has needed the other like a hole in the head, but also fundamentally and truly. Nothing really matters except for this moment in this van with these people in this breath. In a way, Ron has given me the power not to care. For my part, maybe I've shown Ron that some things are worth caring more about.

twenty-nine

The Horribles do show up to the Kikker Club in Utrecht, although they're a little confused and suspicious. I can barely look at them without laughing.

Ron is burning alive on stage tonight and people want to hold their hands to his heat. They reach out and grab his legs. They grab my legs with an eagerness to connect that I can relate to. No one in this room is gonna feel lonely tonight.

Feet stomp and bottles bang on the edge of the stage bringing us back twice for more. Each time we leap off, a cluster of girls descends and envelops me. Each time we head back on, a young punk boy lifts me to the stage

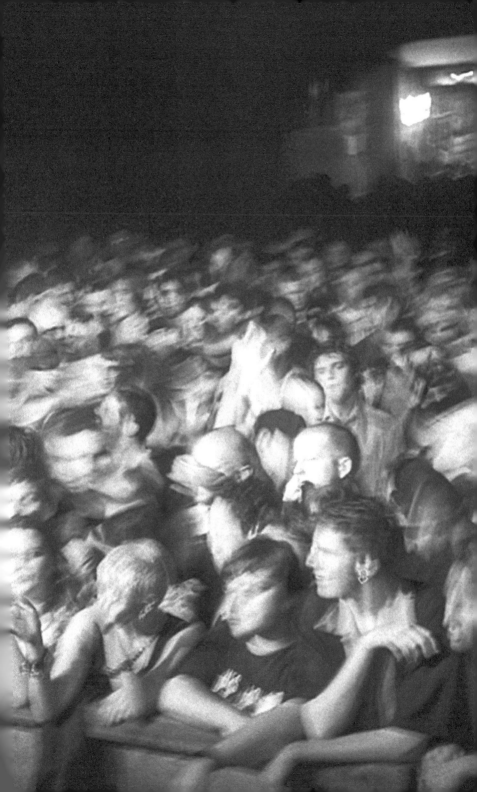

with the intense purpose of Kevin Costner in *The Body-guard*. I don't mind. There's nothing in it for him except for more fun.

Our last song—the last one we'll play on this, our first overseas tour—is "Fucked Up Town" which always gets people going. But tonight, before the song crashes in, Ron holds up his hand for us to wait.

"I just wanna say," he wipes the sweat from his fore-head with a handkerchief pulled from his ragged suit jacket, "that they're all fucked-up towns." He crams the handkerchief into his back pocket. "But we're real happy to be here tonight with you in yours!"

After the show, you can't walk across the dressing room for the bodies strewn across the floor. People hug, laugh, drink, sing. Johan eventually pokes his head in. "We gotta go."

I down my drink, and when I stand to leave, an arm bolts up from the pile, latching on to my leg, pulling me down.

"You can't leave!" a girl slurs, "You have to stay here with us!" I lean down to her, swaying a bit myself, kiss my hand and touch her lips with it. "Stay safe."

A gorgeous boy named Ari stops me in the hall to say those three little words every girl like me is dying to hear: "I hate drugs!" I just smile. "Yeah. Me too."

Rob, the promoter that's booked the whole tour for us, has been drinking and dancing all night, arms whirling,

wild hair spinning. It's 3 a.m. and I'm following Johan to the door when Rob's girlfriend, Helga, drunk and flushed, stumbles over to me, pulls me close and shouts over the music into my ear. "It makes me so happy to see a girl up there on stage. Because, you know," she grabs me by both shoulders now and looks tearful. "It's a man's world!"

I throw my arms around her, pull her close, and confide, earnestly, "Well, then, my friend. Join me for the revolution!"

acknowledgments

Thank you, massively ... Matt, Martin, and Ron, who gave me their blessings to tell my version of our story, and who helped shape the woman I've become; All the creative people who ever shared their guts and their glory with me; Joshua Bright, who I discuss absolutely everything with and who has supported me—for hours, days, weeks, years—as I clumsily learn how to express myself, on the page and in life; Harper Brightsmith, for unscrewing my skull and readjusting my brain so that I aspire to be more honest and true every day; Solveig Almaas for being a calm, loving presence and a shining example of the power of young women; Fellow native NY'er, agent Lee Sobel, who told me, early and

often (in his gruff, New York accent that feels like home), "This is a woman's story and that's what matters most"; lovely Dan Ehrenhaft and Blackstone Publishing for agreeing with Lee and never trying to make me change that fact; Miriam Shor, who insisted "YOU NEED TO WRITE A MEMOIR!" and then cried with joy when I actually did. Andy Action, Speedball Baby drummer after Martin, who acted like it was his full time job to make me laugh. Mary Smith, for being a strong woman and for encouraging me to "be happy" even when I can't be; Peter and Linda Bright, who never questioned why I needed to lock myself in their conservatory for weeks in order to write; Hannah Bright, and Lizzie and Ian Powell for their encouragement; André Smith, who gave me plenty of grist for the mill and taught me to speak out and stand out; everyone at OST Coffee Shop on Grand Street in New York City who let me write for hours on end, day after day, for the price of an almond croissant and iced oat milk latte; all the incredible women in my life—musicians, artists, writers, chefs, nurses, judges, students, teachers, yogis, revolutionaries, friends, sisters, family (birth and chosen)—who have, or will, take their own versions of the journey I've written about here. I salute you all.

In Memory of Kim Shattuck, Kendra Zimmerman, Linda Bright, Maggie Estep, and Melanie Wadsworth.

This story is based on my version of the truth (as supported by lots of fact checking, journal reading, photo perusing, handwringing, and question-asking). If I've

gotten anything wrong according to someone else who was there, please know I did my absolute best to represent everything truthfully. Some timelines have been compressed for the sake of narrative—because life is a sometimes boring, always messy venture—and some names have been changed just to keep everyone happy.

INTERIOR PHOTO CREDITS
Except in the following cases, all interior photos were taken (and copyrighted) by Ali Smith:

Ali with Disney Records–author's archives
Ali with Mom on NYC Subway–author's archives
Odeon Postcard–Existing Art
Band in Bed–Gigi Elmes
El Rey Theatre–Martin Owens
Hendrix Motel–author's archives
Ali Playing Live— Lynda Cohen
Ali with VW bus–author's archives
Anna Gonçalves–Photographer unknown
Ali and Matt dance–Martin Owens

Endsheet 1 (front):
Top: Martin Owens
Middle: Alex Story
Bottom: Ali Smith
Vinyl record and polaroid photo frame images from Adobe Stock

Endsheet 2 (back):
Top: Author's archives
Middle: Film still from the Oubliettes video
"Angel Baby" by Toby Amies and Darry Logan
Bottom: Ali Smith
Vinyl record and polaroid photo frame images from Adobe Stock

The vibrant style ALI SMITH has brought to her writing and photography—featured regularly in the *New York Times*, *the Guardian*, and other publications internationally—was forged in New York's underground music scene, where she played bass in the seminal punk / blues / avant-garde band Speedball Baby. After touring worldwide and recording nine albums, Ali released two books of photography about women's lives. The first, *Laws of the Bandit Queens*, led to a feature on OWN, Oprah Winfrey's television network. The second, *Momma Love: How the Mother Half Lives*, won a Silver IPPY and an International Book Awards prize, was praised by the *New York Times*, and Gloria Steinem called it "a gift to moms." With a passion for telling women's stories, Ali's memoir, *The Ballad of Speedball Baby*, is her literary debut. Learn more about her at AliSmith.com and @mommaloveAli on Instagram. Learn more about Speedball Baby @speedballbaby on Instagram.